The Murmuring of the Artistic Multitude
Global Art, Memory and Post-Fordism

Pascal Gielen

Antennae
Valiz, Amsterdam

For the Murmuring
For Reba, Lune, Ono and Milan

The Murmuring of the Artistic Multitude:
Global Art, Memory and Post-Fordism

Pascal Gielen

'By helping to overthrow the conventions bound up with the old domestic world, and also to overcome the inflexibilities of the industrial order – bureaucratic hierarchies and standardized production – the artistic critique opened up an opportunity for capitalism to base itself on new forms of control and commodify new, more individualized and "authentic" goods.'

Luc Boltanski & Eve Chiapello

Introduction

The art world has changed out of all recognition in the last twenty years. Not only has the number of people that call themselves artists increased tremendously since the nineteen eighties, but society's attitude to art and artists has changed too. In those days, any eighteen year old who told people he wanted to go to an art school got some funny looks from friends and acquaintances. And such a wish was often vetoed by parents, or at least hedged around with the condition that the youngster first learned 'a real profession'. Twenty years later, much less fuss is made when someone chooses to ply a creative trade, and the exotic aura around the artist's calling has evaporated somewhat. Today, creativity, innovation, authenticity and even idiosyncrasy are embraced by the business world and governments alike. The 'progressive' entrepreneur has grasped the benefits of artistic entrepreneurship for his Post-Fordian business, and politicians embrace the arts with a view to an attractive creative city that can hold its own in the global competition of places to be. In other words, art — or at least 'the artistic' — has been promoted in the course of twenty years from the margins of society to its heart. Or, as the Italian philosopher Paolo Virno declares, echoing the German writer Hans Enzensberger: art has been diluted in society like a soluble tablet in a glass of water.

This book will defend the hypothesis that modern art has played a role in this process itself, because the social structure of the early modern art world was one of the social laboratories in which the current Post-Fordian work ethic was produced. It is all part of the post-industrial economy to focus on qualities such as communication skills, eloquence, creativity and authenticity, as well as to think in terms of projects, with temporary contracts or none at all, flexible working hours and physical and mental mobility. But these qualities were once defended, and in fact still are, as the central values of the art scene. And with them the art world fits seamlessly into the spirit of capitalism's endless spiral of accumulation, as the French thinkers Luc Boltanski and Eve Chiapello have convincingly argued. Or, to paraphrase them: art criticism has been absorbed by the capitalist ideology, and is nowadays productively put to work within the neoliberal labour system.

This last sentence introduces a loaded word that will feature regularly in this book, namely 'neoliberalism'. Since this idea appears here in the role of ideological enemy, some explanation seems in order. First of all, let us be clear: this book is not a plea against liberal or neoliberal politics. As long as an ideological programme

is defended in the political arena, it explicitly admits to being an ideology which people can be for or against. No good democrat can have anything against that. What is more, let us not forget that both liberalism and neoliberalism prize individual freedom and autonomy very highly. And these are crucial values which modern art and artists could hardly survive without. In other words, we too enjoy the fruits of neoliberalism.

The neoliberalism that does occasionally come under fire in this book is of another order entirely. This is the neoliberalism that has left the political area and, just like Virno's soluble tablet, has dissolved into society to permeate it. It includes an ideological programme that denies that it is an ideology. This neoliberalism takes the form of a pervasive crypto-ideology — in other words, it purports to be the only 'realistic' option. It goes even further than that: neoliberal principles are seen as natural, and as intrinsic to human behaviour. Such a crypto-ideology therefore denies the distinction between nature and culture. A cultural product, which is what every ideology is, is presented as the only possible natural state of affairs. Anything else is dismissed as naive gibberish and banished to the graveyard of utopian dreams. With the manager as protagonist, this neoliberalism has crept into other areas of society that lie well beyond the market and the economy. In educational circles, for example, it has become commonplace to hear people talking of output and returns on investment — as if they were talking about a bank. Even in politics, neoliberal discourse is very widely accepted, whether in the neoliberal, the Catholic or the Socialist camps. And — to stay within the territory of this book — in the field of art and culture, when people talk about grants they no longer talk in terms of 'nurturing' the arts and our cultural heritage, but in terms of 'government interventions', as if they were referring to an unavoidable market correction, a necessary evil. At least, this is what is happening in the Netherlands. Moreover, the artist must also be an artistic entrepreneur, while cultural participation is first and foremost a matter of viewing statistics and visitor numbers. As we all know, there is hardly a museum, theatre or public broadcasting corporation in Europe that has escaped this logic of accumulation. In their own way, the mass media too have largely been reprogrammed in line with neoliberal thinking. And what are we to think of the 'value-free' scientific research that unquestioningly places itself at the service of this logic and decks it out with the most sophisticated methodological rules?

In the name of efficiency, freedom of competition is seen as a universal good, and nobody looks at what might be lost to it. This sometimes leads to a blind logic of accumulation of which the latest financial crisis is perhaps the most obvious result. Once again: it is not political and publicly expressed neoliberalism that this book opposes. One can only respect those who speak out in the political arena, if only because these are people who have the courage to show their true colours. Whether we agree with their political stand is another matter. But at least we are able to take up a position on it.

Another word that crops up a lot in this book is 'globalization'. The term is chiefly used to refer to the latest wave of globalization that has swept across the globe since the fall of the Berlin Wall. Critics sometimes claim that globalization is a fashionable term that has been so overused as to become almost meaningless. They also claim that globalization has been going on ever since the first trading towns grew up. There is little to be said against these points. And yet we really can identify different waves of globalization, the latest of which is characterized by a global hypermobility of people, money, goods and information. It is the speed with which this happens nowadays that distinguishes the new wave of globalization from previous ones. Moreover, today's globalization is marching in step with the spreading monolithic paradigm of free market capitalism, itself shored up by the creeping neoliberalism I have already mentioned. This is the globalization referred to in this book.

The theoretical insights on which most of the essays are based are a product of the alchemy between the sociology of art and critical social theory. The key writers in the former discipline are Pierre Bourdieu, Nathalie Heinich and Bruno Latour, chief architect of the Actor-Network theory (hereafter ANT), while the work of Luc Boltanski, Laurent Thévenot and Eve Chiapello play an important role too. The second 'discipline' is chiefly driven by the mainly political-philosophical insights of Chantal Mouffe, Paolo Virno, Giorgio Agamben, Antonio Negri and Michael Hardt (although the work of Pierre Bourdieu can equally well be placed within this critical tradition).

This perhaps rather idiosyncratic seeming combination of sociology and critical social theory grew out of personal interest, but it also relates to the evolution of the sociology of art. First of all, it should be pointed out that not many new ideas have surfaced in

the sociology of art since the work of Pierre Bourdieu and Niklas Luhmann. Most art-sociological theory restricts itself to commentary on, and fairly modest revisions of the work of these godfathers of the discipline. This is particularly true of the work of Bourdieu. Most cultural sociological research — and certainly quantitative research — does not go beyond adding to and perhaps refining the insights that the French sociologist first aired in the nineteen sixties. Secondly, it would appear that critical social theory was banished from most sociology departments after the nineteen seventies. And in the name of value-free research, sociology finds itself swept along in a methodological current dominated by quantitative methods. The discipline technocratizes and rejects — or, rather, suppresses — any ideological positioning. What this means in practice, however, in the context of the above-mentioned all-pervasive neoliberalism, is that sociology blindly follows the dominant paradigm. This book is an attempt to give back to critical social theory its meaningful place in the sociology of art.

While regularly homing in on theoretical and empirical insights, the book takes the form of a collection of essays, and is quite insistent on this point. The essay form allows for more hypothetical, speculative discourses, alongside normative, ideological and political ones. Moreover, the essays in this book were originally written independently of each other, although they have been thoroughly revised to make this volume a coherent whole. In some cases, especially the older essays, this means that they were half rewritten. Notwithstanding the chosen format, half of the essays are based on classical empirical research such as document analysis, in-depth interviews, data analysis, and participatory observation. Other contributions are based purely on theoretical insights and are speculative in nature. The different types of essay are deliberately presented here without differentiation, however. Implicitly, this choice underlines that even the best-grounded empirical research — quantitative research included — cannot do without the speculative space created by the sociological imagination, while speculations about society will be unlikely to convince the reader if they are not supported by empirical observations, however intuitive these may be.

The book consists of three parts. The three essays in Chapter One look at the facts about the art world and its institutions, such as museums and biennales. But these institutions are mentioned chiefly in order to illustrate the theoretical framework of

5

the book as a whole: notions such as 'multitude', 'Post-Fordism', 'immaterial labour' and 'biopolitics'. The second part of the book zooms in on the perception of art and cultural heritage in the context of globalization, and examines the influence on our collective memory of both the nation state and the rise of mass media and the internet. A stroll through the Post-Fordian city shows us how it uses art and aesthetics to take part in a global competition between places to be. The last two essays in the middle section analyse how museums present — or can present — both art and the past in a more reflective and yet political way. The third and last section of the book returns to the production side of the art world. It outlines the impact of globalization and the still expanding neoliberalism on artists and other actors in the art world, and goes on to point out a few alternative avenues. Whether these are convincing alternatives or whether they belong largely to the world of the murmuring is left for the reader to decide.

It remains for me to say a word of thanks. In the first place, to Fontys College for the Arts, and particularly to its director, Rien van der Vleuten, who made the Arts in Society research group possible, thereby creating a rare intellectual space in an educational climate in which almost everything is evaluated in terms of returns on investment. This programme represents a commitment to a long-term approach which it is hoped will make for sustainable quality art education. This is why we have chosen to launch a series of publications which we hope will gradually infiltrate the school's curriculum — and be consulted well beyond it too.

Many thanks, as well, to my colleague Paul De Bruyne, and to those of his associates who offered feedback and enthusiasm. Colleagues at my other workplace, Groningen University, also deserve a mention for the amicable atmosphere and solidarity they create on the generally informal workfloor there. There are few universities where you can still find this. I would also like to express my respect for Valiz publishers, who were happy to commit themselves to this publication and to our forthcoming, more or less speculative, writings. I'm especially grateful to Rudi Laermans, who critically examined various earlier incarnations of essays in this collection, and who remains an important fellow-thinker or partner in crime. And finally, much love for Liesbeth. In an earlier publication I said that living with a writer is a bit like a polygamous marriage. She still stands by me after the sixth book — or is it the seventh? The only possible response to this is one of admiration and respect.

Introduction

Chapter I
Art and
Post-Fordism

The Murmuring of the Artistic Multitude

'An ideology of property isolates the "author",
the "creator", and the "work". In reality, creation
is a disseminated proliferation. It swarms and
throbs.'
Michel de Certeau

Writing without saying anything. It shouldn't be allowed. Not here.
Writing here is assumed to be meaningful writing. In short, writing
that really says something about reality. Nonreferential drivel or base-
less babble have no place in a book, especially not in one that passes
as non-fiction. What is more, we expect what is written here not
just to make sense in the context of this book, but also to have some
meaning beyond it. That means that the accumulated meanings on
these pages should have some direction, be consistently build up, and
preferably should not contradict each other (too much). An essay in a
book can perhaps be seen as the opposite of the phenomenon under
discussion here: the murmuring.

Murmuring means literally to speak indistinctly, under your
breath. But etymology suggests a richer history for the term. To start
with the Greek word *mormurein*, the semantic register expands from
the obvious 'buzzing' to a more vitalistic 'sparkling' or 'fizzing'. In
Armenian, *mrmram* even means 'growl' — just the opposite of some-
thing incomprehensible muttered half under the breath. Whether it is
quiet or loud, murmuring is meaningless in any case. This might be
because it in no way refers to an outer, assumed reality, but hangs in
the ether like a formless crackle. Or it might be for the opposite rea-
son. The murmuring might be pregnant with meaning, but contain
so many contradictions and paradoxes that the utterance is adrift. In
this case too, we are dealing with meaningless murmuring in which
contradictory meanings cancel each other out.

However, there's more to the Greek *mormurein* that meaning-
less babble. As I have mentioned, the ancient Greeks also attributed
vitalistic qualities to murmuring. At least, 'fizzing' opens up more
possibilities and associations with the 'bios' of life. A life full of fizz is
one that is 'full of life' and liveliness. At the very least, 'fizzing' seems
to carry a promise of life: it implies potential, great things to come.
It was in the context of the Greek double meaning of 'meaningless
buzzing' on the one hand and 'fizzing' (with life) on the other that
both Michel Foucault (1966) and Michel de Certeau (1998) theorized
about the murmuring. According to Foucault, murmuring arises at

12

the place where language reaches its limits. It is both pre-linguistic and post-linguistic. We all know that babbling is one of a baby's favourite activities. It is his pre-linguistic promise of future meaningful speech (or so it is hoped). The babble — or murmur — of the newborn is pure potential. But referenceless babble is also characteristic of people at the end of their lives. It evokes images of a delirious person on his deathbed desperately trying to attach meaning to the memories that pass through his mind but persistently escape his grasp. Murmuring marks the beginning and the end of life, then, as if it stands at the door of death.

Michel de Certeau, too, ascribes a vitalistic power to murmuring. The French theologian finds a thousand and one creative activities, endless lexicons and exotic vocabularies, not so much in the art world, but in the folds and cracks of ordinary life. Everywhere there is teeming, buzzing life that is paradoxically stilled when it gets locked up between the walls of a museum. According to De Certeau, culture proliferates at the margins where it is not yet authorized. The buzz of creativity belongs to a collective that is hard to define. De Certeau speaks then of a swarm that is constantly on the move and that is there one moment and gone the next. Creation is transient and passes us by fleetingly because it is an action. But when an ideology of property catches up with it and turns it into an artistic object or product, the creative buzz evaporates. The murmuring is solidified into a meaning, in a comprehensible vocabulary which makes it recuperable, graspable, in economic, political, and above all perhaps, in mediagenic terms.

So why pay so much attention here to this quintessentially human activity of murmuring? Anyone who, over the past fifteen years or so, has attended the 'Documenta' in Kassel, in Germany or the Biennales of Venice or Istanbul, and indeed anyone who regularly visits an art school, might have some idea what I am getting at. Both the democratization of art education since the nineteen seventies and the more recent globalization have changed the morphology of the art world considerably. The former phenomenon has ensured that the number of graduate fine artists has increased fivefold in less than forty years, at least by some calculations. Other calculations — based on a broader definition of creative professions — suggest an increase by fourteen times. The second macro-sociological phenomenon, globalization, has ensured that the creative potential of practically all the corners of the globe can be unlocked. This was perhaps most visible in the fine arts after the fall of the Berlin Wall, when the former

Eastern Block was eagerly screened for artistic talent. About five years later it was Africa's turn, and now it is that of China and India. This proliferation of artists generates a true artistic multitude, a swarm that is hard to define because it is so heterogeneous, to fall back on De Certeau's word. The latter could hardly have predicted back in the nineteen seventies that the creative buzz that he detected on the margins of a culture would come to be the centre of both artistic and economic life — witness the flourishing of the cultural and creative industry. Or rather: the margin is now at the centre, rendering Certeau's binary thinking redundant. Admittedly, his idea of the creative murmur and the swarm are still remarkably relevant. But let us return to the artistic multitude. As we have seen, this is hard to define, because today there is very little sign of the artistic movements that, up until the nineteen eighties, tended to last about ten years. At the most, you can still detect whimsical trends or fashions which, just like the swarm, come together and fall apart with the same ease: yesterday we were still postmodern, today we are socially and politically engaged. The transitoriness of the art world has become almost 'instantaneous' (Urry, 2000). One of the reasons for this is that singularity or idiosyncrasy flourish more than ever nowadays as the dominant values in the artistic regime, as the French sociologist Nathalie Heinich (1991) has pointed out. The mass accumulation of the creative artist generates a polyphony of singularities and idiosyncratic meanings alongside and in opposition to each other. The art world today is a field full of paradoxical meanings that constantly contradict, undermine and invoke each other. It is indeed a collective visual or auditory murmur. At the lowest estimate, about ninety percent of the artists graduating from the schools today spend their entire careers as promise or potential — and thus as murmur. And that happens even when they seek to link their careers in to the professional art world.

But isn't there another way in which we can look at the artistic murmur? Within the dominant imagery of advertising, MTV, the internet and design in which artistic works — usually with a meaningful aesthetic — are easily integrated and recuperated, the murmuring may be (a degree of caution is in order here) a modest form of resistance. In which case, it expresses — whether consciously or not — the refusal to get caught up in an economic or media logic. Or: it does not want to be viable or a potential creative force in these fields. This artistic murmuring has more in common with that of the dying man referred to earlier than with that of the infant. It rejects in advance the promise of an economic, political or mediagenic life. Whether a conscious murmuring is

14

a decisive or effective strategy is left unresolved here. What is important is that we can understand the phenomenon in at least two ways: On the one hand as a 'can't' and on the other hand as a 'don't want to'.

The Artistic Multitude

So a heterogeneous murmuring is the mark of an artistic multitude. Before stating the main hypothesis of this essay, it seems useful to pay some attention to the second key concept in its title, and to consult the political philosophers Michael Hardt and Antonio Negri, authors of the book *Multitude* (2004), and Paolo Virno and his *Grammar of the Multitude* (2004). Incidentally, these thinkers themselves got the seed of the idea of the multitude from the seventeenth century Dutch-Jewish philosopher Baruch Spinoza (1677).

In many languages, the term 'multitude' has connotations of the masses. But this is not what Hardt and Negri mean by it. 'The masses' suggests a grey or colourless, uniform and undifferentiated whole. What is more, the masses cannot act on their own initiative, which is why they are so vulnerable to external manipulation, or so political philosophers tell us. The multitude, on the other hand, enjoys an internal diversity, but can communicate and collaborate in spite of strong individual differences. So we're dealing with an active social subject. The multitude is characterized by communal life and work in spite, or perhaps because, of considerable individual freedom and cultural differences. Think for example of an improvising orchestra or dance company in which many individual actors and skills go into a joint artistic composition or choreography. Every actor makes a unique individual contribution, and yet the result is a joint creation that cannot be reduced to the sum of its parts, although it wouldn't stand up without them. This description could, however, all too easily be understood as an overly one-sided human interpretation of the notion. So let us be clear: the multitude is not necessarily a crowd of people. It could also be made up of a heterogeneous jumble of singular ideas, things, actions or attitudes. Multiple attitudes: the association may even be raised by the word 'multitude' itself.

The multitude distinguishes itself for the above-mentioned reasons not only from the masses, but also from the people who make up a nation. The multitude transcends the geographical borders of the nation state. It is precisely an intercultural whole of people, conventions, actions … whereas a nation all too readily assumes a unique identity. The nation — incidentally an indisputably central referent

15

for both the liberal and the socialist political traditions — is of course made up of diverse individuals and social classes, but those social differences are reduced to one national identity, and preferably to one will, as Thomas Hobbes pointed out some centuries ago (1642).

While the neo-Marxist Hardt and Negri now place their hopes of breaking the current capitalist impasse on the multitude, Paolo Virno has developed a somewhat different version of the concept. He sees the multitude quite simply as a by-product of the Post-Fordian production process. Just as the consumer is a by-product of advanced capitalism's transition from a product market to a symbol market, so is the multitude the product of the technical transformation of the production process. In contrast to Fordism, things like flexibility, language, communication and affective relationships have gained considerable importance on the shop floor today. And these are precisely the components that the multitude responds to — a point that will be returned to later. The formal characteristics that Virno ascribes to the multitude are in line with those suggested by Hardt and Negri: it is hybrid, fluid, in constant flux, and deterritorialized. Moreover, the multitude fosters a permanent sense of 'not-feeling-at-home', in Virno's own words. Yet in spite of these qualities, the multitude is seen as quite a threat by the nation state and national politicians. Technological developments such as the internet and relatively cheap transport create both a real and a virtual mobility that enable the multitude to race around the world and to be everywhere at once. The exponential increase in mobility — of migrants, refugees and artists, but also of cultural products such as images and melodies, effortlessly cuts across both regional cultural practices and the boundaries of the traditional nation state. The exercise of power, hitherto localizable because it was based on territory, is moving to a space that is in constant flux. This makes it harder and harder for governments to govern their regions or nations in the way that a farmer is in charge of his well-fenced fields. Meanwhile, geographical borders let more through than they keep out. And when they do succeed in erecting a barrier, the multitude finds a way round it. So rather than the farmer, a better metaphor for today's politician might be the traffic controller. A major challenge for those involved in policy these days is to manage the massed influences passing through the electoral territory via stations, airports, cargo, the internet, and so on. The political region or nation state mutated at the start of the twenty first century into a transit zone for capital, goods, people, viruses, and tidal waves of information. After the postmodernist period when vertical mobility was used to try to

deconstruct the difference between high and low culture, it is now mostly horizontal mobility that leads us into different cultural experiences. And, as we know, these sorts of fundamental changes tend to lead to prophecies of both utopian and apocalyptic kinds.

An important point for our purposes is that the artistic world has become very much a part of this globalized horde, with the visual arts, popular music and the new media in the vanguard, followed by dance, which is rather less mobile due to the unbreakable bond between the artwork and the body, and with theatre bringing up the rear as it is so language-bound. The artistic multitude today may still depend on subsidies — at least in Europe — and therefore on national governments, but it is finding plenty of alternatives both at home and abroad, and is therefore increasingly able to escape from the clutches of national governments. It is precisely in this dependence on the many that the individual artist can afford even more singularity, and thus be absorbed together with countless peers into the murmuring multitude.

Building a Hypothesis

Having reflected on the ambivalence of the artistic murmur as both an 'inability' and a 'tactical refusal' to speak out or have meaning, and having sketched out the art world's current condition as that of an artistic multitude influenced by democratization of education and globalization, it is now possible to posit a hypothesis. For form's sake it should be made explicit from the start that we really do mean a hypothesis and neither a thesis nor empirical research findings. This does not rule out the possibility that there are good arguments for supporting the hypothesis or for declaring that it merits research. The hypothesis is inspired by Paolo Virno's *Grammar of the Multitude*, supplemented by the ideas of Michael Hardt and Antonio Negri and art sociologists such as Pierre Bourdieu and Nathalie Heinich. In other words, the formulation of the hypothesis largely rests on a meeting between political-philosophical and art-sociological insights, starting out from the former and then giving things a sociological twist. One of the effects of this switch between disciplines is a more concrete re-iteration of what the philosophers themselves express in more abstract terms. Admittedly, this translation often leads to a fairly idiosyncratic interpretation, sometimes bordering on a sweeping anthropologizing.

17

Post-Fordism

In referring to Virno above, I made a link between the multitude and Post-Fordism and suggested that the multitude was a by-product of the Post-Fordian production process. In view of the central place of this concept in Virno's work, it seems useful to reflect on the characteristics of this model of production. The transition from a Fordian to a Post-Fordian (or 'Toyotist') production process is broadly marked by the passage from 'material' to 'immaterial' labour and from the production of material goods to the production of non-material goods, in which the symbolic value outweighs the use value. So a car nowadays must not only drive well, but must also have an eye-catching design; we don't buy a new mobile phone because our old one doesn't work any more but because it is 'so last year' or because it doesn't match the status of our new job. Design, aesthetics ... outer signs or symbols are now a major motor of the economy because they help to keep up the thirst for consumption. This is an all too familiar story which has been told by assorted postmodern psychologists, sociologists and philosophers since the nineteen seventies.

But what about the shop floor and the production process in this symbol industry? This too has been pretty much transformed over the past forty years, with the most significant shift being that from material to immaterial labour. However, Hardt and Negri remind us that we shouldn't imagine that material labour has disappeared entirely. No — that kind of work has been shifted wherever possible to other parts of the globe, viz. the low wage countries. The real point is that the production logic — and possibly also the work ethic (P.G.) — of the immaterial labour determines the hegemony. That is to say that the material labour, and even that of the farmer, increasingly takes place under the dispensation of the immaterial labour. So what are the characteristics of such immaterial labour?

According to Virno — and there are others who have worked this out with and before him — the central qualities these days are mobility, flexible work hours, communication and language (knowledge sharing), playfulness, *'détachement'* (with its double meaning of objectivity and the ability to delegate) and adaptability. In other words, the immaterial labourer can be 'plugged in' anywhere and any time. Where Virno's take on immaterial labour does offer a fresh and surprising perspective is the link he makes with notions such as potency, subjectivity (including informality and affection), curiosity, virtuosity, personalization of a product, opportunism, cynicism and baseless babble. Admittedly, at first sight it looks as though immaterial

labour is held together by a bundle of heterogeneous characteristics. It might be useful to pick out some key characteristics from the list. I will start by surveying the better known aspects of the phenomenon and go on to look at them from a Virno-esque angle.

Physical and Mental Mobility

A brief summary such as the above can easily leave out of the account what immaterial labour actually demands from people, and what far-reaching social consequences this new production form therefore has. Mobility, for example, is often understood in terms of the increasing physical mobility whose negative effects we tend to experience in the form of traffic jams, full trains, pollution caused by air traffic, et cetera. The workers of today no longer live all their lives next to the factory or office where they work, but have to travel to a number of different work places or to move house regularly due to promotions or company reorganizations. Besides this growing physical mobility however, it is a mental mobility that increasingly lies at the heart of current working conditions. Immaterial workers work mainly with their head, which they can (and indeed have to) take with them wherever they go. Immaterial labour doesn't stop, then, when the worker leaves the office. Immaterial workers can easily take their work home, to bed and even, in the worst case scenario, on holiday with them. They are accessible via mobile phones or the internet, and can plug in to the shop floor at any moment. Mental mobility makes working hours not just flexible but fluid, which 'hybridizes' the spheres of private and working life and places the responsibility for setting boundaries between them almost entirely on the shoulders of the employee. This sketch of the situation may seem rather oppressive, but that is probably how it is experienced by many immaterial workers — witness the increasing amount of work-related stress and depression. One of the causes of depression is in fact the immaterial worker's awareness of the permanent possibility of a surplus of thoughts and ideas — something of which he is always being reminded in the workplace. The idea of an endless mental resource is therefore not so much a psychologically as a socially conditioned principle. At any point, there may always be another creative idea hidden in the brain. The knowledge that people can keep trying harder, that they always have hidden and unused potential, can lead to psychosis. So burnout results less from feeling that one has run out of ideas than from frustration that there is always an unexploited, passive zone in the grey matter

that could be activated. The immaterial worker who can no longer stop the introspective journey of inventiveness drives himself into the ground, or seeks escape in intoxication, in alcohol, so that he no longer has to think. The creative power is then deliberately switched off. But in the face of this bold and extremely sombre account of the effects of immaterial labour, it should be noted that this mental work form can also be liberating. After all, nobody can see into the minds of a designer, artist, engineer, ICT programmer or manager to check whether he is really thinking productively and in the interests of the business. What is more, it is hard to measure the time that goes into developing ideas. A good idea or a beautiful design can issue from the brilliant brain of an immaterial worker in a second, but it can equally well take months. What is more, the same worker can keep his best ideas for the moment when he has saved up enough to start his own business. The owner of immaterial capital, in other words, can play with it invisibly — literally, in this case.

Potency, Biopower, Biopolitics and Laziness

It follows from the above that the employer of an immaterial worker invests not so much in effective labour as in potential: in creative powers and promise. The immaterial worker continuously carries around an as yet unrealized and hoped-for capacity. It could be that the brilliant designer, engineer, manager or programmer who has just been hired for a large sum has run out of steam. Or he might just have fallen in love, causing his thoughts to drift to other things than productive labour. And perhaps his recent brilliant idea or design was his last, or the last for another ten years. Who knows?

This kind of workforce is an unrealized potential that is nevertheless bought and sold as if it were a material good (and from the employee's point of view one can talk in terms of labour power, since he is at least partially in control of his own thinking capacity and therefore has a certain degree of power). These paradoxical characteristics call for biopolitical practices, according to Virno. That is to say that the employer — preferably with the help of the government — needs to develop some ingenious tools for optimalizing — or at least securing — immaterial labour. Since physical and mental capacity are inseparable, such tools will target the whole life of the immaterial worker — hence biopolitics. Virno writes,

'Where something which exists only as possibility is sold, this something is not separable from the living person of the seller.

The living body of the worker is the substratum of that labor-power which, in itself, has no independent existence. "Life", pure and simple bios, acquires a specific importance in as much as it is the tabernacle of dynamis, of mere potential. Capitalists are interested in the life of the worker, in the body of the worker, only for an indirect reason: this life, this body, are what contains the faculty, the potential, the dynamis. The living body becomes an object to be governed … Life lies at the center of politics when the prize to be won is immaterial (and in itself non-present) labor-power' (Virno, 2004).

Biopolitics therefore comes into play when the potential dimension of human existence is centre stage. Virno's interpretation of the concept is fairly one-sided however: he sees it as a form of control, as an instrumentalization of the human body in an economic rationale, or in Max Weber's terms, within goal-rational action. However, this is just one possible approach to the concept. If we look at the way the writer who first put biopolitics on the philosophical agenda has pursued the concept throughout his oeuvre, we can justify a more polysemic interpretation. For Michel Foucault, biopolitics does indeed mean the twin possibilities of controlling, producing and transforming life at individual level and of defining or modulating social relations and ways of life. Biopolitical practices focus, in other words, both on the individual body of flesh and blood and on the societal 'body'. In Foucault's work, the prefix 'bio' points to a dual relationship between politics and life. On the one hand, life in the modern era is goal-rationally brought under control or 'normalized' and disciplined by making physical powers governable and profitable. At societal level, this takes place by means of reproduction management, health care, urban planning et cetera. And this is the line that Virno takes. But in Foucault's later work (1984) we encounter a rather different use of the concept, which could be described as vitalistic. In his remarks about what he calls 'self practice' and 'self care', he is mainly addressing the possibility of creating life, new ways of life and relationships. In order to distinguish clearly between the controlling and normalizing function on the one hand, and the self-creative, vitalizing possibilities on the other, Negri and Hardt make a distinction between biopower and biopolitics. In the light of the assertions made above about immaterial labour, this dialectical take on the subject does not seem out of place — which it would do if it were assumed that only with similar biopolitics can biopower be challenged, circumscribed or at least held at bay. In concrete terms, as we have seen, the immaterial worker is always in control of the creative capacities

in his head. It is therefore always possible for him to create new creative life and escape the control of the biopower. And the immaterial worker always has the option of developing his intellectual aptitude in line with the employer's wishes — or not. Then again, he may do so up to a point, and who would know? What is more, the knowledge worker can scramble his brain by excessive cocaine use, for example. The employer may at some point find out about this, but how long will that take? The point is that the immaterial worker is in possession of various means of resistance. And yet this resistance is hard to trace because it too is immaterial in nature. Whereas rebellion by the material worker is usually visible, for example in the form of a strike, the immaterial worker can exercise far less traceable forms of 'unproductive' resistance. After all, doesn't folk wisdom say that a true genius always has a lazy streak?

Communication, Linguistic Virtuosity and Informality

It is with a certain irony that Virno recalls that on the good old Fordian workfloor there sometimes hung a sign saying, 'Silence, work in progress'. Nowadays, he suggests, the sign should read, 'Work in progress. Speak!', because communication has taken up a central place in the Post-Fordian context. This would seem an obvious correlative of the fact that immaterial labour stands or falls with the sharing of knowledge or ideas. In the contemporary workplace, then, communication is productive, whereas for the material worker it was seen as counterproductive. This kind of worker is a 'doer' who has to work with his hands, even if only to press a button. Any chatter is distracting.

But when communication plays a key role in the workplace, one of the key skills is to negotiate and persuade by means of language. This means that powers of persuasion become important in the workplace. Someone with good verbal skills gets more done (and may get more attention). The crucial 'virtuosity' shifts from manual skills (seen most clearly in crafts) to verbal skills. For Virno, such virtuosity has two characteristics: (1) it is its own reward, without leading to an objective end product, and (2) virtuosity always assumes the presence of others, of a public. In other words, the immaterial worker is a good performer. The only way to convince colleagues of a good idea is verbally, through language. But even if there is no good idea, the immaterial worker still depends on his linguistic talents to constantly give the impression that he is deep in thought and hard at work

22

to come up with the (immaterial) goods. And the role of others is to confirm or contradict this. Because the public and the linguistic are so central in the Post-Fordian workplace, Virno speaks of its political character. He also draws parallels with the virtuosity of a pianist, in his case Glenn Gould. It requires little imagination to extend the comparison to dance or the theatre. In these disciplines too, production is inseparable from the body, and here too, virtuosity has pride of place and is evaluated by an audience. But it is worth pursuing this train of thought a bit further.

Virno says that communication entails more than just virtuosity, and that it has a specific effect on the relations between immaterial workers. At the very least, it demands a capacity to relate that actually has little to do with the production process. Immaterial workers have to be able to get along together, so the human relations element gains an important role in the workplace. Virno talks of 'the inclusion of the very anthropogenesis in the existing mode of production'. When the human relational aspect starts to play a role in the office or factory, something else comes into play, namely informality. Getting along together — and concretely in this context, daring to test ideas on colleagues — requires a certain degree of trust. This is an idea that goes beyond Virno, and is worth exploring further. One can always ask whether informality doesn't also have a productive role in the immaterial workplace, and not just in terms of bringing about good communication and a meaningful exchange of information. Informal relationships also lead to people knowing more about each other. For example, how things are going with the children or with non-professional relationships. Is this information from their private lives not a good touchstone for checking whether the immaterial worker is still on task? And, in the light of the above, whether he is really thinking productively and in the interests of the business? To put it more strongly and therefore more speculatively: is the informalization of the workplace not biopower's ultimate tool? In an informal chat, the thinking capacity of the immaterial worker can be checked up on without his noticing. 'A good working atmosphere' — which means, among other things, that people regularly have a nice chat in the corridor, lunch together or go for a beer after work — has a dual function. On the one hand it can increase production because the worker comes to work cheerfully (even if the work itself is not that interesting, the nice colleagues make up for it), but on the other hand, it is an ingenious form of control, namely the control of people's actual lives. After all, informalization makes it possible to biopolitically catch out

the immaterial worker in his incapacity to generate productive ideas. And that is biopower in the real sense: not the power of formal rules, but a control that is always and everywhere just around the corner ready to encroach on the body in a highly subjectivized manner.

Opportunism

The last characteristic of immaterial labour to be discussed here is the effect of a well-known aspect of Post-Fordism, namely 'de-routin-ization'. While in Fordism, routine labour and repetition of the same activities were at the heart of the production process, Post-Fordism is typified by continuous change in the work context. This is a widely known phenomenon, which Virno admittedly approached from a fresh theoretical angle. The chronic instability caused by unexpected developments, permanent innovation, ever-changing possibilities and opportunities in the contemporary workplace, as well as in the wider environment, demands a specific skill of Post-Fordian workers. They must continuously take advantage of changing opportunities and a kaleidoscope of options, and be able to turn every opportunity that presents itself into a win-win situation. The good immaterial worker is therefore a big opportunist because he can be put to work in all sorts of situations. And, in contrast to common everyday practice, Virno sees this in amoral terms, without evaluating it as positive or negative. After all, the 'good' opportunist knows how to turn any situation to his advantage, whether that is a financial advantage or in the interests of some higher goal. The crucial point is that the immaterial worker is mentally flexible. He should always be open to new circumstances and new ideas, in order to put them to work for the immaterial production process.

Art and
Post-Fordism

Many an artist and creative soul can probably identify to a large extent with the above sketch of the immaterial worker. For the artist too, working hours are not neatly nine-to-five, and constant demands are made on forthcoming good ideas, on potential. And since the under-mining of the craft side of creativity — at least in the contemporary visual arts — the artist has come to depend on communication, lin-guistic virtuosity and the performance of his ideas. And isn't the artist also regularly accused of laziness? And, finally, isn't the artist also an opportunist?

It takes little argumentation to portray the artist as an immaterial

worker. This applies to some artistic fields such as theatre, dance and music, in which the artistic product is inseparable from the body of the performer, at least where live performances are concerned. Moreover, language and communication are central to artistic creation in these disciplines, particularly when it is not a solo performance that is in question, but that of a theatre company, a dance troupe or a musical ensemble. Such performances require regular consultation during rehearsals. Picturing the visual arts as a form of immaterial labour is a bit more challenging, however. A counter-argument can be offered that ninety nine percent of visual artists do still produce a finished material product. And the Romantic cliché image insists that the creative soul works mainly in isolation. Nonetheless, what follows is a defence of the idea that in the contemporary visual arts, too, it is not the material product but the immaterial labour which is crucial, so that communication and linguistic virtuosity are pushed to the forefront. But this idea will be taken further than drawing a parallel between the visual arts and immaterial labour. Using a few artistic examples, I will hypothesize that the modern art world has been a social laboratory for immaterial labour, and thus for Post-Fordism. For Hardt and Negri, for Virno and also for De Certeau, the historical turning point for the transition from Fordism to Post-Fordism, and thus to the hegemony of immaterial labour, was the early nineteen seventies. The student revolt of 1968 and the Fiat strikes of the early seventies were key moments. In relation to this upheaval, Virno defends the intriguing proposition that this revolution was fundamentally different to the one in the nineteen twenties. The social conflict of the nineteen sixties and seventies was in defence of non-socialist and even anti-socialist demands, such as a radical critique of labour (which is the central motor of society for socialism), and the right to express individual tastes and to a far-reaching individualism in general. These demands were swiftly embraced by capitalism, however, and led to precisely the Post-Fordian forms of product described above. After all, didn't the workers of the nineteen sixties to some extent themselves demand 'a more human workplace', more consultation, flexible working hours and a shorter working week? Well, these are the very immaterial working conditions they have created today, a fact which leads Virno to the ironic pronouncement that 'Post-Fordism is the communism of capital'.

Now, it would be very inappropriate and unfair to contradict this dating of the rise of Post-Fordism back to the nineteen seventies, since there are good empirical grounds for it. But we can ask whether

25

there were not certain societal spaces in which the logics and ethics of that Post-Fordism were (perhaps unconsciously) prepared. As I have indicated, the early modern art world seems to have served as a laboratory for this process. In the following I seek to justify this hypothesis with reference to examples from the visual arts — for the simple reason that I have done most of my research in this field. This does not mean that other arts could not be demonstrated to have performed the laboratory function as well.

Singularity, Potential and Authorship

The multitude — which Virno sees as a by-product of Post-Fordism — consists of many different individuals. That is what distinguishes the multitude from the masses. With Nathalie Heinich's art sociological work at hand, we can now defend the proposition that it was precisely this singularity as a productive social principle that was born in the art world. Heinich sketches out the genesis of singularity in her first published study *La Gloire de Van Gogh* (1991). She does not present it as a transcendent or universal principle, but gives a detailed analysis of how the principle emerged at a certain point in art history. In the historical breach between academism and modern art, Vincent van Gogh figures large in the transition to individualist values and the dismissal of the collective regime of the classical art academy. This time-honoured apparatus for the validation of art relied on conformism as the barometer for artistic quality. Artists' ranking on the hierarchical ladder depended on how they obeyed established artistic rules. This principle meant that consecration and recognition could be granted even during an artist's lifetime. The essence of a collective regime lies in a relative group conformity. In the early nineteenth century art world, this included obedience to the collective rules of the academy. By contrast, for contemporary western society, what matters most is conforming to democratic principles of equality. And so it is clear that the collective regime changes with time and place. According to Heinich, in the art world, the rise of modernism spelled the end of testing works against a stable set of rules. The first Romantic artists at the end of the eighteenth century gained recognition precisely for their abnormality, their excess and exceptionality. During their lifetimes they tended to be met with bafflement. The eccentricity of the artist meant that his whole life long he swung between being celebrated and being stigmatized, between originality and excess. Only later would his successors come to appreciate his true artistic worth.

26

Between the end of the nineteenth century and the end of the Second World War, the value systems of the academy's collective regime and of individualism co-existed side by side. Only at the end of the nineteen forties did the latter regime gain dominance and conquer the entire art world (Heinich, 1996). While the Romantic artist resisted the remnants of the aristocratic rules of the academy, the avant-garde took up arms against bourgeois society (which had largely supported the Romantic artist). And yet this artistic avant-garde were building on the value system first set out by the Romantic artist. The avant-garde shared the Romantic view that an artist's poverty is proof of quality, and marginality is a sign of exceptionality. This is exactly what is controversial about Heinich's vision. Whereas 'official' art history says that the historical avant-garde did away with the Romantic artist, Heinich argues that it clung onto key Romantic values. On the one hand, the avant-garde's resistance to bourgeois art constituted an artistic rift. On the other hand, they took over and even radicalized the individualist regime set up by the Romantic artist. The opposition between the individualist and the collective regimes was heightened by the tensions between the avant-garde and bourgeois society (Heinich, 1991).

The importance of Heinich's sociological-historical analysis lies in her assertion that as early as the late nineteenth century, the singular was positively sanctioned as a value in a specific societal space, namely the world of the visual arts. It crept in gradually at first, but was the dominant principle from the nineteen fifties. A first sub-hypothesis can be derived from this. Is it not precisely this validation of singularity as the basis for innovation that became a generally accepted principle in a far wider range of types of work from the nineteen seventies?

Harrison and Cynthia White's study, *Canvases and Careers* (1965) also took the break with the academy system as the overture to a number of important shifts in the profession of the artist. When the Parisian Académie des Peinture et Sculpture and the annual Salon fell, partly under morphological pressure, this heralded the birth of what White and White call the 'dealer-critic' system. In the process, not only did the immaterial principle of the primacy of language and the word gain a key role through the rise of the art critic, but the artist's remit changed fundamentally too. As is well known, personal style became more important than conformity to a uniform system of rules. It is no longer that one hoped-for masterpiece per year that counts, but a coherent oeuvre that confirms the enduring quality of the artist. Or, as the title of White and White's study underlines, not

the canvas but the career of the artist takes centre stage in the post-academy art system. There lurks a simple capitalist logic behind this shift, though. After all, the potential buyer has to be convinced of the quality of an artwork. The main arguments that a seller can use are, firstly, the existing critical evaluations of the work and, secondly, the positive perceptions of the artist's earlier work. Within an oeuvre, previously delivered quality is taken as a promise of future quality. This works through a mechanism I have described elsewhere as the 'retro-prospective' nature of an artistic career (Gielen, 2003). What is important, however, is that we once again stumble on one of the central characteristics that Virno ascribed to Post-Fordism. It was established by the Italian thinker that in immaterial labour it was not the product (read: the canvas) but the productive powers or capacity that counted, economically. It was made clear, however, that this is based on the assumption that potentiality and the body are closely connected. But don't we see that in the signature? It is just this silent bond between artwork and artist that renders the product practically inseparable from its creator. The ease with which the work of an artist and his name are interchangeable in artistic discourse is witness to this. A painting by Dumas or Tuymans is commonly referred to as 'a Dumas' or 'a Tuymans', for example. Is it not in fact this individualizing and subjectivizing that is taken over later by other fields of immaterial labour such as design — 'an Alessi', for instance? In other words, do we not find the 'personalization of the product', as Virno called one of the Post-Fordian characteristics he identified, in an early form in the art world? This could be called a second sub-hypothesis.

Art Theory, Linguistic Virtuosity and Cynicism

The Belgian art theorist Thierry de Duve (1991) argues that the democratization of art began with the controversial first impressionist exhibition. From that time the artistic artefact would no longer be tested deductively against the rules, but a system of rules would be inductively constructed and advocated anew with every new artistic movement. So it was not just the art critic who was born with the end of the academy system — as White and White indicated — but all critical evaluation of art embarked on a democratization process that continued into the present age when virtually anyone can express an opinion on the value of art, or on whether something can be called art. What is particularly significant here is that the decision as to whether something is art or not is left to commentary, or what Virno calls

linguistic virtuosity or performativity. The American philosopher Arthur Danto may be using the same logic when he announces the end of art in his much-cited book *The Philosophical Disenfranchisement of Art* (1984). Danto asserts that it is the space between the artefact and the perception of it that has become the most important factor. And this space is filled by theory, pushing the artistic object itself into the background. By the end of art Danto does not mean that no more art will be made, but that the theorizing around art will take over the function of the artefact itself. He finds his evidence for this in, for instance, Marcel Duchamp's ready-mades or Andy Warhol's *Brillo Boxes*. That linguistic virtuosity was playing a major role in the visual arts some decades before the breakthrough of immaterial labour is illustrated by a particularly amusing passage from an interview with Marcel Duchamp by the French cultural sociologist Pierre Bourdieu:

Bourdieu: 'To come back to your ready-mades: I thought that R. Mutt, the signature on Fountain, was the manufacturer's name. But then I read in an article by Rosalinda Krauss: "R. Mutt, a Word-play on the German Word for Poverty" — which would give Fountain a whole new meaning.'

Duchamp: 'Rosalinda Krauss? That girl with the red hair? She's got it all wrong. Mutt comes from Mott Works, the name of a big sanitary firm. But Mott brought it too close, so I turned it into Mutt because at that time there was a cartoon in the papers, Mutt and Jef, which everybody knew. So at first it referred to something well-known ... Mutt was a funny little fellow, Jef a tall, thin one ... I wanted another name. And I added Richard ... Richard means rich one and that goes well with a urinal! As you see, the opposite of poverty ... But even that was too much, that's why just R, so: R. Mutt.'

Bourdieu: 'What is the meaning of *Roue de bicyclette*? Can it be interpreted as the integration of movement into an artwork? Or as a fundamental starting point, like the Chinese inventing the wheel?'

Duchamp: 'The only meaning of that machine was not to re-semble an artwork. It was a fantasy. I have never called it an "artwork". I wanted to get away from striving to create artworks. Why should works be static? The object — that bicycle wheel — was there before the idea. I didn't want to make a fuss about it, or to say: "I made this and nobody has ever done it before". Something that is original never sells well, anyway.'

Bourdieu: 'And the geometry book exposed to the elements? Was that the idea of integrating time and space? With a word play on "spatial geometry" and the word *"temps"* in the double sense of

weather and time, which change the appearance of the book?'

Duchamp: 'No. Nor was it the idea of integrating movement into sculpture. It was just a joke. Nothing but that, a joke. To break through the seriousness of the textbook.' (Bourdieu, 1989)

This hasn't been touched on yet, but along with the capacity for opportunism, Virno ascribed cynicism to the immaterial worker. Cynicism is generated from the awareness that people experience rules but that they are distant from the 'facts' or the reality. The rules are therefore exposed as being merely conventional and therefore groundless. As a consequence, Virno (2004) states:

'... one is no longer immersed in a predefined "game", participating therein with true allegiance. Instead, one catches a glimpse of oneself in individual "games" which are destitute of all seriousness and obviousness, having become nothing more than a place for immediate self-affirmation ...'

The above excerpt from the interview with Duchamp raises the suspicion that this exceptional artist had a good dose of the capacities of the immaterial worker. He already knew how to play a highly individualistic game in which, above all, he affirmed himself as artist. This is only possible if you know the rules of the art game exceptionally well, and, in Virno's terms, understand their emptiness. At that point, operating cynically becomes highly productive. But the fragment shows more than that. It illustrates, just as Bourdieu intended, that it is commentary, and commentary on commentary, that gives an artwork its meaning. And the contribution of the artist, who reveals the error of the commentary in a manner both naive and crafty, plays an important role in this. And thus is the artwork created and recreated, not twice but a hundred times. As mentioned earlier, with reference to Virno, virtuosity shifts from craft to language, and artists must first and foremost be a good performer of their ideas. So does this make Monsieur Marcel a Post-Fordian worker before his time? With 'Fountain' and all the other ready-mades, isn't he pushing the product to one side in favour of the word — an endless murmuring of meanings? In 1912, Duchamp wrote to himself: 'No more painting, get a job'. In the light of the above it can safely be claimed that he wasn't talking nonsense when he wrote that. With the dismantling of

the artwork, the refusal of any trade or metier, Duchamp did indeed become a worker, but then of the immaterial variety.

An Artistic Socio-logic

It was certainly not my intention to put Marcel Duchamp on yet another pedestal, this time not an art-historical one but a labour history one. Once again: I chose this example because my own work is largely focused on the world of the visual arts, and also perhaps because the Duchamp case is very well documented. The main point is to posit with this essay a hypothesis that declares certain characteristics of the art world as meriting research because they may have been the forerunner or laboratory for Post-Fordism. To this end, other parallels between the art world and that of immaterial labour could have been scrutinized, such as opportunism, the importance of baseless babble and gossip in the art world, or the role of the relational and the informal. Various themes will be developed further in what follows. But if the hypothesis is ever verified, then one populist misconception can be dispelled for ever. The often-heard judgement that contemporary art is decadent or alienated from society, has then found its toughest counter argument. A confirmation of the hypothesis would in fact mean that the logic of the art world no longer belongs on the margins but has established itself at the heart of a significant part of our society. It is not just that society has then been aestheticized, as a number of postmodern philosophers and sociologists have claimed, but that the social logic of the artistic world has reached the heart of society. Whether the art world should rejoice at this is another question. For the time being, it cannot easily escape the monster of its own creation. Or, if at all, perhaps only by continuing to murmur quietly from the sidelines.

Bibliography

Bourdieu, P. (1977). 'La production de la croyance: Contribution à une économie des biens symboliques'. Actes de la recherche en sciences sociales, 13
Bourdieu, P. (1989). Opstellen over smaak, habitus en het veldbegrip. Amsterdam: Van Gennep
Certeau (de), M. (1998). Culture in the Plural. Minneapolis and London: University of Minnesota Press
Danto, A. (1984). The Philosophical Disenfranchisement of Art. New York: Colombia University Press
De Duve, T. (1991). Au Nom de l'art: Pour une archéologie de la modernité. Paris: Editions de la Nuit
De Duve, T. (2005). Pictorial Nominalism: On Marcel Duchamps' Passage from Painting to the Readymade. Minnesota: Minnesota Press
Foucault, M. (1966). 'La pensée du dehors'. Critique 229: 523-46
Foucault, M. (1975). Surveiller et punir: Naissance de la prison. Paris: Gallimard

Foucault, M. (1984). Le Souci de soi. **Paris: Gallimard**

Gielen, P. (2003 and 2008). Kunst in netwerken: Artistieke selecties in de hedendaagse dans en de beeldende kunst. **Leuven: LannooCampus**

Gielen, P., and R. Laermans (2005). Een omgeving voor actuele kunst: Een toekomstperspectief voor het beeldende-kunstenlandschap in Vlaanderen. **Tielt: Lannoo**

Hardt, M., and A. Negri (2000). Empire. **Cambridge, Mass, and London: Harvard University Press**

Hardt, M., and A. Negri (2004). Multitude: War and Democracy in the Age of Empire. **London: Penguin Books**

Heinich, N. (1991). La Gloire de Van Gogh: Essai d'anthropologie de l'admiration. **Paris: Éditions de Minuit**

Heinich, N. (1996). Être artiste: Les transformations du statut des peintres et des sculpteurs. **Paris: Klincksieck**

Hobbes, T. ([1642] 1949). De Cive. **New York: Appleton-Century-Crofts**

Spinoza, B. ([1677] 2000). Tractatus Politicas. **Indianapolis: Hackett Publishers**

Urry, J. (2000). Sociology Beyond Societies. **London: Routledge**

Virno, P. (2004). Grammar of the Multitude. **Los Angeles: Colombia University**

White, C., and H. White (1965). Canvases and Careers: Institutional Change in the French Painting World. **Chicago: University of Chicago Press**

32

.

The Biennale: A Post-Institution for Immaterial Labour

The art biennale — once a means of promoting the nation state and its secularized faith, nationalism — has taken on a somewhat different guise today. The political agenda has been relegated to the background and replaced by a worldwide competition among cities and other places-to-be that has spawned a profusion of biennales. The success of these events cannot be explained without reference to the enthusiasm with which politicians, managers and other sponsors have embraced them. And it is precisely this heterogeneous interest that makes the biennale suspect. After all, it fits easily within a neoliberal city marketing strategy for so-called creative cities. Anyone idly leafing through the catalogues of art events might be surprised to find them described in these terms: something that suggests that the biennale frequently regards itself as a problematic hybrid monster. At the very least, it can be concluded that there are artists, curators and critics involved who do not lack the requisite self-reflection. Yet they continue to take part, cheerfully, full of ambition, but at times physically and mentally exhausted, in this amazing world. There are probably as many different motives for doing as there are artistic actors travelling the globe. No doubt they include the ambition to make it in the art world some day. But there is certainly just as much genuine interest and idealism. There is no denying, however, that even the sincerest of curators constantly comes up against an all-encompassing neoliberalism. A certain degree of cynicism and opportunism seems necessary for survival within the global art system. Because we are dealing here with two emotionally charged — and usually negatively charged — concepts, a little explanation seems appropriate.

The Joyful Rider

In common parlance, cynicism and opportunism have negative connotations, and are usually ascribed to an individual. Here, however, as mentioned in relation to the Italian thinker Paolo Virno, cynicism and opportunism are not used pejoratively (2004), but in a value-free sense. Furthermore, they define not so much the actions of an individual, but the general mood of a collective. Cynicism and opportunism are now a structural component of our globalized society. Or, as Virno argues, they colour the 'emotional tonality of the multitude' within a Post-Fordian world economy. Applied to the contemporary art world, cynicism and opportunism have become necessary modes of operation. This deserves a more detail explanation.

Cynicism comes from the realization that rules and the reality

they supposedly regulate are miles apart, even as people still operate according to these rules. Those who know the rules of the present-day art world, for example, go in for themed exhibitions, which today prefer to embrace social responsibility — witness the boom of new engagement, social activism, political or ecological criticism, et cetera. All of this is taking place against the backdrop of a neoliberal reality of commercial telephone providers and airlines with an excess of ecologically irresponsible flights, mass tourism and virtually inescapable global marketing strategies. If we observe the discourse presented by most globally operating curators and artists on the one hand, and their actual actions on the other, we repeatedly come up against a yawning gap between the two. Operating cynically turns out to be functional within the global network of the biennales.

This conclusion allows critics to point out consequences with a certain amount of schadenfreude. Yet precisely because it ascribes the characteristic to the individual, this criticism often neglects to examine the institutional nature of the problem. It definitely denies the critical potential, at the very least the potentially manipulative or subversive quality, of the cynical operation. Selecting and using the marvellous resources that the neoliberal market economy puts at our disposal today also provides a chance to pervert them. An all-encompassing neoliberalism already provides all the instruments with which to keep proclaiming ever-changing possibilities — if only purely discursively. The globetrotting curator may share the view of the above-mentioned critic, but uses fundamentally different strategies to achieve his objectives. Whereas the critic abstains with a certain puritanical asceticism from the pleasures of capitalism (at least discursively), the former is an optimistic joyrider who outlines escape routes in the heart of the neoliberal hegemony — with a glass of good wine in his hand. Stoicism in one area does not preclude idealism in the other. In fact, the latter demands a healthy dose of cynicism, something that Bertolt Brecht understood back in the nineteen thirties. Which is the better strategy remains unclear. What is clear is that the second, approach, in all its ambivalence, is more complex than the first. This complexity may provide a better answer to an ever more complex world. However, it remains a particularly difficult balancing exercise as well.

The internationally operating curator — and indeed every globally operating artistic actor — thus enjoys the pleasures afforded by today's widespread neoliberal market economy, and seizes every opportunity to tell a critical, engaged or unique story. In other words,

such a curator is always a big opportunist. We must understand opportunism, however, in the literal and neutral sense of 'the ability to grab opportunities', which includes the dexterity to allude in a non-routine fashion to a constantly changing work context. It is the art of living with chronic instability, with unexpected turns of events and perpetual innovation — a world in which new possibilities and opportunities are continually presenting themselves. Likewise, internationally operating curators repeatedly find themselves having to respond meaningfully to new geographical, social and political contexts. They must make use of each new opportunity and turn it into a win-win situation. This demands, at the very least, a significant capacity for translation along with a generous dose of mental flexibility. Ever-changing circumstances and new ideas have to be transformed into a preferably controversial end product: the exhibition. Perhaps the travelling Manifesta exhibition is the best example of an organization that has incorporated this opportunistic tonality down to the meso-level. After all, every time it moves it feels out the local economic, political and social opportunities. The travelling curator is constantly confronted by different working conditions in local, merely temporary stations that are often called biennales.

A Good Idea

Yet what does this curator have to offer the station at which he alights for a while? Or conversely, why is this particular curator engaged to do his 'thing' in this particular spot in the world? Is it to do with his organizational capacities? Or it is simply about fame and a name? These things probably play a role, but the core of the transaction is even more ephemeral and precarious than that. After all, those who shop in the curator market with any integrity, i.e. without ulterior economic or political motives, are primarily looking for a good and appropriate idea. Yet what is a good idea? A good idea in today's art world should still be understood according to the axioms of modernity, as a new or innovative thought. Even the veteran curator, well-established with his concept, can ill afford to become repetitive. That might have been permissible to a certain extent for the first generation of independent curators, whose names were frequently linked to a monolithic concept (although even here a certain malleability was desired). But today this rigidity works far less effectively. This is why the adjective 'appropriate' is of equal importance for the idea produced. A good idea, after all, constantly renews itself, and that can

mean, among other things, that it responds to the geographic or social context, the client, the artistic setting, et cetera. Simply copying an exhibition concept from New York to Istanbul would miss the point completely. Just like the artist who repeats himself, the recidivist curator would soon be taken to task for his mouldy ideas.

It should therefore come as no surprise that young curators are frequently hired. After all, sclerosis is less likely to have set in among this category, but that is not the point. The point is that today a good idea has to be appropriate as well as innovative: it takes into account the local artistic, economic and/or political circumstances. A good idea, in other words, is opportunistic (in the neutral, non-judgemental sense of the word). So the smart curator delivers his idea with the necessary adaptability and flexibility. It should therefore come as no surprise either that the interview, or at least the dialogue, has emerged over the last decade as the favourite working method of the exhibition organizer. After all, this format offers an opportunity to test the potential exhibition concept against the new context.

But how does one know that the engaged curator will deliver a good idea? Well, the answer is as simple as it is disturbing. It simply cannot be predicted. Investing in a hoped-for good idea, a show that works or an exhibition concept that functions within the given context is always a risky undertaking. When the curator is engaged, the good idea or the interesting, appropriate concept is only potentially present. It still belongs to the unreal world of promise. Of course there are means of assessing the risk of the investment: the 'retro-prospective principle' applies to the exhibition career of the curator as it does to the oeuvre of the artist (Gielen 2004 and 2005). Previously produced work is used as a touchstone to gauge the quality of work yet to be produced. Yet this hoped-for realization remains largely speculative. In drawing up a contract with a curator, the organizer of a biennale is not therefore capitalizing on a finished product, but on a potential or a promise. This, says Virno, is precisely the core of the Post-Fordian work environment, or — to paraphrase — the crux of immaterial labour.

According to many labour sociologists and political philosophers, this Post-Fordism — with its individualization, de-routinization, flexible working hours, mental labour, et cetera — expanded with the student revolts of 1968 and the Fiat strikes of the nineteen seventies. As mentioned before, Antonio Negri and Michael Hardt (2004) even argue that immaterial labour began to constitute the hegemony for all forms of production, even for material labour and

agricultural labour. This does not mean, of course, that material labour or routine factory labour simply vanished. Instead, it usually moved to low-wage countries. As suggested in the first essay, even this labour, however, became coded within the social logic of Post-Fordism. The nineteen seventies are often identified as the period in which this process of immaterialization took place. It is probably not a coincidence that it is also the period in which one of the first internationally operating curators began to attract attention. Harald Szeemann escaped from the museum in the same period as his material artefacts did. An object history was replaced by a conceptual approach. Or, with the preceding in mind, the emphasis shifted from displaying material works to immaterial labour. As in other work environments, this does not mean that the material object — in this case the work of art — simply vanished, but that it came to be staged within a performance of ideas. Even the ins and outs of the art world, in other words, cannot escape the new machinery of Post-Fordism.

Intermezzo: The White Cube or Neoliberal Denial

We have just briefly reflected on the ambivalent operation of the curator within a pervasive Post-Fordism. This requires, among other things, an opportunistic attitude, which succeeds in responding to ever-changing artistic, economic and political working conditions. At the same time, art historian and curator Elena Filipovic (2005) points out that the majority of biennales, paradoxically, still make use of their historical antipode, the museum. This is even true of the nomadic Manifesta. It involves the repeated use of the classic white cube, which Alfred Barr made the hallmark of the MoMA back in the late 1920s. Filipovic astutely remarks that the Nazis opted for the same interior, less than 10 years later, for the *Haus der Kunst* in Munich, prompting her to wonder what makes this white space appealing to these two totally divergent ideological worlds. The answer is somewhat predictable: 'order', 'rationality', 'universality' and '(Western) modernity'. Two other ascribed qualities, however, deserve particular attention within this narrative, namely 'neutrality' and (especially) 'disconnection from the context'. The white cube cherished by biennales and curators thus cuts itself off from the variable environment in which it finds itself. This sometimes results in rather hallucinatory displays, as Filipovic writes, among other things, about Okwui Enwezor's 'Documenta 11': 'The exhibition brought, as one critic noted, "issues of genocide, poverty, political incarceration, industrial

pollution, earthquake wreckage, strip-mine devastation, and news of fresh disasters into the inviolable white cube.'" (2005)

The white cube is so widespread as a global institution because its staging of autonomy denies any political, economic or religious entanglement. The integration of these spheres in the museum also threatens to neutralize any problem or social conflict within the safe zone of fiction. Perhaps that is what makes the white cube so beloved, and very exceptionally even by totalitarian regimes. Within an all-encompassing neoliberalism, the ideological silence of the white space is a godsend. Every dominant paradigm of faith, after all, is served by the denial of its own ideological character. That way it can easily masquerade as an insurmountable realism.

Flirting with Deleuze

'Rhizomes, 'networks', 'nomadism', 'escape routes', 'non-hierarchical forms of organization', et cetera — these are the words with which biennales have increasingly presented their own operations over the last 10 years. 'Documenta 12' may have represented the saturation point of this Deleuzian discourse. Who can say? The question, however, is whether today's biennales genuinely incorporate these characteristics. The above intermezzo suggests otherwise. The equivocal relationship between biennale and white cube, event and museum demonstrates at the very least a certain ambivalence. The classical museum, in particular, is one of the institutionalized entities that are coming under increasing pressure. Yet the institution has not yet vanished over the horizon. That is probably what frequently makes it the black sheep, certainly where large institutions are concerned (see Möntmann, 2008, for example). But what is it about this institution that supposedly hinders the biennale and the nomadic curator?

The institution is probably one of the most examined subjects in sociology (Gielen, 2007). What is relevant to this argument is that this science interprets the notion in two ways. On the one hand, 'institution' refers to concrete organizations of people, buildings and things. On the other hand, the concept of the institution is extended to the whole system of values, norms and customs considered significant in a society. This is why they are institutionalized, set down in a more or less rigid fashion, watched over and sanctioned. The best-known institution is probably the family, which regulates procreation within a specific cultural context. But in this context the institution of the 'church' is perhaps a more relevant example. Within the sociology

41

of religion, a distinction is made between the Church with a capital C and the church with a small c. The first refers to the whole system of beliefs, norms and values it installs and perpetuates, the second to the 'organizational infrastructure' of people, buildings, relics, et cetera that materialize the institution and keep it alive. Well, a similar dual meaning is found in the art institution. On the one hand, after all, it consists of galleries, biennales, art centres, museums, and the people and artworks that populate them; on the other hand it also represents the whole system of artistic and cultural values (for instance authenticity, creativity, idiosyncrasy) it expresses within a society — in the past usually the nation state. In essence, all artistic organizations are part of the art institution, but major institutions like museums occupy a special place in this. More than the others, after all, they are expected to be well-oiled organizations and to simultaneously take on the role of the 'guardian' and 'facilitator' of specific artistic values and practices. This might sound pompous, but it is an accepted idea in sociology that cultural practices keep in step with a powerful societal hierarchization of values and norms. The institution, according to classical sociology, features a number of essential characteristics, a few of which are highlighted here as a reminder. Such an exercise, it is hoped, will help to clarify what the problem is for biennales and for nomadic curators. The institution is primarily experienced as an external reality and objectivity. This means that it stands above individual manufacturability, which is, moreover, considered relatively self-evident. This brings us straight up against an important focus of criticism in the art world, in which the singular regime of values is after all the central principle around which everything revolves, as Nathalie Heinich (1991) showed us. It is a fact that both the artist and the curator jealously defend their individuality and authenticity. They probably shudder at the idea of a supra-individual machine. What is more significant within this argument, however, is that the institution incorporates historicity. This entails two things. First, the institution has its own history and often relies on this history to preserve or even to legitimize its existence and activities within contemporary society. But the institution also constantly and actively engages with the past, by selecting from it and by activating and perhaps re-articulating some historical issues. Or, as the American anthropologist Mary Douglas (1986) once put it, 'institutions remember and forget'. And this leads us to the important heritage function of the art institution. It is, after all, responsible for what is remembered and forgotten. In the case of museums, we can hardly ignore this conservation function. Even

their current artistic activities take place, preferably, not in a historical vacuum, but with a strong awareness of what used to be. At its best, this produces an interesting tension between innovation and conservation, a tension which will be also discussed later in the chapter about memory and the Antwerp Museum of Contemporary Art. Ideally, as crucial platforms of the art institution, museums represent its historical conscience. In the process they also generate the necessary 'inertia' to which everything experimental or innovative should, or at least can, relate. Museums, therefore, in part control the temporal logic or artistic conjuncture of the whole art institution. When they let in innovation, they immediately proclaim a new era for the whole local, national or international art world. Large institutions usually do this only occasionally. It is, after all, their societal task to constantly weigh the present against the past. This admittedly also entails the risk that they might become too sluggish and hold back innovation for too long, losing their 'grandeur' in the process. It is precisely biennales and internationally operating curators who have fought against this 'grandeur' over the last 30 years (and certainly in the initial phase), among other things because it was felt that the museum hindered innovation. As we have seen, a good idea in today's art world is still, according to modernist doctrine, a new idea. Such an ethos constantly wrestles with the past and the cultural heritage. This is not only because of the braking effect of art traditions, but also because history might well reveal that a new idea is not so new after all.

The characteristics of the art institution listed above, however, feature at a macro-sociological level at which both the biennale and the nomadic curator struggle against 'the institution' as a societal phenomenon. At the meso-sociological level, or the level of the organization, other factors come into play. The classically institutionalized organization, after all, stands for a rigid hierarchy with fixed positions in a not very flexible work environment. This highly simplified picture may reflect an outdated cliché. And yet, in observing the majority of art museums (certainly in Europe), one still comes across ingredients that confirm this picture. To name only four: fixed working hours (and opening hours), fixed appointments, a rigid differentiation between functional units (artistic staff, educational department, public relations, maintenance and management) and a strong focus on the material (the collection or at least artworks). The second characteristic certainly impedes the Post-Fordian requirement of flexibility within a globally operating art world. It is precisely the biennale that partly fulfils these immaterial working conditions, thus displaying the

43

hallmarks of a post-institution. Its periodic and event-based character in itself makes it easy to work with temporary contracts. This is a key observation of labour sociology, which in today's art world is rather romantically translated into an uncritical cultivation of a nomadic existence within constantly moving networks. However, this Deleuzian flirting with the post-institution (not that Deleuze, incidentally, ever pointed in this direction; what is at issue here is rather the way the art world uses the jargon) — with the contemporary biennale as protagonist — significantly suppresses the wealth of the classical art institution. Occasional visitors to biennales are regularly confronted, for example, by structural amnesia, the negation of the local context and superficiality, usually with a lack of concentration. The biennale, or to put it a better way, the excessive boom in biennales, offers little room any more for historicity; even less does it generate the necessary time for thorough research, and furthermore it often ignores the locality — see the foregoing story of the white cube. These are precisely the things that a museum, as a classical art institution, did stand for. That museum, however, has also been significantly transformed in recent decades, with, among other things, an increase in temporary exhibitions and an inversely proportional decrease in research into and attention to the collection. Even the museum — certainly if it is a contemporary art museum — has been infected by the biennale virus. Even the museum is displaying post-institutional characteristics, for it too has become a Post-Fordian enterprise.

Schizophrenic Longing

The structural amnesia mentioned above, the lack of concentration and the development of a globally floating art world are gradually eliciting questions about the direction in which the art biennale has evolved over the past decade. Indeed we are seeing early attempts toward re-articulation and even reorganization within the art world. The curator, for example, is once again seeking out the locality, or tries to link international flows with local artistic and cultural practices at a 'glocal' level (witness for instance the Gwangju Biennale of 2002, but also the effect of the MaCBA in Barcelona). At the very least, we can observe today a schizophrenic longing, which on the one hand endorses the mobility, horizontal openness, curiosity and innovative drive of the post-institution, while on the other hand showing a growing predilection for local embedding, for the collective memory, and for the durability once offered by the institution.

44

This schizophrenia between the post-institution and the 'classical' modern art institution can now also be linked back to the internal tension within a good idea outlined above.

As I have said: a good idea in the contemporary art world is still a new idea. That also means that it is authentic and that it is defended and established with the required resolve. Furthermore, a new idea is only a good idea if it can be weighed against history, and the art institution, with the classic museum, used to provide an answer for this. Within today's network world embraced by the nomadic curator, however, the emphasis is being placed instead on the appropriate idea. Loyalty to an originally authentic concept can quickly come to be interpreted as inflexibility and a lack of openness. The authentic idea, in other words, lacks the infinite variability and adaptability required within networks that are always unstable. Or as Boltanski and Chiapello (2005) argue:

'... the deconstruction of the old notion of authenticity – as loyalty to self, as the subject's resistance to pressure from others, as a demand for truth in the sense of conformity to an ideal – goes hand in glove with the concept of a network world. In a connexionist world, loyalty to the self looks like inflexibility; resistance to others seems like a refusal to make connections; truth defined by the identity between a representation and an original is regarded as a failure to understand the infinite variability of the beings who circulate in the network, and change every time they enter into relation with different beings, so that none of their manifestations can be taken as a point of origin with which other expressions can be compared. In a network world, the question of authenticity can no longer be formally posed.'

The internal tension of an authentic artistic idea or a new and appropriate exhibition concept is in step with the fluctuating relationship between the classical art institution and the post-institution. The design of the first Brussels Biennale (2008), for example, was

marked by the same schizophrenic longing. This can be deduced, among other things, from the endeavour to re-articulate the locality of the biennale. The focus is no longer on the nation-state, but the worldwide promotion of the city was accompanied by attention to the 'Eurocore' — if only by allowing art organizations from Flanders (and thus not just from Brussels), Germany and the Netherlands to play a part in setting the programme. In addition, there was an attempt to counter the historical deficit of the hectic global flow by working closely with institutions that should still have a memory, especially museums. Authenticity defended with rigidity can thus be balanced with the infinite variability and diversity demanded by the global neoliberal network system. Such undertakings can probably be seen as still early and therefore fragile trial runs for new strategies with which well-intentioned biennales and curators will experiment in the future. It is to be hoped that they will some day generate the necessary 'inertia' and 'glocality' as a counterpoint to the all-encompassing global competition hysteria in which today's biennales increasingly find themselves.

Bibliography

Boltanski, L., and E. Chiapello (2005). The New Spirit of Capitalism. **London and New York: Verso**
Douglas, M. (1986). How Institutions Think. **New York: Syracuse University Press**
Filipovic, E. (2005). 'The Global White Cube'. In The Manifesta Decade: Debates on Contemporary Art Exhibitions and Biennials in Post-Wall Europe, **ed.** Barbara Vanderlinden and Elena Filipovic. **Cambridge, Mass: MIT Press**
Gielen, P. (2003 and 2008). Kunst in netwerken: Artistieke selecties in de hedendaagse dans en de beeldende kunst. **Leuven: LannooCampus**
Gielen, P. (2005). 'Art and Social Value Regimes'. Current Sociology 53 (5): 789-806
Gielen, P. (2007). De kunstinstitutie: De artistieke identiteit en de maatschappelijke positie van de instellingen van de Vlaamse Gemeenschap. **Antwerp: OIV**
Hardt, M., and A. Negri (2004). Multitude: War and Democracy in the Age of Empire. **London: Penguin Books**
Heinich, N. (1991). La Gloire de Van Gogh: Essai d'anthropologie de l'admiration **Paris: Editions de Minuit**
Möntmann, N. (2008). 'Playing the Wild Child: Art Institutions in a New Public Sphere'. Open 14: 16-27
Virno, P. (2004). Grammar of the Multitude. **Los Angeles: Colombia University**

The Biennale: A Post-Institution for Immaterial Labour

47

The Art Scene: A Production Unit for Economic Exploitation?

If a *Kunsthalle*, an experimental theatre, an international dance school, an alternative cinema, a couple of fusion restaurants and lounge bars and — don't forget — sufficient gays are concentrated in a place with high social density and mobility, the result is an art scene. "What's there? Who's there? And what's going on?" are what the American social geographer Richard Florida calls the three 'W questions' (he just happens to like simple management jargon). Those three questions have to be answered if we want to know whether ours is a 'place-to-be' (2005). A creative scene of this kind is good for the economy, for a city's image, and for intercultural tolerance, it would seem.

Today the art scene has become an important economic variable and a popular subject for study. However, the term is not exactly thriving in the sociological context. The classical sociologist does know how to cope with concepts like the group, the category, the network and the subculture, and the social scene remains relatively unexplored as an area of research. Obviously there are exceptions, like the work done by Alan Blum (2001). Yet the lack of scholarly interest is surprising, since the scene is perhaps the best-suited format for social intercourse. Within the prevailing Post-Fordian economy, with its fluid working hours, high mobility, hyper-communication, flexibility and special interest in creativity and performance, the scene is a highly functional social organizational form. Moreover, it is a favourite temporary haven for all those who trek over the globe with enthusiasm. Why is the scene such a good social binding agent in a Post-Fordian society?

Scene to Be Seen

In everyday usage the word 'scene' invariably prevails in alternative discursive settings. For example, it is rarely found to indicate socially appropriate professions or groups. We do not refer to the scene in relation to civil servants, bankers, the police or heterosexuals; but we do refer to the art scene, the theatre scene, the gay scene and, not forgetting, the drugs or the criminal scene. Creativity and criminality seem to occur to a notable extent in the same semantic circles. They have at least one characteristic in common within society: both creative and criminal networks stand for innovation. Regardless of whether it is a matter of innovative cultural practices, alternative lifestyles or illegal economic transactions, they all form alternatives to what is socially acceptable or to common sense. The word 'scene' would always seem available to accommodate heterodox forms in the discursive sense.

Yet in recent decades there has been a remarkable advance of the discursive fringe towards the centre. In other words: the 'alternative scene' has become a quality label within the social centre. Today labels like 'alternative', 'independent', 'avant-garde' and so on rank as welcome brands in the economic epicentre. So the word 'scene' cannot lag behind. Something that Richard Florida understood clearly.

The scene as a form of social organization meets a number of criteria that fit relatively recent developments in society. In a world in which individuality and authenticity are highly prized in leisure-time pursuits as well as in the workplace, the scene constitutes a comfortable setting. That form of social organization generates the freedom of temporary and flexible relations not offered by, for instance, the group, with its relatively closed membership. The scene produces social cohesion and shared identity unknown in a social category like an age or professional group. Relations within the scene are relatively free of obligations, but not without rules. Someone wishing to enter the art scene, for example, must comply with certain rules or social codes. Yet they are far less specific than the admission codes of a group like the football club, youth movement or lodge. Added to which, one scene can easily be exchanged for another. That is where it differs from the subculture, which requires a specific, almost rigid identity.

These are the very characteristics that make the scene an ideal form of social organization in the present network society. Local scenes prove to be a familiar focal point in a worldwide network. They generate just enough, but not too much, intimacy for global nomads. If you visit the art scenes in Shanghai, Tokyo, New York, London, Berlin or Brussels, you find a familiar frame of reference in what are sometimes totally different cultural contexts. If, some time ago, you had mentioned the name Damien Hirst in one of those art scenes, you would immediately have had common ground for interaction, whether an intellectual debate or a pub chat. The scene provides a safe and familiar, though admittedly temporary, home in a globalized world. Or, as Alan Blum puts it: it offers a kind of 'urban intimacy' that enables a person to survive in a chilly urban environment and an anonymous global time. That is to some extent because professional and public activities within a scene affect the domestic domain. Professional and private activities, working and personal relationships often merge seamlessly, while the hotel lounge, vernissage or fusion restaurant is a setting for both informal chatter and professional deals. In fact, professional deals may well depend on gossip — and conversely, informal chatter may prompt professional deals. So the scene is the

place where formality and informality effortlessly intersect. And in the light of what was said about informality in the first essay of this book, the scene is the ultimate locus of biopolitical control.

The foregoing inventory of public and semi-public spaces that fit comfortably in the scene uncovers another aspect of this form of social organization. It creates a Foucaultian panoptical décor for visual control of seeing and being seen. If anything: whoever is not seen 'on the scene' does not belong to the scene, and the scene which is not seen is a non-scene. And so the notion remains very close to its original etymological meaning. The Greek *skènè* was actually a tent, the hut or wooden structure from which the actors emerged. Theatricality is an important constituent of 'the scene'. In other words, the scene always implies a *mise-en-scène*. And by extension, it ties in seamlessly with the demands made of the present-day Post-Fordian worker who lives, as we have seen, largely on the performance of creative ideas. Anyone who does that has much to gain from those ideas being communicated to an audience that is as wide and as international as possible. Foreign is chic on the scene. But this only works if the audience is reliable. After all, an idea can easily be ridiculed, and can easily be stolen too. An economy of ideas lives in a permanent state of paranoia. Boltanski and Chiapello (2005): 'With the increase of demand for singularity, we can thus foresee an increase in paranoid behaviour by people who are forever fearful that they have been manipulated, plagiarized or hijacked.'

A public, international yet intimate environment is just the place to promote the social conditions that enable the exchange of ideas to take place relatively safely. Anyone stealing ideas within the scene will at least receive a verbal sanction. A claim that an original thought has been copied elsewhere is only an option if there are witnesses and that thought has been aired in public. The originality or authenticity of an idea can, therefore, be measured recursively if that idea was ever 'put on the stage'.

Freiheit macht Arbeit
– Freedom Creates Work

Events like biennials and buildings like a *Kunsthalle* or museum are ideal semi-public venues for the art scene around which creative ideas can circulate. You could say they form the concrete infrastructure. Or rather, they make the scene more visible — the unseen scene becomes the seen scene. That primarily applies to artists whose work is displayed by the organizations in question or is on display in the build-

ings. The concrete infrastructure literally stages the art scene, thus making it something more or less lasting. And the staging of the scene takes place in complete accordance with the rules of Post-Fordian art, as already explained. The consequence is that someone works with a temporary contract or, in the art world itself, often without a contract — in what is always a vitalistic, project-based setting and of course with flexible hours, invariably involving night work, and irrepressible creative enthusiasm. In short, it involves a work ethic in which work is always enjoyable — or should be; in which dynamism is boosted unconditionally by young talent; and in which commitment outstrips money. That is what determines the spirit of the artistic scene. If you try to rationalize this great, spontaneous desire and freedom to work (for instance, by means of rigid contracts or labour agreements) or bureaucratize or routinize it, you are in danger of letting the meta-phorical creative genie out of the bottle. However, we should not forget that creative work like this is always a form of cheap, unstable work where social security is exchanged for so called freedom — something that makes the art scene of great interest to outsiders like company managers and politicians. Not only does it boost the local economy and introduce the city into the world market. It also, and especially, reveals a biopolitical ethic which nowadays benefits the economy. The protagonists of the creative scene appear not to be-lieve that 'Arbeit macht frei', as in the Nazi concentration camp, but that 'Freiheit macht Arbeit' (freedom makes work). Such an ethic of 'creative' freedom is eagerly adopted by temp agencies that advertise temporary contracts in terms of the 'freedom' they allow.

The following scenario might be a slight exaggeration, but there's a kernel of truth in it: you are dumped by the cultural econ-omy because you've had a burnout, because you are forty five and no longer young and sexy, but above all because you are no longer affordable. You suddenly realize that you have no children (having kids is not done on the scene — it rules out flexible working hours); that your partner has just left you because you were always abroad; that your nearest friend is at least 350 kilometres away so you've got no one to help you move house; and that you haven't saved a cent to-wards your pension because you've always worked on temporary con-tracts or no contract at all. This is the often-forgotten shadow side of the cultural industry and the creative city that is blindly embraced by quite a lot of cultural policymakers and other politicians nowadays.

It is better to offer no opinion as to whether, with the rhe-torical reversal 'Freiheit macht Arbeit', the concentration camp has

53

become the central social structure of all society, as Giorgio Agamben claims (1995). If the cross-over between professional, public and domestic activities — but especially, on the one hand, the interplay between formality and informality, and, on the other, seeing and being seen — is exploited on a rationally economic basis, the cultivated freedom of the art scene gets uncomfortably close to the inhuman lack of freedom of the camp. To draw such a comparison between scene and camp is no doubt carrying things too far, and disrespectful of the appalling suffering of the inmates of the Nazi camps. However, the point is that the freedom of the art scene within the capitalist *mise-en-scène* can merely be a false freedom, because it always serves a well-defined (i.e. un-free) goal: the pursuit of profit.

The fact that Richard Florida and his neoliberal ilk are perfectly happy with this scene renders it suspect to say the least. Of course, interest in the art scene from politicians and managers need not lead to paranoia. Their focus does, after all, demonstrate to some extent that artistic phenomena have considerable social support. But as soon as that focus causes the artistic scene to be exploited on account of its informality and ethic of freedom, and thus restructured via biopower into a real lack of freedom, the art scene will have something to worry about.

Bibliography

Agamben, G. ([1995] 1998). Homo Sacer: Sovereign Power and Bare Life. **Stanford: Stanford University Press**
Blum, A. (2001). 'Scenes'. In 'Scenes and the City', ed. J. Marchessault and W. Straw. Public 22/23
Boltanski, L., and E. Chiapello (2005). The New Spirit of Capitalism. **London and New York: Verso**
Florida, R. (2005). Cities and the Creative Class. **New York: Routledge**
Virno, P. (2004). Grammar of the Multitude. **Los Angeles: Colombia University**

The Art Scene: A Production Unit for Economic Exploitation?

Chapter II
Global
Memory

Remembering in
the Global Age

'Are there any historical events that occurred during your lifetime which you especially remember?' This simple question was posed to about 156 heritage participants in Flanders[1] (Belgium) in the course of a survey. The question is so general that one may expect a wide variety of answers to it, all the more so because it was put to a very heterogeneous cross-section of heritage participants and passers-by, including recreationalists, archaeologists, historians, amateur historians, museum workers, policy makers, and so on. In addition, a wide variety of socio-professional categories such as policemen, journalists, professors, construction workers, pensioners, unemployed, students, and so on were interviewed. Respondents included women and men aged from eighteen to ninety. Some of them told a very personal story, such as the birth of their children or, less pleasant, having experienced a heart attack or the suicide of a loved one. Others preferred to remain at a distance, and referred to world events such as 'the fall of the Berlin Wall', '9/11', or closer to home, 'Leuven Vlaams'[2], 'Dutroux'[3] ... This range of responses drives researchers in search of some kind of system to despair. However, there is at least one clear demarcation line, namely a line between generations born before and those born after the Second World War. The answers differ not so much in terms of personal stories, but in terms of overall historical events. For someone born before 1940 the Second World War, the World Exhibition of 1958 in Brussels, the colonial history of the Congo, the death of King Boudewijn and the 'Dutroux case' seem to be the most prominent memories. But for the post-war generation, the historical frame of reference is more often formed by 'the fall of the Berlin Wall', 'the Gulf War', and '9/11'.

At first sight these answers seem quite predictable. Those who are older and thus have lived through more of the events construct a different 'memory horizon' than someone who has lived a mere twenty years. The generational habitus, as Bourdieu once called it (1977), certainly plays a role here. Shared social, political, and cultural events generate shared memories which contribute to constructing the identity of a generation. Each age group builds up a relevant meaning fund, by means of which it distances itself from the next generation. And this fund is drawn on to give meaning to current phenomena and new developments. In other words, former experiences form a frame with which one reads future events.

Without a doubt this generational memory played a role in the answers prompted by our research question. Yet is there not a lot more going on here? When one studies the answers, something else

stands out at once. The historical events mentioned by the older generation were usually part of Belgian national history, while those born after World War Two more often refer to the world outside. This is intriguing. Are different events remembered nowadays and does this also occur in a different manner? Which actors played and continue to play an important role in the work of memory? Moreover, have the accents and methods of intermediaries between past and present changed over the years? In other words, has the construction of our memory mutated?

Beyond the Nation State?
The Memory of a Multitude?

According to British sociologist Zygmunt Bauman(1990), the nation state is an odd, even artificial social body. Tribes or communities socialize their members in a game of friendships and enmities, attraction and repulsion, self-selection and self-segregation. This game is characterized by closeness or high social density. On the other hand, the territorial size of the nation state gives rise to a situation in which inhabitants live together with people they do not know, and perhaps will never meet. The stranger, in other words, is always part of the nation, Bauman continues, and in this respect the nation differs from other social arrangements. Building a shared culture and constructing a collectivity within such a large political entity can only take place through conscious efforts and by wielding power. Solidarity in such a construction is artificial and actively mobilized. In order to keep this

1 Flanders is the Dutch speaking region of Belgium, which since 1967 has a separate culture and education policy, including with regard to cultural heritage. Our research focused on the presentation and perception of cultural heritage in ten cases within the region. It included interviews with heritage brokers and heritage participants. In addition the presentation of heritage and the behaviour of visitors was filmed. The central question of the three-year research is: how is heritage represented, what are the goals of heritage workers and how is this seen by the general public? In-depth interviews with respondents went further than this question, however. For example, we also asked them questions about which historical events they remembered, whether they travelled a lot, and what kind of history interested them.

2 'Leuven Vlaams' (Leuven Flemish) refers to a political student revolt in 1968 in the university town of Leuven (Belgium), in aid of equal status for Dutch. Students refused lessons in French and demanded the division of the Catholic University of Leuven into a Dutch-speaking and a French-speaking curriculum. This revolt may also be seen as an important breaking point in Belgian history, because it worked as a catalyst for the federalization of the nation, with a Walloon (French and German speaking) and Flemish (Dutch speaking) government.

3 In 1995 Belgium was shaken up by a paedophilia and child murder scandal, in which Marc Dutroux was found guilty.

poorly organized social conglomerate and formation together, national ideology started to take shape. And one of the key products of this secularized religion, as it was called by Emile Durkheim (1912), one of the godfathers of sociology, turns out to be the national monument. Patrimony or cultural heritage is the very child of the nation state. Through careful selection of the past, the nation state generated a shared historical memory and thus constructed a cultural homogeneity. In other words, heritage fitted into a programme of social engineering, which was to create shared sentiments within a somewhat formal, distant, and above all rationally organized 'state factory'.

In his more than usually bulky volume *Les lieux de mémoire*, French historian Pierre Nora (1984) follows a similar line of thought. Not only cultural heritage but also historical education helped to keep the nineteenth century nation state under control through efficient management. With it, the nation state guaranteed an official historical interpretation which legitimized itself. A glorious past also fostered the belief in a golden future. In other words, culture, heritage, historical education and the nation state formed an alliance which for a long time managed our vision of the past. According to Nora, only somewhere between the two world wars did the nation lose this monopoly on the historical gaze due to the gradual emergence and democratization of the mass media. Likewise, the state-controlled archaeologist, archivist, and historian and their subsidized institutions lost their monopoly over legitimate history. Journalists and public opinion nowadays have much more of a grip on historical representation. History, and in particular the way it is portrayed, has been democratized. Yet as a consequence, the past reaches us in an exceedingly fragmented manner.

The aforementioned generational divide in the way relevant historical events are remembered thus turns out to be no coincidence, for Belgium, much like other nations, did not remain unaffected by the advance of mass media. Especially through the emergence of television from the nineteen fifties onwards, histories penetrate into living rooms, alongside official history education. Many events from all over the world are branded onto our retina, leaving traces on our memory. Images, according to a number of memory thinkers, tend to be branded with much force onto our memory, exactly because the work of memory itself is based upon imag(e)ination: memory is largely built with imagery. Even though we may hear a story or read a text about one or other event, it is only through imagination that what has been told remains in our memory. Or, in the words of English cultural philosopher Annette Kuhn (2000): 'The language of

memory does seem to be above all a language of images'.

The national government's loss of monopoly over historical representation runs quasi-synchronously with other developments, thus giving rise to the transformation of more than just memory content. Not only what, but also how the work of memory is performed, changes over time. The professional historian transmits a validated and almost indisputable knowledge. Not only the history teacher, but also other memory workers, such as nineteenth-century museums, used to make use of text in particular, in order to interpret what was on display. In a Post-Fordian society, by contrast, the mass media rely mainly on the medium of image. Images are not only more powerful and performative, but also more open and suggestive. Moreover, the mass media resemble an image rhizome. The latter is related to the excess of image material that mass media offers us, by means of information on a daily basis. Readers quickly skim through a magazine or newspaper until suddenly a photograph catches their attention. This is even more the case for television watchers, who change channels until they find an image that sticks. In other words, events reach us contingently. In a highly personal and eclectic manner, the channel switcher appropriates events, or rather, information on events. This is an entirely different praxis than that of the student in a classroom who is presented with a standard history lesson. The latter absorbs the information in a group, and many before or after him are offered the same historical perspective. In short, with the emergence of the mass media a tendency towards 'destandardization' of representation of the past and present can be seen, and with the advent of the Internet this process has only been accelerated. The latter medium in particular seems to have stimulated the polyphony, as television reinforces a massive standardization of its own. For example, television — in the hands of a few power centres in this world — generated a rather stereotype presentation of Islam after '9/11'.

Offering several generations the same history lesson is one of the ways to build up a collective memory. With the introduction of this term in 1926, French thinker Maurice Halbwachs launched a concept which nowadays still largely dominates the discourse on cultural heritage. Following Durkheim's notion of the collective conscience, Halbwachs presupposes the existence of a shared memory. Both men claim the necessity of a collective consciousness (Durkheim) or collective memory (Halbwachs) for the social integration of a community. According to Durkheim, this integration is also instrumental within the framework of an artificially constructed nation, in which

the integrative function of religion has less and less impact. However, both the notion of 'collective consciousness' and that of 'collective memory' depart from an implicit assumption that there exists such a thing as a shared mental world. In this view, experiences are given the same meaning and interpretation by different individuals. In other words, Durkheim and Halbwachs argued for a psychologism in which a particular work of memory is projected without further ado onto a collectivity. Yet this assumption of a literally shared memory which is the same in all people's heads, much like a collective body, is hardly tenable. The metaphor was perhaps useful in a period in which almost all citizens were offered the same historical 'truth' — be it within the boundaries of a same nation state. But even in that case, the concept does not take into account that within the same political entity different social groups, classes, subcultures and so on, may remember the same events in a very different manner. Halbwachs, however, is not blind to the existence of for example a specific class memory or family memory, though he still presupposes a group memory with little variety. Halbwachs did not elaborate on the fact that official- ized memories elicit alternative memory works — or in the words of Michel Foucault (1977) *contre-mémoires*. He did not consider the possibilities of resistance or, to use Chantal Mouffe's word (Mouffe, 2005), 'agonistic' memory work. The social background as well as the singularity of an individual biography, moreover, determines what is worth remembering as well as what leads to systematic amnesia. Thus social remembering is far more vast and complex than what is grasped by psychology's concept of reminiscence (Radley, 1990). And once we are dealing with an episode of competing histories and the heterogeneous memory work of a multitude, an even more dif- ferent conceptualization is called for. Current memory theory, there- fore, makes frantic efforts to get rid of the too equivocal and one- dimensional notion of 'collective memory'. Neural network is one of the metaphors which regularly emerge as an alternative for indicating the contingency of our memory work (see for example Locke, 2000). In this metaphor, both the individual and the social memory are re- garded as a dynamic relational system in which (often coincidental) connections determine whether something is remembered or not. Shared interpretations only temporarily come into being, by means of physical as well as virtual connections between people, things and images. The so-called collective memory therefore belongs primarily to a community's imaginative sphere: its existence is pre- supposed by many — but not all — of its members, in the first place

by those who act as spokespersons for their communities. It is a product of imaginative power which is appropriate in a most particular manner. Likewise, Nora regards contemporary memory as fragmented and pluralistic. Shared memory can only consist of a variety of memories, which are never shared in the same way in toto by a collectivity.

It should be noted that a dichotomy has arisen in theories about remembering 'in and after the nation state', creating a contrast between hierarchy and rhizome, text and image, homogeneity and heterogeneity, fixation and mobility, the geographically delineated locality (of the nation state) and an ever expanding (global) space, collective memory and neural network, unity and fragmentation, the surveyable perspective and the difficult to grasp collage, and so on. A number of theoreticians are convinced that the first of each of these polarized pairs is rapidly losing ground to the second, which is in keeping with the dominant image of a transition from a modern to a postmodern culture or society. This thesis will now be investigated.

Remembering in Digital Networks

Since the nineteen fifties a number of important societal and especially technological developments have generated a globalized memory, albeit with a highly variable impact in the different regions of the world due to the great differences in mass media and especially digital networking. As mentioned before, there is the rise in the distribution of mass media. Real time broadcasting such as CNN, for example, nowadays brings news from all around the world in no time. A nation's geographical borders hardly form a buffer for these kind of satellite connections, which also are of major importance to diaspora communities (it is no coincidence that satellite dishes adorn many a migrant home). In addition, physical mobility has greatly increased during the last decennia, allowing an increasing number of people to construct memories outside their country of birth. The appearance of the Internet and other digital networks since the nineteen nineties only intensifies this global memory work even more. The net effects of these developments are difficult to assess at the moment, as virtual connections have not yet reached the entire world.

Much like satellite connections, the worldwide web knows no geographical boundaries. Through hyperlinks, almost anything can be connected to anything else. The Internet surfer can travel under one or several virtual identities from one data entry to another.

The Internet enables a distinctly associative remembering, by means of which a historical artefact, document or story, may be linked with texts that have been written on the subject, or with its economic value or political context. And the surfer can travel through different time frames. In short, the Internet enables smooth associations and translations of events from the past to other (artistic, economic, political, geographical, temporal) realities or virtualities. This has led critics and theoreticians alike into utopian as well as apocalyptic speculations. In any case, it goes without saying that the worldwide web has greatly accelerated the process of globalization and has become the chief motor in what Manuel Castells (1996) labelled 'the network society', also known as 'the information age'. Social configurations have been transformed, which in turn is bound to change our memory work. An important question in this matter is therefore: what possibilities does the Internet offer, and how does it influence our dealings with the past? A related question is: does the Internet — due to its quasi-borderless nature — send out an a-national message and imply the existence of a borderless multitude? The best way to find an answer to these questions is to surf on the net. Let us click on a number of cases.

A rather enthusiastic text by Gerard Rooijakkers (1999) on the Scottish Cultural Resource Access Network or SCRAN invites us on a virtual tour of the Scottish highlands. The Dutch ethnologist mentions amongst other things the fantastic possibilities of hyperlinks, which enable one to travel through time without a jetlag by means of a thematic coach. With one click on the rather obvious tartans, Rooijakkers is whisked off to postcards of these tartans via children's clothing, sewing boxes, travellers in 1900 and textile fragments from the third century B.C. Knowledge and tourism are combined and the surfer travels through time in a very eclectic manner.

Rooijakkers' judgement, however, is not entirely favourable. For the political will to invest in SCRAN has much to do with the need of Scottish people to affirm their identity within the United Kingdom. Again we find ourselves in the aforementioned nation state politics albeit in a regional version. A virtual visit does indeed teach us that the horizon of the so-called borderless hyperlinks tends to be limited to the autochthonous group. SCRAN's potential for links is not used to suggest a pluriform or transcultural multitude. Nor do we find a balanced historical view on the paradoxes and contradictions in Scottish society. The taste of Scotland on display, in other words, is highly selective. Even though we find ourselves on the worldwide web, we are served an old-fashioned, self-praising, nationalistic his-

tory. Sites on this hypermodern medium, in other words, do not guarantee a complex memory content of a multitude. This does of course occur once we start 'Googling' and search the actual www outside the boundaries of the site. Doing this makes it possible to 'readjust' our image of Scotland quite easily.

By contrast, we can make other virtual journeys that do show how even specifically thematic sites and closed intranet systems can generate more complex forms of remembering more in line with a borderless 'www philosophy'. One example is the digital remains of an exhibition 'De Virtuele Vitrine' (The Virtual Showcase), created by the Jewish Historical Museum of Amsterdam in 2000. Visitors to the site could select from the collection via the Internet and construct an exhibition with their own favourite artefacts. The museum then used this virtual selection to create an off-line exhibition in the museum. So the Jewish Historical museum has made full use of the interactivity of the Internet to explore the potential of a radical democratic multitude — an experiment which always carries the risk of a direct democratic populism.

In his own project, Rooijakkers goes one step further. In Dutch province of North Brabant, one may visit *Identiteitsfabriek Zuidoost* (Identity Factory South-east), where the interested viewer is offered a virtual bicycle ride through the landscape by means of a small portable computer, while asking for historical information in a rather eclectic fashion. This time it is not the Internet but an intranet structure that is our guide. By means of a central laboratory, 'heritage productions' are made with which mobile surfer can play to their hearts' content. As long as one's computer does not crash, the use of the intranet offers a very flexible cultural-historical and recreational trajectory. Users make their own way through the heritage landscape and construct memories of the region in a most particular way. Rooijakkers refers to this as cultural biography, meaning a mental construction or a multitude of stories and imaginations. These come into being thanks to the many traces of human activity throughout the ages, which are activated by the Identity Factory using a variety of narrative techniques.

The name of the project as well as its method suggests a particularly reflexive way of dealing with the past. No secret is made of a clearly constructivist approach, for a cultural biography only comes into being in a cluster of many, sometimes contradictory narratives and testimonies. Moreover, these histories may be narrated through hyperlinks in ever-changing ways. Here we see how the use of a net

structure literally infiltrates memory work. The character of the medium — unlike the Scottish story — falls together with the way the content is presented.

This modest journey on the web shows how technological evolutions such as intra- and internet have a real impact on our memory work. 'The digitalization of the past' offers new opportunities, which on the other hand may also reactivate older heritage frames. What then is the true potential, but perhaps also the problem of a more interactive memory work? A possible answer may be found in the very readable book with the equally simple title *On the Internet*, by Herbert Dreyfus (2001). This American philosopher does not explicitly deal with memory, but with a subject matter closely related to it. He writes about the changes in learning processes due to the interpellation of the net. Dreyfus starts his dissertation with the crucial insight that computers do not order information semantically, as humans do, but syntactically. Meanings as such therefore, for a computer, have no … meaning.

Dreyfus makes a useful distinction between the old library culture and the present hyperlink culture. Whereas the former is characterized by a stable, hierarchically structured classification, the latter revolves around flexible diversification which is only ordered on one level (the famous rhizome structure), allowing all possible associations. Within the library culture, one has to select carefully, for it is simply not possible to stock everything. In the hyperlink culture this is far less the case, because in principle everything can be 'saved'. The accumulation of old material and so-called e-waste are not, for the present, a real problem for the Internet. This in turn makes it possible to collect dynamically, whereby data are cobbled together through playful surfing in an inter-textual way. In a library culture, the permanent collection of static texts does not allow such frivolous dealings with the patrimony.

Dreyfus' chain of opposites tends to come across as rather black and white, and his own take on the 'hyperlink culture' is often quite negative. But the comparison between the two regimes teaches us a few things about contemporary remembering. Memory institutions such as archives, libraries and museums are bounded not only by the nation state, but also by the limits of the library culture Dreyfus described. Memory workers have to come to terms with the possibilities of the Internet and the digital information culture, which confronts old collecting and presentation paradigms with new ones, often leading to friction. Roughly speaking, the well thought-out historical

exposition by an expert can nowadays be traded in for a frivolous, a-historical narrative, cobbled together by an amateur surfer or an anonymous surfers' collective, as in the case of the 'Virtual Showcase'. Whereas, in the past, the former may have generated somewhat lifeless presentations, the latter carries the risk of interpretations that are all too free of engagement or fail to become more than a completely senseless murmuring. In other words, while the memory work of a multitude can throw up interesting counter-memories in a creative agonistic tradition, it can also come close to a populist use of history. The same critique is frequently levelled at the idea of direct democracy as developed by Hardt and Negri in *Multitude*.

But Dreyfus's dichotomy draws our attention to yet another point, for his description of the hyperlink culture has a lot in common with the way in which contemporary memory thinkers understand our memory work. Their metaphor of a neural network also implies a rhizomatic, associative, decentralized and contingent functioning. This similarity should come as no surprise, however, as many theoreticians borrow from computer sciences, Internet theories and insights into artificial intelligence to adjust their conception of memory. British Internet theoretician Chris Locke (2000), for example, refers with some amusement to the Memex (the predecessor of the current computer): 'Ironically, a system that was intended to aid the fallible, forgetful human memory has instead become a metaphor for postmodern definitions of human memory itself'.

Two things stand out from our virtual surf. Firstly, the development of the borderless Internet does not preclude its use to disseminate a time-honoured nation state rhetoric, organized quite strictly and hierarchically. The latter simply continues to exist alongside a fragmented, global memory supply. Moreover, it can be concluded that the Internet has changed not only the ways in which we remember, but also — and perhaps mainly — our thinking about (and theorizing of) memory work.

Memory Work and Social Integration

The construction of shared memories evokes imaginary communities, a term coined by Benedict Anderson (1989) in the context of the debate on nationalism. Yet feelings of social cohesion are generated not so much because a group of people has had the same history lesson, for these only emerge when the past is linked with emotion, sentiment or commotion. Only then does a history become a moving

69

history which can give rise to fierce discussions between standpoints with which social groups identify. In days gone by, the nation state attempted to exploit this coupling of sentiment to the past to stimulate the social integration of a political entity. This is the analysis of sociologists such as Durkheim, Halbwachs and Bauman.

French sociologist Michel Maffesoli (1988), on the other hand, makes a bold proposition with regard to this question. He is of the opinion that the nation state can never reach social integration, because it relies far too much on rational principles of organization, such as politics and economy. The latter mainly serve to guarantee the private acquisitions of the individual. What is more, the state, according to Maffesoli, is the expression par excellence of a political order which protects the individual citizen against borderless multitudes, which need to be kept under control as much as possible. To that end, a government appeals to scientific research and rational constructions such as referendums, surveys, and regulations to get a grip on the collectivity. Social integration or the deliberate production of a joint social connection through rational societal principles in this age of globalization comes under more and more pressure. According to this French sociologist, nowadays a heterogeneous 'communal' atmosphere of ambiences, sensuality and feelings determine the new sociability. Time tested segregation principles, such as distinction, differentiation and segmentation by means of cultural and economical capital, disappear and give rise to a loss of many, mostly temporary collective subjects. Maffesoli calls this phenomenon neotribalism, which differs from premodern tribalism in its volatility, multipli-city, overlapping nature, and temporary memberships and identifications — all characteristics of the multitude. The collective experience revolves around an aesthetic ethic or a shared lifestyle. The latter is a feature of both the new tribalism and its predecessor. Both pre- and postmodern community forms rely on a collective consciousness, vitalism, and 'transcendental warmth' of the collectivity, according to Maffesoli. The most important religion of this group is the social self. For the members of the new tribe, the experienced sociability is its highest good. It should be noted that the experience of collectivity withstands every rational, social organizational principle. Therefore, it cannot be explained or analyzed with notions that apply to the nation state, such as ideology, morality or ethics. The group only celebrates itself. Not the intrinsic meaning, but the cycle of the rite keeps a group together in a feeling of 'belonging'. Therefore modern individualism in many late modern collectivities starts to melt away, according to Maffesoli.

Admittedly, the thesis of our French colleague could be called speculative, to say the least. In particular, his supposition that the individual nowadays completely dissolves in social communities is an overstatement. Two of Maffesoli's ideas, however, are food for thought. One is the idea that the individual fragments into a multitude of memberships of the most divergent social configurations. For this reason, Maffesoli no longer speaks of individuals, but of *personages* (characters) with different masks, depending on the neotribal group in which they find themselves. In addition, this cultural sociologist regards society as a patchwork quilt of many different neotribes, flourishing within as well as beyond the boundaries of the nation state.

A search through heritage land teaches that quite a few social configurations come together precisely in what may be called emotionally remembering. Heritage workers and other 'memory engineers' are becoming increasingly aware of the role of emotions in our memory work. One of the visible symptoms of this is the development of an economy of experience and empathy in the Post-Fordian heritage sector. Sentiment and empathy appeal more to the imagination and, according to many memory theoreticians, are more memorable than 'dry' enumerations of a few historical facts. This is, for example, the opinion of social psychologist John Shotter. Affects, according to him, should not be regarded as pre- or post-cognitive, but as constitutive of practical, embodied thinking (Shotter, 1990).

It should be noted, however, that in this emotional remembering the group is celebrating itself and in doing so is constructing a perhaps temporary, imaginary, shared identity. This may vary from a spontaneous chat on the Internet to a more organized experience such as museum festivals, an evening light show in an open air museum or other professionally organized heritage activities. In these neo-tribal gatherings that mainly appeal to sentiment and aim for atmosphere, historical events or history are only a pretext for meeting each other, for the social happening has more weight than what is being commemorated. Moreover, in this 'sensuous' remembering, one continuously actualizes and transforms the past. In other words, due to these emotional events the tribe reaffirms itself time and again through a feeling of 'pastness'. Such happenings, however, were also calculatingly organized by the nation state. Given its rational nature and especially its direction towards the individual and against community formation, if we consistently follow Maffesoli's line of thought, it did not succeed. And sentimental social configurations have completely taken over from rational ones, according to the French sociologist.

71

What can be assumed from all of the above is that an eclectic and fragmented memory flourishes in a globalized world in which the most divergent histories are at our disposal, histories around which ever different, at times volatile micro-communities and multitudes coagulate. The social integration of the multitude follows a selective course, depending on what and how one remembers. It forms one of the principles around which attraction and repulsion, social inclusion and exclusion, self-selection and self-segregation take place. In other words, we find ourselves yet again in Bauman's narrative about the period preceding that of the nation state. The social integration of the multitude (beyond the nation state) depends on a premodern and pre-rational (but not, for clarity's sake, irrational) sentiment. The geographical nearness of the premodern tribe has been rendered superfluous by the Internet and increasing physical mobility. However, this fragmentation into many small memory communities does not imply the dissolution of the nation state. Notwithstanding the patchwork quilt of many divergent micro-communities which operate on a global as well as very local level, national sentiments remain important. Equally, national history syllabi continue to exist alongside many other alternative memory groups that mediate between past and present. Both nation states and the media, both digital networks and local memory communities are aiming at remembering in a global age — something confirmed by our journeys on inter- and intranets. Due to technological developments and a more explicit appeal to sentiment, it is possible that people remember in a new way today. But, contrary to the views of some theoreticians, this alternative memory work does not completely deconstruct the nation state memory, which persists alongside many other mediators. As a consequence, social integration happens in many divergent ways. Or, in the words of an interviewed museum visitor:

'I don't have a problem putting on different hats. I feel a Brugean, a Flemish, a Belgian, a European, and a world citizen, depending on the situation in which I find myself. Dealing with the past, being conscious of the many histories which surround me, offers me a sort of balance, a peace within myself, on all those levels.'

Bibliography

Anderson, B. (1989). Imagined Communities. London: Verso
Bauman, Z. (1990). 'Modernity and Ambivalence'. In Global Culture: Nationalism, Globalization and Modernity, ed. M. Featherstone. London, Newbury Park, New Delhi: Sage
Bourdieu, P. (1977). Outline of a Theory of Practice. Cambridge, UK: Cambridge University Press
Castells, M. (1996). The Information Age. Oxford: Blackwell
Crane, D., N. Kwashima, and K. Kawasaki (eds.) (2002). Global Culture: Media, Arts, Policy and Globalization. London and New York: Routledge
Dreyfus, H.L. (2001). On the Internet. London and New York: Routledge
Durkheim, E. ([1912] 1985). Les Formes élémentaires de la vie religieuse. Paris: Quadrige/Presses Universitaires de France
Featherstone, M. (ed.) (1990). Global Culture: Nationalism, Globalization and Modernity. London: Newbury Park, and New Delhi: Sage
Foucault, M. (1977). Language, Counter-memory, Practice: Selected Essays and Interviews. New York: Cornell University Press
Fowler, P.J. (1992). Then, Now: The Past in Contemporary Society. London and New York: Routledge
Gielen, P. (2005). 'Sign 'O' the Times'. In Veldstraat/Gent, ed. H. Defoort and W. de Vuyst. Tielt: Lannoo, Ghent: Gent Cultuurstad
Halbwachs, M. ([1926] 1992). On Collective Memory. Chicago: Chicago University Press
Isin, E.F., and P. Wood (1999). Citizenship and Identity. London, Thousand Oaks and New Delhi: Sage
Jacobs, M. (2003). 'Immaterieel Erfgoed' of 'Volkscultuur'. Brussels: Vlaams Centrum voor Volkscultuur
Kuhn, A. (2000). 'A Journey through Memory'. In Memory and Methodology, ed. S. Redstone. New York: Berg
Locke, C. (2000). 'Digital Memory and the Problem of Forgetting'. In Memory and Methodology, ed. S. Redstone. New York: Berg
Maffesoli, M. (1988). Les Temps des Tribus. Paris: Méridiens Klincksieck
Middleton, D., and D. Edwards (eds.) (1990). Collective Remembering. London, Thousand Oaks and New Delhi: Sage
Misztal, B.A. (2003). Theories of Social Remembering. Maidenhead, Philadelphia: Open University Press
Mouffe, C. (2005). On the Political. London and New York: Taylor and Francis Group
Nora, P. (1984). Les Lieux de mémoire. Paris: Quarto Gallimard
Radley, A. (1990). 'Artefacts, Memory and a Sense of the Past'. In Collective Remembering, ed. D. Middleton and D. Edwards. London, Thousand Oaks and New Delhi: Sage
Redstone, S. (ed.) (2000). Memory and Methodology. New York: Berg
Rooijakkers, G. (1999). 'Het leven van alledag benoemen: Cultureel erfgoed tussen ondernemerschap en nieuwe technologie', Boekmancahier 41: 275-90
Shotter, J. (1990). 'The Social Construction of Remembering and Forgetting'. In Collective Remembering, ed. D. Middleton and D. Edwards. London, Thousand Oaks and New Delhi: Sage
Tollebeek, J. (1960). De ekster en de kooi: Nieuwe opstellen over de geschiedschrijving. Amsterdam: Uitgeverij Bert Bakker

Shopping
Memories in
the Global City

Wander down a high street or through a shopping mall anywhere in the Western World and it will never take long before you come across a McDonald's. Paradoxically enough, the American fast food chain is conspicuous for its very inconspicuousness. Only the advertisements make it clear that it's a catering outlet — very unlike the typical Belgian chip shop, which lures its customers from far with the penetrating aroma of hot fat and sizzling potatoes. No, there is not a trace of cooking oil at the chain outlet. Far from dripping with fat, McDonald's is a spotless restaurant that meets modern hygienic standards and the requirements of Post-Fordism.

The well-trained friendly smile of the man or woman behind the counter demonstrates that McDonald's is an exemplary product of our times. This combination of material labour (making a hamburger) and immaterial service (the trained smile) is the jewel in the crown of many centuries of western civilization. The total lack of oilfactory or tactile experience, such as sticky fat, is not unique to McDonald's, however: sensory cleansing has spread all down the high street. The sickly sweet smell of warm waffles that escapes from the odd stall is the proverbial exception that proves the rule.

Mud has long disappeared from our city streets, garbage is promptly collected, there are fines for dog-fouling and air-conditioners and other sophisticated systems keep our air 'clean'. Even cigarette smoke has practically disappeared. Sharp tones and loud noise have been muffled by monotonous muzak. The thorough elimination of most sensory experience means that we can really have no idea how life was in the European city of a hundred years ago. And medieval urban life, with its stenches and damp alleyways, is entirely beyond our late modern sensibilities. The en*light*enment cast its light — the biggest prerequisite for being able to see — on the sense at the top of the hierarchy of the senses: sight. As early as the turn of the twentieth century, the German thinker Georg Simmel wrote about the importance of sight in the modern city. In his sociology of the senses, sight plays a crucial role in social relations. After all, sight is the only sense that offers the possibility of establishing a social relationship at a relatively great distance. It is always possible to answer a glance with a glance. With hearing, it is a very different story: the ear can take everything in, but can give nothing back. Our ears play a very small role in the creation of the urban intimacy and the Post-Fordian sociability that are so characteristic of the contemporary high street. As in the art scene described earlier, the game of seeing and being seen governs social traffic in the shopping centre too. Anyone we look at can respond

with a glance that subtly but clearly communicates reassurance, curiosity, indifference or disgust — although it is worth noting in passing that a shopping centre is not a scene in the sociological sense, because there is no overlap between public and domestic territory.

The sense of sight also allows us to possess something. Whereas tones and sounds come and go, odours pass by and we cannot get hold of them, the eyes can hold onto something for longer. We can keep an eye on other consumers while we rummage through consumer goods. We take in the entire scene, in fact. This seeing is the first step towards having. The acquisitive or envious look is one of the main symptoms of our capitalist consumer society. That visual power was increased by the advent of electricity, street lighting, shop window lighting and of course photography and film. Our love affair with looking is intensifying now on the worldwide web which our eyes glide over as they inspect the world. What is more, watching has established itself in the modern age as the main metaphor for power, control and science. In prisons, psychiatric institutions and borstals, the 'residents' are surveyed, while beyond their gates, a security officer screens people, a camera records speeders and a scientist observes the object of research with an objective gaze. And back in the shopping centre, we look to our hearts' content while a security camera keeps an eye on us.

With so much regard for the eyeball, it should be no surprise that our everyday environment is dominated by images. We live in an iconocracy in which the visual sign monopolizes all the attention. Advertising hoardings and large shop windows feed an all-encompassing visual hegemony. The high street is in fact one big shop window, a peepshow that sucks the consumer into a visual feast to which all the other senses are subordinated. The shopper tempts and is tempted in an iconographical game of fashionable signs. The effect of the dominant visual economy explains why the shopping centre no longer has any character, identity or style of its own. All over the world, the shop window display has become the handmaid of the insatiable gaze of the consumer. That is why it is completely interchangeable with any other shopping centre on the globe. For flashing lights, all local character and history was literally demolished. There's no unseemly patina on a slick shop window. It has no meaning in itself; its only function is to display its contents. The shop window should be as inconspicuous as possible; it is not allowed to be itself. That transparency must at the same time represent the honest trader who has nothing to hide. The essence of the shop window, then, lies in the fact that you can see through it.

And what you can see through the shop window changes all the time. The shopping centre facade could be said to have the most unstable identity in modernity. The call of the ever-new prevents any continuity and stability from being established. A shop window draws all our attention to that constant change. Only when we stroll through the high street of a historical city at night do we notice that there is something above it. Now that the shop windows stop screaming for our attention, we discover the characteristic old gables. Only at night does the architecture and the history of the city speak to us. When the sun comes up again, our gaze lowers once more to the shop windows where we are seduced by all that new, new, new.

The impoverishment of sensory experiences and of a local sensory pallet in favour of the sense of sight, coupled with the demolition of historical facades for uniform shop fronts creates the ideal decor for non-places, as the French thinker Marc Augé so accurately calls them. Airports, bus terminal, car parks and shopping centres form meaningless junctions for a globalized society. They create the same recognizable places all over the world. Roots make way for roads; the local inn is pushed out by a motel or Holiday Inn; the ubiquitous automobile traverses and scars the once so distinctive landscape; and the local cuisine is driven out by an American chain. This brings us back to our starting point: McDonald's. The fast food chain is just the harbinger of a world of retail chains which dominate city streets all over the world or certainly the West. H&M, C&A, P&C, WE and the like ensure that we can shop for variations of the same thing in any city. The systematic exchange of full names for acronyms serves to disguise even the national origin of the multinational chains. Today's consumer shops in stores with meaningless names from which any geographical genesis has been wiped. The world citizen becomes a world consumer who can buy the same fashion and identity in Tokyo, New York, Paris or Brussels.

By getting rid of individuality, uniqueness and local colour, the contemporary consumer society seems to eradicate all signs of the past, and of historical and cultural heritage. Marc Augé's non-place lost not just its specific identity but also its memory. Amnesia and loss of identity go hand in hand, in fact. A person who doesn't know who he is and a place that doesn't recall itself — after all, identity is very much a question of recall, of repetition — are suffering from the same disease. Both lack a firm basis because they lack a history. Like the amnesia patient, the non-place spins around in an endless sensation of momentariness. Because without a sense of the past there is no future either:

all chronology dissolves in a dizzying present. The globalized locus of consumption, ever dazzled by the latest of the latest, is one of those places that can easily make us forget. Is it then the antithesis or perhaps the great enemy of everything that stands for our cultural memory?

Freedom To and
Freedom From

At first sight, the answer to the above question would be an unabashed yes. Strolling down the high street, we see how the excesses of unrestrained capitalism have blasted a crater in the landscape. Traces of the past have been obliterated and politicians do not seem to have come up with any effective legislation for resisting the ongoing demolition of our sense of history. The effects of global money flows are difficult for local governments to resist. In a post-political age, all politicians can try to do is to steer them in the right direction. It already looks as though planning permission and rules no longer exist for shopping centres. This exemption, or lucrative dismissal of a strict regulatory system, characterizes the modern consumer society — which defends it by invoking one of the fundamental principles of the French Revolution, that of freedom. In the consumption game, however, this key democratic value is transformed from a freedom to into a freedom from. The freedom to be self-determining, to acquire knowledge and to engage in enterprise has degenerated in the post-political era into a demand for freedom from legislation ('there are too many rules!'), the dismissal of authority, and an escape from social responsibilities. In other words, the freedom to take our fate into our own hands and lead our own lives came to be interpreted in more and more negative terms as a freedom from all demands on us by society. The persistent neoliberal lament about 'too much government' or 'state' is certainly closely related to this. This symptom — we could call it 'negative liberalism' or 'a-citizenship' — can be detected in the contemporary consumer too. In early modern times, when the use value of consumer goods came to be accompanied by an immaterial symbolic value, possibilities for creating meanings for the self were opened up. The choice of clothing, luxury goods and so on now did more than just highlight individual identities. The creation of an outer image was part of the search for a self, an 'authentic' personality. The vast choice between different products generated scope to put together an idiosyncratic identity, and helped to create the so-called 'cult of the self'. But in a Post-Fordian context, this freedom of self-determination evolved into an ironic, and for Paolo Virno even cynical,

79

game played with many roles. Contemporary consumers no longer go shopping in search of things with which to illustrate their own identities, but to create various different images. Today's shoppers know that they can buy a lot of individual items and play with them. The single identity dissolves into a multi-schizophrenic self. And this releases the Post-Fordian consumer from the last modern responsibility, namely the requirement to be himself. When one role no longer fits or suits him, the opportunistic shopper picks another one — much like a famous television actor. The late modern consumer lives in a permanent trance of escapism which enables him to live free from any consistency. After all, people who no longer fulfil the requirement to be themselves cannot be held to account for their previous actions, or for the consequences of them. And so the freedom to position oneself within a society turns into a freedom from any social commitment.

The end of that responsibility to be oneself destroys that last overlap between the consumer and the citizen, too. The late-modern shopper is anything but a citizen, as conceived of in the nineteenth century. After all, the ideal citizen is brimming with a sense of responsibility. He cultivates his own freedom in order to play a valuable role in society. The citizen keeps abreast of politics, cultivates his artistic tastes and participates in public debates. He is a wholehearted participant who is aware of his environment and the history that goes with it. The citizen, even the citizen of the world, is always conscious of a locality. That is why the term 'citizen' is so often followed by 'of ... [a country]'. The citizen's mandate is therefore grounded in and interwoven with a political entity. Whereas the browsing consumer is adrift, the citizen feels deeply connected with his environment. While the former is free of any responsibility, the latter uses his freedom to take up responsibilities. This distinction characterizes the difference between the cultural consumer, the audience or the passer-by on the one hand, and the cultural participant on the other. The latter is an informed and active pleasure-seeker who wants to sharpen his cultural competence, while the former enjoys, first and foremost, an escape from the daily grind.

Admittedly, this sketch of the contrast between consumer and citizen is somewhat black and white. Of course, the citizen goes shopping too, and often with pleasure, while the consumer regularly fulfils his duties as a citizen. But an extreme formulation of the difference between the consumer and the citizen sheds light on the status of the shopping centre and its relation to cultural heritage. One of the conclusions we can draw from this distinction is that the shopping

centre is not in fact the public space it is generally assumed to be. The shopping centre meets none of the nineteenth-century criteria for an environment that is full of politics, culture and history. In a genuine public space, traces of the past are everywhere. They point to the many historical layers on which it stands, the cultural-historical basis on which the citizen builds. The public place is also a space for public exchange of opinions, for discussion and argument. It is ruled by a hegemony of the word, sometimes emotionally laden and sometimes rational and measured, and not by the hegemony of the image, as is the shopping centre. To put it strongly once again: the citizen listens and speaks in the context of a history he identifies with, while the consumer is blinded by the ceaseless whirl of the new.

The contrast between freedom to contribute to society and the freedom from all rules and responsibilities that a populist neoliberalism argues for has something to teach us about the relation between consumption and heritage cultures, or between consumer goods and 'heritage goods'. These realities are located in very different social value regimes. Artefacts and buildings that have been designated cultural heritage relate to their environment rather as citizens relates to their region or country. Before something is declared part of the national heritage, it is the subject of debate. Legislation has to be drawn up, committees formed, political dossiers prepared, and government subsidies granted. In other words, the construction of cultural heritage is accompanied by a lot of talk — chatter even — in the form of discussion, lobbying and negotiations. In short, heritage is backed up by good argumentation, and in this it differs radically from the free-wheeling nature of consumer goods. If you want to raise something to the status of historical monument, you have to have good arguments; the shopper has to answer to nothing and no one. What is more, cultural heritage is like the citizen in being closely connected with a district, region or country. That makes both of them susceptible to regionalist and nationalist reflexes. Legislation anchors buildings and artefacts in a local setting, even if they are called 'world heritage'. The mediation of the word through arguments, dossiers and regulations lends such heritage a certain solidity and, of course, an identity. Heritage goods are not exchangeable at the drop of a hat, because people have invested in them. And so there grows up a symbolic economy that differs from the capitalist monetary economy. It is an emotional involvement through blood, sweat and tears that makes heritage special. All those human investments turn a once meaningless object into a quasi-subject or living creature that starts to contribute

to shaping a community and a particular culture. It is immediately clear that consumer goods, too, can be transformed into heritage. The mediation of the word, the human investment in arguments among juries, committees and heritage institutions can place an object outside the capitalist market. These are the translation centres that turn a thing into more than just a thing because their argumentation endows it with symbolic value. Once that value has been added, it is no longer marketable or straightforwardly exchangeable. Finally: the more words we expend on it, the more anchored an object becomes in a specific social fabric. The contrast between consumer goods and cultural heritage is, in other words, a matter of degree. The more arguments we can and wish to invest in it, the more unique the object. Designer goods, for example, demand more explanation than purely functional equipment. More words are expended on *haute couture* than on off-the-peg clothes. And the sometimes endless babble about and around contemporary art lends some objects the status of significant heritage before they've even been properly finished. In short, words, arguments, discourse and rules generate a discursive basis which turns a thing into more than just a thing. Through its story it gains a history and a singularity. Documents, artefacts and buildings are literally written into a specific cultural history, doing away with their chances of unconditional exchangeability. And in this lies a fundamental difference between cultural heritage and a consumer product. And yet …

No Cultural Heritage without Consumption

The value regimes within which cultural heritage and consumer goods are located seem to clash. However, they are really two sides of the same coin, and the coin is called 'modernity'. In *The Heritage Crusade and the Spoils of History*, the British geographer David Lowenthal (1998) points out that awareness of heritage is a relatively recent phenomenon. Ninety five percent of our historical museums were established since the Second World War. From dictionaries from fifty years ago, Lowenthal deduces that the English word 'heritage' then only referred to family inheritance and the tax regulations around it. The shift in meaning to that of a collective past, roots and identity only really got going in the nineteen fifties. The same is true for the French word 'patrimoine.' Before the war, the Larousse dictionary sticks to the definition 'goods inherited from parents'. The collectivization of heritage as a historical factor for a culture, a region and a country, is very recent, then. The origin of the heritage cult, as Lowenthal calls

it, lies in the large-scale, fast changes of the last five decades. And so we come back to our shopping centre, which symbolizes all the mobility of the modern age. That modernity only began to reach all the layers of the population in the nineteen sixties. From that time on, there was no stopping it. Radio, telephone, washing machines, television, microwaves, computers and mobile phones followed each other at breakneck speed. At the same time, the idea of 'my car, my freedom' made an individualized freedom the democratic right of every Tom, Dick and Harry.

Mobility, speed, progress ... these are the characteristics of modernity which injected a permanent feeling of loss into the very fabric of society. Stability evaporated in a continuous flow of changes. For many, this unstoppable influx of the new is truly horrific. Turbulent times with technological revolutions go hand in hand with other social phenomena that are not to everyone's taste. Lowenthal concludes that they cause a trauma of loss and anxiety in contemporary society. And it is exactly that which brings about a longing for the past. History becomes a nostalgic engine of projection about the good old days of stability, tradition, peace and community. Cultural heritage delivers the ingredients for a therapy for surviving the side effects of modernity. The shopping centre as symbol of the novel and slippery identity inevitably calls up a counter movement. Only through our awareness of change and the possibility of loss can something like awareness of cultural heritage grow up. So there is no cultural heritage without the non-place.

Continuous social change creates a penchant for the past which goes hand in hand with a longing for authenticity, genuineness and localized experience. To borrow the theatrical metaphor of the American sociologist Erving Goffman: the harassed citizen wants to take a look behind the scenes of all that glamour of the new. By doing so, he hopes to reach more stable ground. The Post-Fordian human being longs to snuffle around in the wings, and get a look backstage. He wants to see what is behind the facades, what has been swept away by all those dazzling window displays. The contemporary tourist, likewise, is no longer interested in the shopping street that he could see anywhere in the world. He flees from the standardized high street down the smaller alleys in search of the past. This is why some theorists call him a post-tourist. It is not sameness but difference that can satisfy his longing for authenticity and local colour. Far from the madding malls, the traveller hopes to catch a glimpse of the 'true' city. Why else would he travel? The Post-Fordian heritage industry plays

on this quite skilfully, though, by constructing an authentic-looking backstage. And the wings are just a new facade, part of a well thought-out and stage-managed authenticity. Historical facades are cleaned up, tarmac is replaced by cobblestones, over-modern street fixtures are chucked into the skip, and cars are tucked away in underground car parks below ... yet another historical looking square. This era of renovation projects and restoration fever is not just giving foreign tourists a sense of history; it is doing so for local residents too. Today's resident can look at his own surroundings as at a picture. After all, the renovation of historical buildings transforms city facades into aesthetic objects. The resident becomes a tourist in his own country, a development described by English sociologist John Urry in the late nineteen eighties as 'the institutionalization of the tourist gaze' (1990). The indigenous city resident increasingly lives in the scenery for a beautiful postcard. And it is not just in the art-historical cities but also in abandoned industrial sites over the whole world that renovation projects follow hot on each other's heels. If there is no historical frame of reference to hand, then a lively art scene with contemporary art and culture can save the day. Besides the young and lively dynamism, the already described art scene with its cultural animation programmes, artists' residences, subsidized workshops and (above all) art in public spaces, can give a hitherto desolate looking place an attractive and, yes, an 'authentic' image. In the Post-Fordian society, artists, cultural mediators and other immaterial labourers play a crucial role in constructing a new authenticity. In a globalized world, the main thing is to distinguish yourself, so the non-place seeks to regain the appeal of a recognizable place. Local histories are dredged up for the purpose, and if they do not exist, they are made up. In the process, the penchant for authenticity and the past acquires a good dose of consumerism. The globetrotter shops for places to record in his digital camera. When the acquisitive gaze falls on it, heritage becomes a consumer good. The historical scene can seduce us just like the products in the shop window. Through the mediation of the work, consumer goods can be turned into heritage, but when that discourse is absorbed into a visual hegemony, we go back to an iconographic game of seduction. One place becomes exchangeable for another, for a price (in the form of a train or plane ticket). In other words, cultural heritage, too, has an important symbolic value. Within a global perspective, the remnants of the past and the simulations of heritage function as the ultimate means of individuation. Just as the consumer buys himself an identity with fashion, so can the local politicians, helped by an army

84

of building contractors and cultural mediators, create the identity of a place. And here we stumble upon the great paradox of every policy related to artistic and cultural heritage, its management and restoration. People with a sense of citizenship all argue with great conviction for the need to respect their history. They express their connection with the city or district through an engagement with its local history. However, this justifiable concern with cultural heritage often leads to an aestheticization of the past, turning it into pretty pictures. By doing this, heritage generates a visual myth which is stripped of all history. The word and the narrative end up giving way to the consuming gaze of the tourist. Stories about the past are reduced to an image of 'pastness'.

The escalating urban restoration of the past is giving the shopping centre an eccentric status: paradoxically enough, with all that nostalgia and historical aestheticism, the standardized shopping centre is becoming quite unique, if not in the world then at least in the context of the dominant urban and local decor. Surrounded by simulated 'pastness', the shopping centre itself becomes 'authentic'. It forms one of the last witnesses to early globalization, a Fordian economy in which uniformity prevailed over individuality. Exactly because of its universal retail chains and their shop windows, the shopping centre evokes an (almost) closed chapter of the history of globalization. That is a turn up for the books. Suddenly we get the feeling that we should expend some words on a non-place. We even devote glossy books to it. Who knows, perhaps the shopping centre will be cultural heritage one day.

Bibliography

Corrigan, P. (1997). The Sociology of Consumption. **London, Thousand Oaks and New Delhi: Sage**
Cross, G. (1993). Time and Money: The Making of Consumer Culture. **London and New York: Routledge**
Daunton, M., and M. Hilton (eds.) (2001). The Politics of Consumption: Material Culture and Citizenship in Europe and America. **Oxford and New York: Berg**
Firat, F., and N. Dholakia (1998). Consuming People: From Political Economy to Theaters of Consumption. **London and New York: Routledge**
Goffman, E. (1959). The Presentation of Self in Every Day Life, **Garden City, NY: Double Day**
Goffman, E. (1967). Interaction Rituals: Essays on Face-to-Face Behavior. **New York: Pantheon Books**
Goffman, E. (1974). Frame Analysis: An Essay on the Organization of Experience. **Boston: Northeastern University Press**
Lowenthal, D. (1998). The Heritage Crusade and the Spoils of History. Cambridge, UK: Cambridge University Press
Sulkunen, P., J. Holmwood, H. Radner, and G. Schulze (eds.) (1997). Constructing the New Consumer Society. **Hampshire and London: Macmillan Press Ltd**

Urry, J. (1990). The Tourist Gaze. **London: Sage**
Urry, J. (2000). Sociology Beyond Societies: Mobilities for the Twenty-first Century. **London and New York: Routledge**

Museum Chronotopics: On the Representation of the Past in Museums

'If something is important, then importance must be "ascribed" or "attached" to it; in other words, it is important because the historian is interested in it.'
Georg Simmel[1]

It is an irony of history that Georg Simmel's words apply to himself because twentieth-century sociology textbooks tended to marginalize him in relation to other so-called founding fathers of the discipline, such as Emile Durkheim and Max Weber. Only in the last two decades has Simmel's work come to prominence. In the late-modern period where fragmentation, polyphony and hybridity have become prevailing metaphors for social phenomena, Simmel's micro-observations have begun to be appreciated. At the turn of the last century, this idiosyncratic sociologist was already speaking about social networks and their unconditional hybrid nature. Today, this idea has been happily embraced by network-thinkers such as Manuel Castells, Bruno Latour, Rudi Fuchs and the actor-network school. According to these sociologists, an event only acquires meaning when it is connected to a network, and only within the boundaries of that configuration. This tautological account also applies to history, or rather to historical consciousness. Indeed something or someone only acquires historical importance when this importance is ascribed retroactively. However, not everyone has such intermediating power. Where historical 'facts' are concerned, the historian, for example, plays a crucial intermediate role between the present and the past. Simmel describes this in no uncertain terms in his book *Die Probleme der Geschichtsphilosophie* (*The Problems of the Philosophy of History* [1892/1905] 1977). Whilst the originality of Simmel's argument has already disappeared into the folds of history, he remains a discerning thinker on modern history. Despite his cosmological framework, the principles of his theory have a contemporary relevance; he was one of the first to unsettle historical doxa by establishing their relativity. Nowadays such a pronouncement may seem all too evident or cliché. But we should not forget that Simmel formulated this idea in the early 1890s.

However, the concern of this essay is not to elaborate Simmel's theoretical framework but to show how his ideas may be developed in relation to museums in a globalized society. The importance of his stress on mediating between present and past will be emphasized because, for Simmel, it is not what is said, but how something is said

90

that determines the possibility of a connection between a historical event and the present (Simmel, [1892/1905] 1977). Moreover, causality, consistency and resemblances can only be experienced, not objectively observed. Though the possibility of grasping particular facts and historical events does exist, their mutual coherence is the result of interpretation. In other words, a causal relation and consistency cannot be deductively inferred from empirical facts (Simmel, [1892/1905] 1977). These are, to use Simmel's own expression, retroactively 'woven', and it is the nature of that fabric which determines if the events of the past permeate into the present. Thus the weaver, so to speak, is an important mediating link between different periods of time, and constitutes an indispensable translation centre between present and past. Simmel appreciated the increasing importance of the historian in all of this for his own time. Thus, whilst an existing 'practising memory' was a component of ritual traditions, historical science had gained importance as an intermediary. Within the truth paradigm of modernity, professional historians and their science were becoming an obligatory passage to the days gone by. However, as the twentieth century drew to a close it was becoming apparent that historians were in increasing competition with other 'memory workers' such as the many heritage brokers. It may be that in a secularized world it is the latter who are the heirs to the ritual traditions and to the traditional experience of history. As we have seen, they professionally organize an economy of experience of the past.

Visitor Studies:
Towards a Relational View

In arguing that the presentation of history is a matter of mediation, I do not, of course, mean that this is only done by professional historians and heritage brokers. The museum visitor is also an active interpreter of history. To characterize the visitor as active is to make a distinction between reception and perception. Whereas the former notion refers to a passive taking in of phenomena, the latter indicates an active experience: a museum visitor observes by means of a viewing grid or schema that he has acquired through education or socialization. The same may also be said for the so-called

1 Georg Simmel (1858–1918), who for much of the twentieth century was best known for his influential essay on the metropolis and mental life, also wrote widely on aesthetics and history, as well as sociology. Sociology's much vaunted interest in culture as well as in consumption, sensibility and the body has re-established the importance of his work for the discipline.

'passionate viewer', who is 'blindly' carried away, overwhelmed by the presentation of an art exhibition or a historical event. The relation between subject and object, between the viewer, reader, listener and the museum display, consists of a double synchronous movement of active passion and passive action. The French sociologist Antoine Hennion describes this movement with regard to music (Hennion 1993; Gomart and Hennion, 1999) but it can also be seen at work in a museum. The museum visitor has to develop all kinds of active skills before he can enjoy the museum passively. The point is that the way something is presented can itself stimulate the development of the appropriate skills. Thus, intercourse with museum presentations may be described as a subtle 'interweaving' between manipulation and being manipulated. The visitor may develop skills, practices and a vocabulary, only to be overpowered finally by that which is on display. The quintessential museum experience is, therefore, the result of a reflexive acting and, at the same time, an unreflective undergoing of the visit. Research in *Het huis van Alijn* (Alijn's House), a museum of urban folk culture in Ghent (Belgium) has made it clear that this double movement between 'active' and 'passive' can be established by observing people in the course of their museum visit.[2] Filmed recordings of museum visits show how participants slow down or stand still when they recognize certain artefacts, or when a historical context is offered, possibly by the attendants. However, the appreciation of this double movement is especially sharpened by a particular room in which museum visitors are themselves invited to identify the original uses of objects. This room, the Identification Room, forms part of the standard museum visit, so that every visitor normally passes through it. In the room stands a table with objects from the collection placed upon it. The origins and former uses of some objects are known by the museum staff, but in other cases the original use or meaning is a riddle, both for visitors and for the staff. So visitors are invited to write down on a piece of paper what they think they are about. As an extension of this public space, staff members also take suitcases full of artefacts to homes for elderly people so that residents may talk about the objects and their experiences of using them in the past. As another extension of the Identification Room, objects were publicized in newspapers so that readers could send in their own stories about the artefacts. These stories were, in turn, collected and displayed at the museum, so that new visitors could read about the different interpretations. The research suggested that this alternation between passive viewing and active interpreting serves to intensify the usage of the

whole museum. Thus, for example, the objects in a display cabinet (these are less accessible in *Het huis van Alijn*) were scrutinized further as visitors passed through the Identification Room. In other words, there are museum presentations which transform the viewer into an active participant who starts co-constructing the meanings of things. Or in the words of Gomart and Hennion: '... a sculpture exhibit does not bring together already existing objects, subjects and social groupings — rather, this is a conjunctural event in which the relevant objects, subjects, and social groupings are co-produced' (Gomart and Hennion, 1999).

Thus, without an active gaze, hardly anything is experienced or observed. Gomart and Hennion's sociological insight derives from Actor-Network theory (ANT), which differs from other sociological approaches such as phenomenology and from more structural approaches such as that which is associated with the well known work of Pierre Bourdieu (1979). ANT sees individuals as particular and dynamic actors who can, up to a point, overcome their social background, and are certainly not fixed or imprisoned in their own historical frame. On the contrary, every experience can be a part of an active learning process in which the singular actor develops and even re-articulates their personal mode of attending to the world. In this case, this also means that the relationship between museum and society is a dynamic one in which museum displays can always reach out to endow the visitor with new skills which will help him in redefining his perceptual grid. But on the other hand, the museum will also learn from developments in the wider society to construct other presentation formats. The development of viewing and listening skills generates an observation grid for the visitor by means of which the environment is interpreted. Museum presentations may

2 The general research question was about the presentation and perception of cultural heritage: how is cultural heritage presented in Flanders (the Dutch speaking part of Belgium) and how does the public perceive it? The research started in 2002 at the Centre for Sociology of Culture of the Catholic University of Leuven (Belgium) and continued into 2005. Its main aim was to develop ideal types of presentation models, considering the targets of museum personnel and heritage brokers on the one hand, and the social background of participants on the other hand. The research was mainly based on qualitative methods such as in-depth interviews with museum personnel, heritage brokers and visitors, and the filming of displays and their viewers.
This was done by one post-doctoral researcher with the help of his supervisor and students. Ten cases were selected following selection criteria of the time period, target groups of the museum, 'high' versus 'low' culture, the display format (e.g. use of ICT, extraordinary formats), religious versus secular heritage, etc.

go along with that grid or they may even attempt to change it. In the absence of an 'optimistic' or non-deterministic and dynamic perspective on the social actor, such as that of ANT, the mutability of visitors' frames of reference will always seem to be relatively limited. For it is evident to the sociologist that the spectacles through which reality is viewed remain largely constructed and fixed by everything which Pierre Bourdieu (1979) refers to as primary (upbringing at home) and secondary (education at school) socialization. Sociologists Gordon Fyfe and Max Ross started from these premises in their research on museum visitors (1996). By means of in-depth interviews with families of different social backgrounds they found out that the interpretive reference frame of people visiting a local cultural historical museum differs significantly from that of people visiting a museum of fine arts. The researchers established that the people in the first group are chiefly looking to locate their own existence within a spatio-temporal framework. Exhibitions in cultural history museums serve as a reading grid to confirm the local embeddedness of the visitor. The visitors to a regional cultural historical museum, therefore, are mainly focused on the local histories and events of their local community. It is exactly this local 'interwovenness' that grants the artefacts on display a significant meaning so that the boundaries of a visitor's own territory are thereby seldom exceeded. In contrast, Fyfe and Ross identify the so-called 'trans-local visitor': the man or woman who looks beyond the local *Gemeinschaft*. The boundary-exceeding approach of a museum for fine arts better fits this segment of the public, because their familiar spatio-temporal viewing grid is reconfirmed by the 'trans-local' context of the artistic institution. The museum serves as a source of inspiration in the quest for new ideas that push back the horizon of the professional fine arts visitor. This visitor, who views the world more easily through 'trans-local' spectacles acquired by virtue of his education, training and profession, is characterized by a relatively high degree of detachedness from the local (Fyfe and Ross, 1996). Thus, to a certain extent, what a museum presents can confirm the habitus of the visitor and can play a role in social reproduction and the constructions of identity within specific social strata.

The majority of visitor studies start from the above mentioned premises, namely that there is a causal relation between social background variables and cultural participation. Fyfe and Ross refine that insight by looking at the nature of the local interwovenness: they ask, for example, whether the participant has always lived in the same place, or whether he is an outsider (Fyfe and Ross, 1996).

Social background characteristics and the individual's geographical trajectory both strongly mark the observation grid of the museum visitor. In themselves, these kinds of studies are beyond reproach, for they provide important insights into visitor participation patterns. However, despite their virtues, these studies rarely take into account the distinction which is made here between modes of participation and modes of presentation. For this reason, this kind of research has sometimes been overtaken by new developments in the field. For example, some museums now stage the past by means of all kinds of cross-over techniques for combining so-called high and low culture, and international and local frames of reference. Social anthropologist Sharon Macdonald, for one, demonstrates how the Transcultural Galleries at Cartwright Hall in Bradford, England, present a layered image of a local community by means of presentation methods that transcend the distinction between fine arts and crafts. On the other hand, contemporary artists are engaged to intervene at exhibitions (Macdonald, 2003). In Belgium this is again illustrated by *Het huis van Alijn*, where contemporary visual artists, cartoonists, poets, writers and others are called upon to tell the folk history of a town. Such aesthetic presentations certainly presuppose a different public. The visitor is approached differently, at least, and is addressed by means of another grid of possibilities.

Towards a Chronotopy of the Museum

As already argued, history and heritage do not simply appear in the consciousness of museum visitors. What is perceived as relevant history or heritage is offered to the visitor as an artefact or as an event of some historical importance. The mediator decides what is worth inheriting, so to speak. The occupations of historical mediators, subsidized or not, and perhaps also those of memory workers, official or not, locate what is valuable from the past, and what has historical or eventual relevance on a scale. In fact we often encounter the latter as an argument in exhibition catalogues, discursive presentations of museum collections, or introductions to historical documentaries. What is important about the past is determined by the agenda of the present. Meanwhile, historical events and objects are staged with the dramaturgical means of today. Time and space are said to be the two central ordering principles serving this purpose. Given that, for Western modernity, both dimensions constitute the most important coordinates of human experience, this should come as no surprise (Benjamin,

1996). The perception of the past as well as that of everyday events are given meaning within a spatio-temporal grid. In order further to qualify the relationship between museum displays and the visitor as inhabitant of a global world, this frame has to be refined. This can be done using the notion of chronotopy used by Russian theoretician Mikhail Bakhtin in his posthumously published study of the novel to disentangle the different connections between time and space in that literary genre (1981). Chronotopy means that both dimensions are treated as symmetrical and absolutely interdependent. The experiences of time and space are unconditionally connected and, at least from a theoretical point of view, need to be treated as equivalent analytical concepts. They constitute the observation grid by means of which cultural products, which in the case of Bakhtin were mainly literary, relate to the cultural context within which they are produced as well as perceived. In the case of display theories, visual culture, historical theory, visitor studies, at least three general ways of connecting time and space which are of relevance for studying the museum world can be identified. They are local time, global time and glocal time.

Local Time

A conception of time which is especially relevant to the museum world, and which in the West has constituted a dominant chrono-topy, is linear time. History, conceived in this way, is presented as a chronological succession of events that can be clearly placed along a time-line. Formal history still makes use of this time dimension; it may suffice to recall, for example, the time-line from prehistory until the present day that is represented on the walls of elementary school classrooms. However, not only schools, but also quite a lot of museums make use of linear time as a practical guide. The first room of a museum route invariably starts with period x and we end up many years or decades later with artefacts from period x+1. The past is almost mathematically surveyable and subdivided into little compartments. Such a mode of presentation makes us experience the past in a certain manner. The past is first and foremost a pluperfect time, meaning a closed period for which the story is fixed. The history of how things actually were is known and no longer permeates the present, whilst no one could imagine that a present would still be able to intervene in the past. Chronological narration thus claims an absolute past which in fact is monochronous. Such presentation barely tolerates a personal point of view or a particular vision. One cannot

touch the past, which is impersonal and sacrosanct. Historical events or heroes receive their importance or grandeur from the very fact that they belong to history. The tautology decrees that the past itself is the source of their 'authentic' reality or value. This form of historical narration functions according to the mechanism of the memorial: the history that is narrated is at the same time memorable or consecrated. The American sociologist of performance art, Barbara Kirshenblatt-Gimblett, refers to such presentations as in-context displays. Objects are shepherded in a discursive regime, whereby it is not their own performative strength, aesthetic value or eloquence that most matters. Rather, artefacts are only (re)animated by the story in which they are introduced or the historical knowledge that is released about them. In other words, what is displayed is only an illustration of the discourse that is set up (Kirshenblatt-Gimblett, 1998). In an absolute historical presentation, whatever is to be known about the artefacts has to be taken as the only 'true' interpretation. The model is based on the classical communication scheme in which a message passes noiselessly from sender to receiver. Such a model presupposes a passive participant who barely interprets, and who neither transmutes the things nor moulds them to his own will. It implies a museum visitor who, for certain, does not inhabit the history or geographical setting in which the event occurs. Such a presentation offers the special advantage of telling a lucid story which provides the viewer with a solid grip. Moreover, it may provide objects with a meaningful frame, for as suggested, performative strength lies outside the artefacts which are only given life within their discursive setting. In addition, they derive their historical weight from the place where they are displayed (the museum) and the authorities and experts surrounding them. To explain the success of the chronological narrative line would require research in itself, but one thing may be said without much doubt: from a tender age we are socialized within the idea of causality and chronological succession — witness the classroom timeline. Monochronous narration certainly has an important pedagogical and educational value.

The careful unwinding of time over a linear path often goes hand in hand with an equally meticulous spatial delineation. Historical adventures are unwound within sharply delineated places which are locally traceable. The story of that alliance between chronology and geography has been widely described (see for example Gathercole and Lowenthal, 1990). In the romance of the nation state not only historical scientific analysis, but also ethnology has been readily

used as an instrument within a geopolitical setting. Soil and people merge together in an inextricable choreography of the *Gemeinschaft*. Historical figures or characters are not coincidental residents of an estate. Rather, they are its inhabitants in the sense that they live in and through their environment. Moreover, the geographical setting lives through the medium of community, for the soil counts as the most important bearer of the tradition and the histories of its inhabitants. Roads, paths, trees and buildings constitute the heritage of the ancestors and the links that connect successive generations with each other. Consequently, moving a road, felling a tree or demolishing a building constitutes an attack on the past and also on the continuity of the community. Though this chronotopy is no longer taken seriously by the majority of historians and museum personnel, it is hard to deny that it still acts on the sentiments of some museum visitors. Though it may no longer have much to do with a (geo)political perspective, time and locality are often unconditionally connected. This is reflected for example by the heated discussions regarding a central depot for heritage associations from different parts of a region or the sometimes tedious negotiations by a municipal museum for the loan of works from local museums. The members of heritage associations and people concerned with local (ethnological) museums are often quite attached to their local connections, and sometimes rightly so, as many artefacts become meaningless when they are plucked out of the environment that impregnates them with meaning. Meanwhile the alliance between time and locality, hence 'Local Time' generates a chronotopy that matters for museum visitors, and perhaps chiefly so for 'heritage activists'. Likewise, the spatio-temporal grid remains intact for many 'history-loving souls', when histories are staged on a larger scale in a town or country. It is, of course, widely known that in the latter two cases chronotopy is quite often exploited for commercial reasons such as city marketing, or for political purposes by the nation state.

Global Time

The opposite pole of Local Time is of course Global Time. Whether we like it or not, in the last decade the concept of globalization has been popularized as the master key to social analysis. The frequent use of the notion in various contexts and with diverse meanings has rendered the concept into a rather colourless and perhaps negative definition of social change. Thus, globalization often conveys an understanding of social change as the loss of the local. Roots, in the sense

of people's local roots, become roads, while authentic landscapes, village views, and city squares make way for non-places such as airports, parking lots, uniform shopping malls and the inevitable McDonald's. And in the case of the museum world, we have an institution such as the Guggenheim. In fact globalization often seems to go hand in hand with that other polyvalent concept from the seventies, Americanization. Here we come to a second, crucial chronotopy, as the experiences of time and space interact with each other in quite a different way within a global setting. The markers of time do not claim authenticity which is tied to the soil, but rather they claim universality through identical key points which spread worldwide and thereby install instantaneous time. The latter concept of time is borrowed from the English sociologist John Urry. In *Sociology Beyond Societies* (2000) he describes the experience of time, amongst other things, as the effect of rapid information and communication means that see to it that similar kinds of information spread almost simultaneously over the entire planet. Moreover, within this space of flows, technological developments and hyper-smooth modes of transportation generate a cluttered procession of artefacts between highly divergent cultures. The availability of cultural goods eases them away from their place of origin. So we no longer need to travel in order to eat Pakistani food, buy Chinese clothes or look at African masks. Moreover, the spatio-temporal interpretation grid is made uniform by means of the ever-increasing 'modularization' of education, training, labour and leisure time (Urry, 2000).

The customary 'heritage' presentations associated with this chronotopy are widely known: Disneyland in the United States and Paris, or Mini-Europe and the entirely simulated historical scenery around the Brussels Atomium in Belgium. The rationality of the historical chronology makes room here for an emotionally experienced 'pastness'. Because everything revolves around the direct experience of the past or a touch of the past, correct data, right locations and historical context do not really matter. Time no longer serves as an educative organizer of the heritage experience, but as an animator in which one may lose oneself for a while. The event or sensation gives the participant a flush of past-ness. Far from the aforementioned monochrony, such presentations simulate a history that comes within reach. So it is no coincidence that these Post-Fordian heritage presentations often make use of techniques of mediation which appeal to all of the senses. The remote scientific gaze is exchanged for, or at least compensated by, scents, sounds, and especially a variety of

tactile stimulants. The participant is literally besieged on all sides by a simulacrum of the past.

Historical tourism and other forms of commercial exploitation are often denounced as the causes of such heritage presentations. Hence, Disney becomes an easy target for those of its critics who judge the theme park to be a 'perversion' of the past. Yet history and economy do not necessarily conspire to generate this chronotopy, for the predecessors of simulated heritage cannot be traced to commercial motives alone: dioramas, style rooms and other mimetic recreations of historical settings are well known examples of museum presentations that also appeal to a total experience. Kirshenblatt-Gimblett takes note of that genesis of historical presentations in *Destination Culture* (1998), where she contrasts the in-context displays mentioned above with in-situ displays which favour experience at the expense of historical knowledge. Long before computers existed, these presentations were already simulating a virtual world. The heritage effect is based on the ambience of a travel experience and the pleasure of entering a different way of life. The participant feels that he is a nineteenth-century explorer, and is able for a moment to step into the life of another. The core of the illusion in this chronotopy is the feeling of being able to travel through time without a time machine. The possibility of movement through space is confused with time travel.

Notwithstanding the simulacrum however, it is hard to deny that many museum visitors are seduced by this call of the past and that heritage brokers are aware of that. Some of them, therefore, play with the possibilities of a total experience in order to lure a larger public. For example, museums will make use of anything from scents and soundscapes to virtual simulation machines. An examination of a sample of about two hundred public presentations by museums and other heritage projects revealed that the most of them did not mention the historical period with which they were concerned in promotional materials such as programmes and leaflets. Likewise, a large proportion of museums and heritage mediators seem to prefer to tempt visitors with an enigmatic sense of 'pastness' rather than a lucid past.

Glocal Time

Whereas the past is out of reach in the monochronous narrative, a Global Time simulates the notion that we can step without a hitch into a time machine. However, notwithstanding the great difference in historical experience both presentations follow the same strategy,

for they both deny their own role in mediating between present and past. Within the first chronotopy the expert, usually a historian, effaces his own labour of construction by creating the illusion that historical facts 'speak for themselves'. In the second spatio-temporal frame, the mimetic illusion denies that the past is staged. The Simmelian account of mediation introduced at the beginning of this essay is not reflected by either of these two heritage presentations. Herein lies the very essence of our last chronotopy, which is called Glocal Time. The realization that there exist different localities also generates the consciousness of multiform times. In other words, every locality has its own time. Nevertheless, those same localities can have an international character when they are connected worldwide with other localities. However, it should be noted that only the connection determines a synchronous time experience. For example, the opening hours of the only cafe in a small village may determine the rhythm of a local community. However, that same time goes by differently for employees at the stock exchange in London, New York and Tokyo, who exist within the same chronotopy in spite of their geographical distance. However, this can be quite a different thing to a virtual community chatting away with each other amiably next door to the stock exchange buildings in the respective cities. So it is important to understand that our conception of both time and space comes into being through connections. Our conception of space, like our experience of time, depends on the network or configuration in which we find ourselves. If, after their day's work is finished, our London, New York and Tokyo stockbrokers visit a local pub, they are also entering into different time and space coordinates.

The very consciousness of the diversity of people's own times generates a new, polyphonous, view of days gone by, and different heritage presentations may continuously come up with ever different time loops. In contrast to Global Time, which departs from an absolute relativism, reducing history to an enigmatic 'pastness', a Glocal Time generates the consciousness of diversity. This also constitutes an entirely different conception from the first chronotopy, which organizes history according to one absolute principle, namely monochrony. Apart from the realism of chronological narration, and the absolute relativism of mimetic staging, Glocal Time installs what might be called a relative relativism (Latour, 1993). This is brought about by showing that there exist many experienced pasts, and that access to a specific past depends on the instruments of disclosure that are used to enable it. Hence, the museum personnel may draw their

conclusions from the Simmelian account and exhibit their own role: their staging of the past is put forward as one of the possible stagings. It shows a picture of itself and is thereby reflexive. In other words, the gap between a historical event and the way it is currently presented is dramatized.

The above mentioned complex narration of heritage is what is referred to as the 'novelization' of the past, a notion which, again, is inspired by Mikhail Bakhtin (1981). In his literary research, Bakhtin contrasts the novel with the epic genre. In the case of the latter genre, the adventure unrolls monochronously within an absolutely un-reachable past. The great epic or story of the untouchable hero stands central. The novel, on the other hand, is polyphonous: not only are temporal coordinates shuffled but, and this is crucial for our argument, maximal contact with the present is staged by means of an open ending. The narrated event is connected with the present by means of which a vital contact with an incomplete, yet evolving, contemporary reality comes into being. The open ending of the past provides for a connection with the present by means of which the literary genre accentuates the sense that history has not yet ended. In other words, the 'novelization' infects the past with a spirit of endless incomplete-ness. Bygone days are placed in the extension of a daily flow of events. Through the connection with that contingent 'everydayness' the past is also injected with it. There is no first word any more because the last one has not yet been spoken. This principle of the novel is what we see at work in some heritage presentations. For example, *Het huis van Alijn* deliberately carries the subtitle 'the museum of things that (never) pass'. It is precisely that 'never' between brackets which sym-bolizes the ambivalent and reflexive attitude of an institution which oscillates hesitantly between present and past. When, by contrast, we are dealing with a museum of things that do pass, we fall back into the old chronology of a distant past. A museum of things that never pass, on the other hand, appeals much more to a sense of 'pastness'.

Chronological narration is broken open through the noveliza-tion of the past. The distance between the present and bygone times disappears, not because one can travel without problem through time, but because the present day is located as the extension of history, or rather a multitude of histories. The strategies that museums use for such presentations of the past also display similarities with the style characteristic of a novel. On the one hand, curators use the aestheti-cization of the past, which is enabled through rendering exhibition formats relative. For example, artefacts are no longer only displayed

along a time line; the aesthetic requirements for combining objects are also taken into account. In *Het huis van Alijn*, the arrangement of objects takes place in permanent consultation with a visual artist. An aesthetic bias obviously makes far more configurations possible than a mere monochronous narration. And artefacts are freed from their historical corset by means of a formal play of presentations which also increases the number of interpretative possibilities for the participant. On the other hand, laughter breaches the distance from the past. This second strategy of irony, parody and travesty knocks the heroes, gods and demigods from the absolute past off their pedestals. Such an approach can be discovered in the Belgium Museum of Contemporary Art in Antwerp, where young artists were asked to make so-called 'interventions' in works of the permanent collection. Guests may select works from the collection which they deem 'relevant' and place them in the exhibition space. However, they can also push a collection aside and use it as background for their own artistic project. This often brings about a sort of visual and playful comment on museum pieces. Consecrated artists from the past are thrown off their historical pedestals, but at the same time their very identification constitutes a sort of tribute. In fact, their interventions function like a joke, as Paolo Virno (2008) describes this in relation to innovation. But this will be explored in the following essay. What is important is that laughter, irony, parody and travesty enable a space of open questioning that brings historically consecrated artists and artefacts into an unusually familiar proximity with contemporary artists. This leads them to a 'fearless' zone of observation and investigation. It generates a general feeling that 'it is okay to experiment with the past'. It is exactly this Socratic irony and dialogue that make free research possible, according to Bakhtin: 'Familiarization of the world through laughter and popular speech is an extremely important and indispensable step in making possible free, scientifically knowable and artistically realistic creativity in European civilization.' (Bakhtin, 1981)

The monologue about the past in the aforementioned playfulness is bent to a dialogic imagination. This notion, according to Bakhtin (1981), makes it clear that every meaning can only be seen in relation to other meanings, and that there is permanent interaction between those meanings, so that they also transmute throughout time. In the dialogue a word, a discourse, a culture or a history is made relative, 'less privileged' and at the same time more unstable. It should be noted however, that making something relative does not mean 'minimizing' it. On the contrary, it concerns how we

'constitute a dialogue with' or literally 'relate to' that something. Thus consciousness of a continuous struggle for definition about the same things comes into being. With respect to the historical facts, the 'novelized' museum presentation enters into a dialogue with the past, thus presenting the visitor with an especially complex chronotopy. Not only is he given a historical interpretation, but that very interpretation is also on display in the presentation. The historical staging is literally presented as dependent on time and place. From this grows the realization that the past is time and again given meaning by an ever-moving present.

A Display Example:
In Flanders Fields

All of the above may sound a little abstract, but the example of In Flanders Fields Museum, may make things more concrete. In Flanders Fields, tells the story of the First World War (1914–1918), which is a time, in the Belgian town of Ieper (Ypres), which is a place.[3] Both of these ingredients, those of date and place, constitute the central time-space coordinates of the presentation. We can define this chronotopic as an example of local time. Indeed, we are provided with basic information about our place in linear time and about the concrete location. Nevertheless, other chronotopics are presented apart from these. For example, at the entrance of the museum, the visitor receives a card with the name of someone who played some kind of role in Ieper during World War I. By subsequently inserting the card in different computers, chronologically installed along the museum trajectory, the visitor receives biographical information about 'his' character. This chronotopy follows different time and space coordinates to those of the aforementioned grid. The life that is told usually begins before the tragic events of the Western Front and continues thereafter, unless the person in question is killed in the battle. Moreover, the character may come from a different place and only reside temporarily in Ieper, later on to emerge in yet another location. In other words, the biographical story follows a different chronotopy than that of the factual historical parameters: 1914–1918 at Ieper. In fact we are dealing here with a possible presentation of glocal time because the experience of a grand history (the First World War) is particularized. The visitor gets an idea about how the human disaster was experienced in different ways by different people whose different biographical paths simultaneously evoke other time loops.

In addition to all this, In Flanders Fields Museum regularly

calls on contemporary artists to (re)interpret the events of the beginning of the twentieth century. This often leads to artistic presentations that bring certain universal themes, such as 'war is of all times' or 'the human tragedy' to the fore. This is the very message we receive as we enter the final section of In Flanders Fields: the first modern war, we are told, was not the end, but the beginning of many new wars. Moreover, the tragic events of the past can teach us lessons for the present. With this latter suggestion, the war museum sets itself up as an advocate of peace. The coordinates of time and space, depending on which is the last story to be told, are no longer linked to time and space, for war is now seen as common to all times and a universally deplorable event. This brings us to the above mentioned global time. At times this universalism takes the upper hand at the museum and the visitor who is interested in an economic and political introduction to the First World War may have a hard time finding what he is looking for. The political situations in, for instance, Germany, as well as the economical situation in Europe, are submerged under the universalistic peace message of the museum. In other words, it gives little sense of the wider development of local time (economical and political facts) or glocal time (different interpretations made at that time by, for example, Belgians and Germans about the economical and political situation). This lack of context gives world war the aura of some natural disaster hanging unconditionally above our heads.

In the Museum's different stagings of one historical event we can detect three different general chronotopics. However, whereas some stagings are more developed in their presentation, others are submerged in the dramaturgy. The crucial thing is that the visitor finds points of contact with one or more of them, or perhaps with none of them. Thus, he may let the visit pass by without meaning, due to the lack of a spatio-temporal presentation grid. Social background characteristics as well as the staging of displays see to it that the visitor is attracted by one or other chronotopy. The well-educated world traveller is, for example, more sensitive to glocal time, because he

3 Ieper (Ypres), a small Flemish market town close to the French border, was the scene of some of the worst fighting during a series of three major battles on the Western front during the First World War. Whilst the combined casualty figures for the German and Allied armies are a matter of dispute, the consensus is that at least 550,000 soldiers and thousands of non-combatants were killed. The town was virtually destroyed. Flanders Fields Museum is an award-winning interactive museum which was re-opened following a major refurbishment of the old World War museum in 1998, and which interprets the Great War at Ieper.

understands that different places can have different time experiences. By contrast people who hardly leave their small town, and whose access to the wider world is primarily by means of their televisions, are more sensitive to global time. Of course not all visitors conform to this black-and-white distinction. A lot of visitors can be attracted by several chronotopics and the intelligent exhibition-maker is able to play with those divergent spatio-temporal frames: he can let them merge into each other or accompany each other temporarily, after which they may again go their separate ways. It is then up to the visitor to pursue or not pursue certain coordinates, or to eventually return and combine time and space presentations. However, it should be noted that the notion that the museum visitor has a single and monolithic identity does not conform to reality. A historian, for example, will visit In Flanders Fields with a different expectation pattern than, say, the son or daughter of a war veteran who was actually there in 1917, knee-deep in the mud. And to make the analysis more complex: there are also historians whose fathers were shooting or whose mothers were nursing in 1914 at Ieper. It is precisely this subtle or 'layered' vision of the participant that deserves our attention. The particular ways in which museum visitors appropriate what is presented, and may go on to tinker with and nuance their own identity, is emerging as both an interesting and important question.

'Multi-Chronotopic' Museums and 'Multi-Chronotopic' Visitor Studies

This essay began with Simmel's notion of historical mediation and concluded from this insight that 'classical' visitor studies often lack a relational point of view. They relate the social background of participants only to what is presented and not to how history is told by museums. That is why many visitor studies are overtaken by developments in the field. Today, some historical institutions try to attract different layers of society by developing a polyphonic display strategy. This essay tried to capture this by developing a relational perspective on museum professionals, their displays and the visitor. Bakhtin's notion of chronotopy has proven to be particularly useful in conceptualizing the relation between historical presentations, museums and visitors. A theoretical exploration and analyses of displays reveal that we can discriminate between at least three general chronotopics, namely local, global and glocal times. The example of the displays at the First World War museum, In Flanders Fields, shows how different chronotopics can be presented in a display of the same historical

events. It provides the visitor with several ways into the story. The concept of chronotopy has the potential to help museums to be more reflexive about their own praxis. Which chronotopics, for example, are presented, and which are absent or are less developed? For visitor studies, the idea of chronotopy can be helpful to gain a deeper understanding of visitors themselves. Which chronotopics flourish amongst the public and in society more generally, and how can they be expressed in museum displays? The museum of the future will be a 'multi-chronotopic' museum. This will be a museum which aims not so much to attract as many visitors as possible, but rather one which seeks to enlist a differentiated multitude. In order to develop the museum reflexively in this direction, 'multi-chronotopic' visitor studies are necessary, and can help us to understand the important mediating factors between museum and society.

Bibliography

Bakhtin, M.M. (1981). The Dialogic Imagination. Austin: University of Texas Press
Benjamin, W. (1996). Selected Writings, Volume 1: 1913–1926, ed. M. Bullock and M.W. Jennings. Cambridge, Mass. and London: Harvard University Press
Bourdieu, P. (1979). La Distinction: Critique sociale du jugement. Paris: Les Editions de Minuit
Fyfe, G., and M. Ross (1996). 'Decoding the Visitor's Gaze: Rethinking Museum Visiting'. In Theorizing Museums, ed. S. Macdonald and G. Fyfe. Oxford and Malden: Blackwell Publishers
Gathercole, P., and D. Lowenthal (eds.) (1990). The Politics of the Past. London and New York: Routledge
Gielen, P. (2000). Kleine dramaturgie voor een artefactenstoet: Omtrent 'Gent Cultuurstad'. Ghent: Dienst Cultuur
Glaser, B., and A. Strauss (1967). The Discovery of Grounded Theory. Chicago: Aldine
Gomart, E., and A. Hennion (1999). 'A Sociology of Attachment: Music Amateurs, Drug Users'. In Actor Network Theory and After, ed. J. Law and J. Hassard, 220-47. Oxford and Malden: Blackwell Publishers
Hennion, A. (1993). La Passion musicale: Une sociologie de la médiation. Paris: Edition Métailié
Kirshenblatt-Gimblett, B. (1998). Destination Culture: Tourism, Museums, and Heritage. Berkeley, Los Angeles and London: University of California Press
Laermans, R., I. Vos, and P. Gielen (2003). 'Erfgoedeffecten'. Museumkatern 18: 44-48
Latour, B. (1993). We Have Never Been Modern, transl. by C. Porter. Cambridge, MA: Harvard University Press
Lowenthal, D. (1998). The Heritage Crusade and the Spoils of History. Cambridge, UK: Cambridge University Press
Macdonald, S. (2003). 'Museums, National, Postnational and Transcultural Identities'. Museum and Society 1 (1): 1-16
Simmel, G. ([1892, 2nd ed. 1905] 1977). The Problems of the Philosophy of History: An Epistemological Essay. New York, The Free Press
Thrift, N. (1996). Spatial Formations. London, Thousand Oaks and New Delhi: Sage
Urry, J. (2000). Sociology Beyond Societies: Mobilities for the Twenty-first Century. London and New York: Routledge

Virno, P. (2008). Multitude: Between Innovation and Negation. **Los Angeles:** Semiotext(e)

Vos, I. (2003). 'Een exploratieve matrix van erfgoedinitiatieven'. In Cultuurkijker: Aanzetten voor cultuuronderzoek in Vlaanderen, **ed. R. Laermans, J. Lievens, and H. Waege. Antwerpen: De Boeck**

Memory
and Event

'... the real or the actually happening seems to be very much a mixed class containing events perceived within a primary perspective and also transformed events when these are identified in terms of their status as transformations. And to this must be added the real that is construed retrospectively – brought to mind because of our way of defining something as not qualifying in that way.'
Erving Goffman

The event is a phenomenon that comes in for a great deal of attention in the Post-Fordian spectacle society, and therefore also in the art and heritage sector. Critics speak of a real 'eventization' in the art world and in heritage conservation. One newsworthy happening follows the other, or there are many going on at the same time, so that they inevitably compete with each other. The event is now the most common formula for revealing the past. This has a lot to do with the way media attention to the new infects other sectors. The art sector, too, lives by the grace of the new and the up-to-date (see also Gielen and Laermans, 2005), ranging from the temporary exhibition about the permanent 'dynamism' of a vast museum collection, to large-scale international events such as the biennales already described. Theory about the concept reveals, however, that an event can only be labelled as significant in retrospect (see for example Badiou, 2004; Böhrer, 1994; Goffman, 1974; Lazzarato, 2003). The planning of an event therefore suggests that planners have an eye to a hoped-for effect. Within the cultural industry, the aim of curators, heritage profession-als and other cultural mediators is that the public revelations they or-ganize will later be recognized as significant and remembered as such long afterwards. The event therefore embodies a dream that can only come true after the fact. Of course there are all sorts of strategies for giving an occasion more chance of success and making a major event of it. Making sure it gets plenty of airing in the media and an impres-sive discursive framework around it that emphasizes its newsworthy and perhaps international uniqueness, are among the possibilities for presenting the event as remarkable in advance. But even when every-thing possible is done to raise the occasion to the status of an event, there is always the risk of failure. And if it doesn't achieve the status of event, the greater is the disenchantment. The organized occasion

gets lost in the unread annals of history. It appears to have been waste of energy and sometimes also of large sums of money. The successful event, on the other hand, makes sure that the public questions the evident reality or perceptual framework. According to Italian thinker Maurizio Lazzarato, two things happen at once in such an event. On the one hand, we discover during the event itself that the reality around us or the way we perceive it has quietly become intolerable. And on the other hand, it opens up new possibilities. Something that has always been present virtually is suddenly made visible through the event and becomes a real possibility (Lazzarato, 2003). The key point is therefore that the event creates a sense of possibilities. It causes a shift which opens up new frames of references. This may well be the most positive characteristic of the successful event.

The meaning of the event will be further explored here in the light of the insights of the American sociologist and symbolic interactionist Erving Goffman (1974). How can an everyday situation or obvious context be 'reframed', in Goffman's term, and what are the keys to this process? With this theoretical starting point, we also attempt to escape from the pejorative connotations that the term so often has these days when it is used in discussions and critiques. After all, the aim is not a moral evaluation but a subtle analysis of what makes an event functional (or not, as the case may be) for the art and heritage sector.

The Event
in Theory

Goffman provides a systematic analysis of the transition between frames of reference that takes place during an event in his weighty classic, *Frame Analysis: An Essay on the Organization of Experience* (1974), which describes the strategies people use to move from one frame of reference to the other, in which the concept of keying plays a central role. Although Goffman refers to a number of historical examples such as the French Revolution and a Greek comedy, he mainly focuses on the micro level of everyday life, with a preference for mundane interactions such as a handshake, a wink, an accident or a chess competition. In the tradition of symbolic interactionism, Goffman concentrates on face-to-face interactions. Here, his insights will be applied to artistic and historical events, our understanding of which is enhanced by the notion of keying, described by Goffman as a process by which a set of conventions that gives meaning to an activity is transformed into another set. And this in turn changes the meaning of the same

activities. For example, a fight on the street is very different to a fight in the boxing ring. A key or an event can bring about a sudden transition from one frame of reference to another by a process of 'recuperation' or reframing. To give a simple example: Consider an artwork by the Belgian painter Luc Tuymans, in which only the crown of some trees — they look like firs — is portrayed in blue-black on vertical lines. What we see is actually an almost banal depiction of the trees from a frog's perspective. But if we look at the label next to the painting, we read 'Schwarzheide, 1986, oil on canvas'. This message could have various meanings. Two things are established, at least: the painting we are looking at is indeed the work of an artist, and the material used is oil paint. The year we take to be when the artist completed this work. So far, there is nothing remarkable. But what does 'Schwarzheide' mean? The name might ring a bell for people who lived through the Second World War: Schwarzheide was a Nazi concentration camp, located in a forest. This knowledge, offered via a key on the label, shifts the painting into a whole new frame of reference, within which it gains a very loaded meaning that makes it almost impossible to return to the first frame of reference — Goffman speaks of the primary framework — although this still exists. Whenever we see the painting, we almost automatically open that second meaning register which refers to the Second World War. The rather abstract depiction of a few fir treetops is beside the point. Just like thematic exhibitions, in the art world, labels often function like a key to change the way we see things. But the point here is that keying is a method for bringing experience into a different frame of reference, through which we get a grip on what has happened and can take up a standpoint on it. In this regard, Goffman notes that all forms of 'keying' imply both a reduction and an increase in the complexity of the experience. On the one hand, the key adds a new frame of reference, but at the same time it prevents other possible registers from cropping up, at least for a while. The historian, too, 'keys' in to the same effect at a historical event. In *What is history?* British historian Carr puts it like this: '... the fact remains that the historian must work through the simplification, as well as through the multiplication, of causes. History, like science, advances through this dual and apparently contradictory process.' (Carr, 1961)

Goffman outlines five basic keys which are frequently used in our society for capturing events: make-believe, competitions, ceremonies, technical redoings, and regroundings. It is important to note that the same event can be 'processed' with several of these keys, and that a combination of keys is also possible.

114

Make-believe

This principle is based on what Goffman calls playfulness, in which actors step into a fictitious space knowing full well that the event is not reality. The event is indeed a construction (or reconstruction), and examples include a war game, a game of battleships or historical video games. Real-life reconstructions, such as that of the battle of Waterloo, are among the possibilities. The point is that via this game the original event is made accessible or comprehensible. Whether the understanding of it that is created matches the historical facts is beside the point. Make-believe ensures that the participants separate themselves from contemporary reality through following certain rules of the game. For the historical event, this means a rule whereby people assume that elements of the event are an authentic reconstruction of the historical facts. Through this key, the participants acquiesce in a fictitious world in order to replay the event, which is thus eventized in an extremely active manner. The best-known form of make-believe in the cultural sector is known as re-enactment, and it makes use of a historical in-situ décor as a frame for giving meaning to the activity. Goffman's terminology enables a more subtle analysis of this form of theatre, though, as his next two keys, competition and ceremony, also make regular use of re-enactment, albeit with important differences of nuance.

The Competition

Goffman's second way of framing an event is the competition, which includes sporting events ranging from boxing to fox-hunting. Such contests share a violent model with fighting (or hunting) centre stage. But there are rules that keep the aggression within certain bounds. This type of key differs from its counterpart, make-believe, in its real ending: the sparring partner in a boxing match gets real blows and the hunt ends with the fox really getting killed. However, this is only possible and permissible within the frame of the competition, be it boxing ring or hunting season. These form the frame within which the activities acquire meaning and social acceptability for both participants and bystanders. It is but a small step to extend the application of this type of key to the world of the memory. After all, competitions regularly refer to historical events. A good example of this is the whole discussion in Great Britain about whether to ban collective fox–hunting. One of the arguments used against animal-lovers and

activists was that the hunt is not only a favourite leisure pursuit of the British elite but also part of a cultural heritage. And indeed, the contest is not just about the pointless killing of a poor animal, but is also a kind of re-enactment, with historical costumes and weapons. We might perhaps even carry this one stage further and suggest that while these two examples refer to history or tradition very literally, there are also competitions that do so more implicitly. Don't the World Cup, the Eurovision Song Contest or the Olympic Games always build up the standing of the participating nation states? National borders that were often established historically with a lot of bloodshed are reaffirmed through events like these. After all, only recognized nations can participate, and a war between the countries is 'played' out, albeit in a very different form. Competitions therefore offer a frame of reference for grasping a historical event as well as for commemorating it. Goffman says, 'Some sports, then, can be identified as keyings of elementary combative activity — ritualizations, in ethological terms' (Goffman, 1974). But he goes on to qualify this: 'In developed adult games this reference is attenuated and no great value seems to remain to uncovering possible mythic or historic roots in specific life activity' (Goffman, 1974). However, the latter remark does not mean that the historical frame of reference does not really exist, even though it is forgotten in the current game.

The Ceremony

The ceremony is a third form of keying to give an event a frame of reference, and is particularly common in the world of cultural heritage. Goffman talks about the ceremony as an important key which detaches us temporarily from everyday life and puts us in another frame. He has in mind, in the first place, social rituals such as baptism, weddings and funerals, but also such events as the coronation of Queen Elizabeth. For heritage workers, the ceremony is one of the most obvious keys for processing historical and sometimes traumatic events. The category includes national days and commemorative ceremonies for the dead or for the end of a war. For Goffman, the ceremony differs from the other keys, such as the game (make-believe) and the competition, because of the importance of 'autosymbolization'. In the game and the competition, the actor takes on the role of an other, while the participant in a ceremony represents himself. In a ceremony, the role that someone or something plays in everyday life is magnified and at the same time reconfirmed. A national day reconfirms every year

116

the role of the monarch or the president. The ceremony participant's share in society, or often in a historical event, is literally portrayed or placed within a clear frame of reference. For this reason, a ceremonial event is far more solemn than a game. After all, the symbolic portrayal of the participant is at stake. What is more, if the ceremony disappears, the social representation and legitimacy of the participants evaporates somewhat, and an event in which they played a role is in danger of being forgotten. An obvious example is perhaps the annual commemoration of the Liberation by veterans, a ceremony in which the old soldier symbolizes and confirms his status as veteran in today's society. At the same time, the ritual ensures than we do not forget the historical event. However, these veterans are very worried that with the last breath of the last eye witness 'their' war will become forgotten history. This form of memory work is consequently highly personal and for this very reason can conflict with a professional expression of it. One of the reasons for this is (Dicks, 2000):

'The memorial's function is not to supply new or arresting knowledge for outsiders, but to act as a repository for the everyday memories of the memorial-makers and provide a conduit for them to be passed on down generations of insiders. Professional, exhibitionary discourse, on the other hand, addresses a tourist-spectator for whom the knowledge is new and unfamiliar, encountered in the guise of spectacle.'

The British sociologist Bella Dicks uses the term 'memorialism' for this way of dealing with a historical event. Memorialism is a particular mixture of a longing, on the one hand, to 'commemorate', and a wish to do more than that — to tell 'how things were' (Dicks, 2000). However, the attempt to do this is accompanied by all kinds of transformations of the past that sometimes take it a long way from historiographic interpretations. And the element of personal involvement also often means that memorialism goes together with moralism: the ceremony moralizes the historical event.

Cognitive 'Redoing'

Goffman calls his penultimate key 'technical redoing'. This can range from the forensic reconstruction of a murder through experiments,

exhibitions, documentaries and scientific publications to virtual simulations. Goffman (1974) describes this key as follows:

'Strips of what could have been ordinary activity can be performed, out of their usual context, for utilitarian purposes openly different from those of the original performance, the understanding being that the original outcome of the activity will not occur ... The purpose of this practising is to give the neophyte experience in performing under conditions which (it is felt) no actual engagement with the world is allowed, events having been "decoupled" from their usual embedment in consequentiality.'

In the context of art and heritage, then, a technical reconstruction 'repeats' a historical event or certain aspects of it, without creating the same consequences as the real event. The choice of the word 'technical' is not altogether apt, however. Goffman uses it to indicate the learning of crafts or skills — important ways of internalizing practical and sometimes unconscious memories, or what Bourdieu calls '*le sens pratique*'. Yet Goffman's use of the term also covers exhibitions and documentaries, whose technical character is often overshadowed by other elements such as empathy, emotion and other forms of engagement. Furthermore, such reconstructions are performative, and confirm — far more than make-believe keys do — the status of the historical event as a hard fact, based on firm cognitive foundation. One of the reasons for this is that these reconstructions are often set up by recognized experts such as doctors, researchers, experimental scientists — or, in the arts, curators, art historians, restorers et cetera. So even the discipline of history can be categorized as 'redoing'.

The point is that the cognitive element plays an important role in this form of keying, and this is where it differs from the ceremony. In a ceremony, the historical event is affirmed emotionally, by and large, while a redoing has a more intellectual basis. From now on, then, I shall talk in terms of cognitive, rather than of technical, reconstructions. This rephrasing does not of course mean that such things as emotions, values or ideologies cannot play a role in redoing. But the accent is on the knowledge element. The new frame that is

entered into via this key is only convincing through its claims to truth — about art, or about the past. The maker of an exhibition or a documentary, and even more so the historian, would put their credibility at risk and therefore their position too, if they took liberties with history. And it is precisely because this knowledge aspect plays such an important role that this key is particularly convincing. In relation to the documentary, Goffman (1974) puts it like this:

> 'In our society there is considerable (and growing) use of replicative records of events, that is, replays of a recording of a strip of actual activity for the purpose of establishing as fact, as having occurred, something that happened in the past. ... The power of the documentary key to inhibit original meanings is impressive.'

Goffman seems to have had the influence of the visual media in mind when he wrote this. The claims to truth of the snapshot and the moving image are so strong that representation and presentation are often confused with each other. Live news coverages enjoys an especially high level of credibility. Immediate and excessive coverage also often raises the actual event to the status of significant history at once.

Most exhibitions answer to the description of this kind of 'key'. The majority of representations claim to reflect a truth, whether about the meaning of an artwork or about a historical event. And a curator's authority is also at risk if he doesn't base his activities, at the least, on a genuine claim or a historical fact. In other words, the knowledge aspect plays an important role in the art sector. The fact that a lot of people working in the art and heritage sector today have qualifications in archaeology, history or art history, may well have something to do with this. And as a result, historical studies determine to a fair degree which keys have legitimacy within the sector. Or rather, they certainly create a certain tension between historiography and the artistic and heritage regime, between the sometimes complex historical or art-historical material and the demand to make it accessible to a broad public, or between the historian and the trend-conscious curator — often one and the same person. So we touch here on a classic debate about cultural heritage, raised and lamented by David Lowenthal (1996), among others. But Lowenthal plays the

history card in a rather unsubtle way in order to condemn the heritage sector (see also Gielen and Laermans, 2005) with arguments such as the suggestion that history is 'more objective' because it resists contemporary demands such relevance to current affairs, accessibility to a broad public, or a clear mediagenic message. The concern that curators and heritage workers share for providing an accurate account of the art-historical past also leads to selectiveness. Because they often have to call on visual and other sensory modes of representation, critics, argue, they reduce the past to what can be seen, heard or felt. More abstract aspects of the past that are crucial for our understanding of it, such as the legal system, a mental frame of reference or a scientific paradigm, are hard to find in the contemporary exhibition landscape (see for example Jordanova, 1989). This criticism certainly holds water, and even more so in the Anglo-Saxon heritage sector. But in the debate around this, it is sometimes forgotten that the art and heritage world is largely kept going by professional archaeologists and art historians. This debate is not just between historians and the heritage sector as two separate entities, then, but permeates the entire landscape of art and heritage, throwing up some extraordinary paradoxes that give many curators and heritage workers plenty of food for thought. Because the art and heritage world is less bound to scientific historical methods, the relationship between the academic disciplines of history or art history and exhibition practices may be a bit like that between the academic dissertation and the essay. The latter more freewheeling formula provides, just like the art world, an interesting if more risky space for presenting the past in a way that is more polemical, speculative, and even imaginative, as well as more political, ideological and moralistic. Such chances have to be seized by curators, though — but we will return to this later.

Regrounding

Goffman gives a rather superficial account of his fifth key, which he himself calls 'conceptually the most troublesome'. The one thing that is clear from his description is that it concerns a mix of game, make-believe and reality. He notes that perceptions of the event can vary widely, with those who wield power over the participating actors seeing it quite differently to those under them. Beyond this, Goffman leaves his readers to their own devices.

I am going to take the literal meaning of the word 'regrounding' as the basis for taking Goffman's line of thought further. If we give something a new basis, this means that all its meanings are radi-

cally 'regrounded'. That radicalism does not just apply to the level of the present representation, however; it also has real implications for the future — and therefore for the way history unfolds. It may therefore be permissible to argue that regrounding is primarily political, in the broadest sense of the word (Goffman himself talks of 'those that govern ordinary actors', a power perspective that features rarely in the rest of his weighty tome). It concerns a reinterpretation of an event with a view to enriching the near future. And the confusing game that goes between make-believe and reality plays a significant role in this. Since the historical event called '9/11', it has taken little imagination to grasp this type of 'keying'. The 'new' and extremely cliché-ridden division between the Western and the Islamic worlds — as if they really existed as homogeneous entities — owes much to the make-believe initiatives of the George W. Bush government, supported by a few media giants. The construction of the axis of evil and the arguments used to legitimate the war against Iraq were also based on this keying method. The historical event 'The attack on the World Trade Centre' was repeatedly used to key in a new frame for the world. But because of its political nature, this form of keying generates real impacts. After all, the Iraq war was real, and it could take decades before we are rid of the cliché-ridden division of the world into the West and Islam.

Goffman's example of regrounding suggests that a study, and certainly an exhibition, can easily be 'reused' to steer the further course of history. Of course, this doesn't have to mean that the 'keying' is intentional on the part of the researcher or the curator... In the following I shall take a look at how Goffman's various keys actually function in art museums.

The 'Premeditated' Event in the Art World

The museum of modern art in Antwerp (known in Belgium as MuHKA) seems at first glance to have little to do with the concept of the event. Anyone entering the museum on a weekday encounters spacious, quiet, white rooms with an atmosphere more reminiscent of a holy silence than the noise of an event. But of course the MuHKA does organize events such as temporary exhibitions. In recent years, however, the museum has chosen to limit the number of its events from the more than ten per year under previous policy to four per year nowadays. On the other hand, the permanent collection has been submitted to a strong eventization. As mentioned in the former essay,

mainly young artists were invited to select works from the museum's archives and to exhibit and reinterpret them, possibly with their own work. The aim of these interventions was to 'dynamize' the hitherto static collection, and to turn it into a real 'happening'. And so the collection is transformed into a permanent event. It is worth paying further attention to this undoubtedly innovative approach.

Another example of an exhibition that sets out to be an event was the 2002 opening of the renovated Groeningemuseum — 'the museum of the Flemish primitives' in Bruges in Belgium, an occasion on which the directors of the Bruges museums were aiming at a break with previous policy. With the controversial redesign of the building and the visitors' route through the museum (by the Brussels architects' firm 51 N4E), the management sought to introduce a whole new policy to the public. And the new set-up is certainly unique, and very different to the average museum for historical art. We'll go into the details of what it looks like and how it works in a moment. Another remarkable exhibition organized by the Groeningemuseum was *Fake or Not Fake?* in 2005. In this exhibition, restoration practices were showcased, including outright falsifications — immediately casting doubt on the authenticity of the museum's own collection. Are the Flemish primitives we look at today the same as they were a few centuries ago? The exhibition event was an attempt by the directors of the museum to enrich the somewhat hidebound perception of these world-famous and iconized canvases. In Goffman's terms: the event aimed to offer a key with which the whole collection could — at least for a while — be 'reframed'.

It is not so easy to trace the genesis of a 'premeditated' event in the world of art and heritage. When did this approach to exhibitions start, and how did it gain the status of a fairly standard formula? For one of the sources we could refer to the world exhibitions. Other possibilities are the artistic happenings of the nineteen seventies or the earlier-mentioned rise of the so-called independent curator. In Belgium we can look at the Museum of Modern Art in Ghent, known as S.M.A.K. It was here that Jan Hoet (who was also director of 'Documenta 9') made connections between a dynamic exhibition policy, the media and the world of politics, culminating in the *Chambres d'Amis* exhibition in 1986. Hoet may not have been the first, but in Belgium he was the most prominent curator to turn a museum exhibition into an event, thereby giving form to the Post-Fordization of an art institution. The marriage between art, politics and the media led to all sorts of parties in the S.M.A.K. museum and to a real boxing

match during the official opening. Hoet's dynamism and 'his' museum did not go unnoticed in the wider art and heritage world. Even institutions that are not primarily focused on contemporary art make use of artistic practices in exhibiting their collections. Two examples mentioned in the previous essays are the collaboration with artists at the folklore museum *Het huis van Alijn* and the Flanders Fields War Museum. It seems that the event has come to be seen as an interesting and acceptable formula, and has spread from the contemporary art sector to the entire heritage sector. At least, this is certainly the case in Belgium. In the museums of Ghent, this happened quite specifically in 1998, with the exhibition called *The Purse of Judocus Vijdt*. Under the title 'money and power', this exhibition brought together miscellaneous artefacts from the heritage of Ghent — things which had hitherto rarely been associated with each other. In the Bijloke museum of the time, contemporary art was combined with furniture, beautiful art with machines, paintings with relics, and so on. The event dragged relics out of their apparent context and recontextualized them within an alternative frame. And the curator was … Jan Hoet.

'Eventization' has met with a mixed reception in the art world, though. On the one hand, it is criticized for leading to superficiality, while on the other hand it is seen as a force for galvanizing other actors in the arts into action. And an event can generate energy and enthusiasm, and so bring about change. Yet, according to its critics, the event stands in the way of a serious relationship with the arts. From the late nineteen eighties, it became the preferred form of exhibition. The event made it possible to attract a lots of visitors and thereby — at least in most European countries — to gain a new political legitimacy. The numerous blockbuster exhibitions are a direct symptom of this. With the demise of the classical educational ideal as the basis for political legitimation, subsidized museums were increasingly judged by neoliberal market logic of visitor statistics. Organizing lots of events and one exhibition after another became the preferred way of getting into the media and increasing visitor numbers. This did not always have desirable effects in the museum world. The strong accent on events means that most money and energy is spent on public relations, while collections are shamefully neglected. Less sexy activities such as maintenance, collection-management and restoration take second place, so that museums no longer always satisfactorily play their part in the conservation of heritage. This concern remains relevant to the wider heritage sector, too. It is the result of a neoliberal alliance between the event, media attention, public participation and

123

political legitimation. The problem is, however, that quite a number of critics automatically see the event as a combination of those four components, and particularly as inseparable from the targeting of a big audience. The happening thus comes to be seen as an integral part of the spectacle society, and the meaning of the event is tarnished. Yet we have seen that the event can also bring about an important shift. In the case of the 'premeditated' event, one might ask whether no event exists that admittedly aims at an audience, but not necessarily at a large one. And does an event automatically lead to superficiality? Can we differentiate between organized happenings? The story of the MuHKA shows that there are other ways of going about the organization of an event.

The MuHKA and the 'Eventization' of the Collection

As mentioned in the last essay, the MuHKA nowadays invites (mainly) young artists to intervene in the permanent collection. These guests are given an opportunity to select relevant works from the archives and to exhibit them in the museum. They also have the option of pushing the collection into the background as a contrast to an artistic project of their own. This often leads to a playful visual commentary on museum pieces. Revered artists from the past are taken off their pedestals, although the act of selecting them is itself a way of honouring them. The process creates a new space for open discussion and for research. The classical approach to art history usually used to present collections is called into question by this activity, which we can therefore describe as a genuine event. Some of the artists 're-frame' artefacts with their installation in such a way that they are 'renamed', and rusty old frames of reference used to view the museum's collection are dislodged. Furthermore, each new intervention has the chance to 'rename', so that our perception of historical items or the canon is continuously subjected to discussion, and the very nature of the collection becomes more fluid. And it is not so much the material artwork that matters here as — entirely in line with Post-Fordism — the immaterial way of relating to it. This kind of eventization does not automatically go hand in hand with a lot of media attention, political legitimation and a large audience. In this case, eventization goes hand in hand with research and aims to use a new type of presentation to bring about a shift in our fossilized perception of art. An example is the way Mexican artist Gabriel Kuri went to work with the museum collection in 2003. One of his actions was to place a

washing machine behind a work by Joëlle Tuerlinckx which showed a glass of water on an overhead projector. The projection of the glass and the barrel of the washing machine looked strikingly alike. So this was a visual commentary. But Kuri also selected Joseph Kosuth's self-proclaimed 'dead heavy philosophical' work entitled *The World As I Found It* (1989), in which the revered artist took up a rather solemn position on 'life'. Next to this work, Kuri hung a carpet with enlarged receipts from the *Kruidvat* retail chain which clearly read: incontinence pads for adults. Apparently, that was what he though of 'life'. He sets the mundane and the mortal beside weighty philosophical considerations. Kuri's playful commentary went beyond the collection: he turned the MuHKA itself 'inside out' in his presentation, in part of which backstage became frontstage. The washing machine, for example, came from the cafeteria. It was plugged in, and staff did the laundry in the gallery. An enlarged timetable was stuck on the wall, too, on which the cleaners noted their working hours every day. And so the Mexican artist brought the everyday machinery that keeps the museum running out from behind the scenes. For a while, the everyday became art and the presentation of the collection became an event. Bringing the dynamics of 'behind the scenes at the museum' into the galleries changed these spaces. The collection quite literally became of a moving décor.

By interacting with the artistic heritage in the museum, Kuri also learned to understand and contextualize his own work better. Never before had he placed his artistic practice in a historical perspective. In the MuHKA, he turned his gaze first and foremost on his own position as an artist. So the event in the museum appears to have worked, at least for the artist himself. And in the process, the tensions between cultural heritage and current art come to the fore. Kuri:

'I never thought about my work as cultural heritage. But by working in the museum and with the "heaviness" of the past, I really found out how difficult this is. Can I really put Kosuth next to my work? How far can you go in deconstructing his work, while you respect it at the same time? Is my work on the same level? Will it become heritage? This awareness, that you are responsible for what you are doing, the feeling that you are working for the next

generations, and that those generations can interpret your own work completely different, makes me very little. It gave me more humility.'

Kuri points to the paradox that applies to every modern art museum. As soon as young artists set to work in a heritage institution, they feel all the symbolic weight of the past on their shoulders, and see themselves as art history — and, yes, even as cultural heritage. It is precisely the MuHKA's innovative way of dealing with its collection that raises this paradox and makes it explicit. At the same time, the paradox suggests that a museum of modern art has an interesting dimension that is not often found in a *Kunsthalle* or national gallery, nor in any post-institution such as the biennale. In the MuHKA, the past is understood as a resource for new artistic practices to draw on. For artists, this generates more historical scope, but also increases their modesty. After all, the young artist may put a question mark over his own work by confronting it with that of revered artists. At the same time, by working in a museum, he asserts his position as an artist and that of his work as a potential part of art history. In so doing, this way of interacting with the collection may come close to what Goffman called a ceremony. In the frame of the museum, the artist–performer both symbolizes and validates his own position within the art world. Amid all those more or less revered artists, the young artist proclaims his own existence on the artistic scene. He puts himself in the picture and is therefore seen by others. Or, to use a concept introduced earlier: The museum is now a leading actor in the scene of being seen.

Within the event in the Antwerp museum, several keys come together. Reinterpretations of revered artworks or an art-historical approach, for example, suggest cognitive redoings. In this sense, the MuHKA is a particular frame within which experiments can take place and is comparable with the secluded space of the laboratory that Goffman mentions in his classic work. And finally, there is also an element of playfulness. When this key is at work, its aim is not so much to target particular experiences or sympathies — although these may certainly play a part in the event for the artist — as to literally play with the collection, using irony, parody and travesty. The intervening artist climbs on the shoulders of the rules of art history in order to place beside it his (since modernism) self-evident expression of his singularity (see Heinich, above). The artist plays the fool before his own history. The rules and the singular intervention stand face to face, and the encounter makes it clear that there is an unbridgeable

126

gulf between the rules of art history and the reality of art. This is precisely the function of the joke, according to Paolo Virno (2008): 'A joke takes hold of the empirical and pushes it to the level of being grammatical, and pushes the grammatical to the level of being empirical, thus showing the interchangeable nature of both dimensions'. In other words, to extend Virno's metaphor: in the joke, the river and the river bed begin to merge. In the MuHKA, the singular intervention of the artist is treated as a valid and certainly, at the lowest estimate, possible art-historical interpretation, while the art-historical grammar is seen as just one singular possibility. And it is in this inversion that space is created for innovation. The received truths of art history meet their match — but without being vanquished for ever.

The Groeningemuseum: Between Monochrony and Event

For many an art lover, both local and foreign, the Groeningemuseum in Bruges is above all *the* museum of the Flemish primitives. And certainly, the prominence of famous canvases of Jan van Eyck and his followers such as Petrus Christus, Hans Memling and Gerard David have set their stamp on the museum. But it also offers a much broader perspective on the art of the Low Countries, as we shall see. It is of course the presence of an absolute canon of works from between the late gothic and the renaissance periods has turned the museum into an international attraction. Yet, entering the museum nowadays you are surprised by its remarkable interior design. After all, most museums for historical art are characterized by a nineteenth-century interior, or a simulation of one. Artistic artefacts are places on pedestals, emphasizing their sacrosanct status. In some cases, heritage workers also attempt to evoke the historical context by surrounding the art objects with an interior reminiscent of the culture of their epoch. In this museum, before 2002, the Flemish primitives, some of which were shot through with fifteenth-century religious imagery, were exhibited in small 'chapels'. Some masterpieces even had a chapel to themselves, underlining their sacrosanct value. But when the museum was given a facelift for Bruges's year as the EU's cultural capital in 2002, the Brussels architects' firm 51 N4E made a radical break with tradition and thoroughly restyled the building, in consultation with the museum management. Amongst other things, the chapels were done away with, and were mainly replaced with bright white walls. The floor was tiled in a striking, almost blinding white, and the Groeningemuseum started to look more like a museum of modern

127

art. The architects swapped the cultural-historical context, or rather the evocation of it, for another discursive regime, namely that of the white cube mentioned earlier. The interior design of the building now evokes 'the autonomy of art', and implies that artistic artefacts can only be approached individually or in relation to other artworks. So art communicates with art and not with a cutural-historical or a political, economic or religious environment. We can therefore call the approach of 51 N4E anachronistic. Artworks that are shot through with political, religious and/or economic motives are placed in a modernist frame that suggests the exact opposite, namely the autonomy of art.

The restyling was intended as an event that would put the museum's history in a new light. The controversy it provoked may have something to do with its irreverent treatment of sacrosanct works. The art-historical canon can no longer be placed on a pedestal, and that sometimes leads to shallowness. All the more so since the Flemish primitives are displayed in the museum alongside, and thereby on an equal footing with the works of recent and often living artists. 'Roger Raveel on a par with Van Eyck?', visitors are heard to ask themselves. One thing is sure: the new design has shaken the expectations of quite a lot of visitors. In that regard, the new architecture can certainly be considered a 'success'.

Monochrony

In spite of all the fuss about the new design, it is not a total break with the nineteenth-century museum tradition. It remains largely monochronic and linear in conception, and the artefacts are divided into regions — Flanders and the Southern Netherlands. So the Groeningemuseum retains the kind of highly classical, historiographic perspective characterized in the previous essay as 'local time'. Space and time are always clearly demarcated and closely linked. The architect, Peter Swinnen, has this to say about it:

'When I visit a museum, I first walk through all the rooms to get an overview. I can't stand it if I miss a room. The chronological order – which is not entirely true, actually [the route is not completely chronological; some rooms half way round break the monochrony with a temporary exhibition, for example] – have something to do with it. It makes it easier for visitors, gives them something to hold on to.'

128

The architect does not seem to like the so-called postmodern museum architecture in which the visitor can stroll through the building freely and be selective or eclectic at will — the style that characterizes the MuHKA. The visitor to the Groeningemuseum, by contrast, starts out in room 1 with paintings from the fifteenth and sixteenth centuries. And these are thematically arranged, because they are all works commissioned by the city of Bruges. Room 2 displays the Flemish primitives, room 3 the Renaissance in Bruges, room 4 the late Renaissance and the Baroque periods, room 5 Neoclassicism, and so on until we reach contemporary post-1945 art. The monochronic route through the museum is interrupted by temporary exhibitions, a public archive and a small room reserved for the work of Marcel Broodthaers. But what is this work doing amongst the Flemish primitives? And how are we to relate the living artist Raoul De Keyser to Jan van Eyck? The museum management has 'opted for' a classical monochronic overview of painting in the Low Countries from the fifteenth to the twenty first centuries. 'Opted' in quotation marks because it was not really the management's own choice, but was historically determined, often by fairly haphazard donations and legacies. But it was a choice by the current management to keep the layout as it was. And that choice has various side effects. Firstly, the approach simulates a certain continuity in the visual arts in the Low Countries, which are seen as an entity. This invites the viewer to see more recent artistic developments as building on earlier ones. But besides this genealogical set-up, the more recent work — some of it by living artists — is given a share in the weightiness of the Flemish primitives. This not only determines the frame within which contemporary artists are viewed, but also seems to infect them with a certain aura. The question is, though, whether the more recent artists, at least those on display in the museum, can bear so much historical and symbolic weight.

Above all, what the Groeningemuseum lacks is a good story. There is the first room, which focuses on the commissioner, and there is the wealth and international character of fifteenth-century Bruges that can be inferred from several of the exhibitions. And if visitors use an audio guide, they are treated not only to an art-historical explanation but also to a modest amount of cultural-historical context — to which I shall return below. So the presence of the Broodthaers room is justified by its ironic commentary on the museum as a nineteenth-century institution. Broodthaers offers a key that changes the way the viewer sees the main exhibition. But whether this Virnosian joke has

a real impact on the public is a good question. The museum management also calls attention to the line between figuration and defiguration that the exhibition is supposed to thematize. But you would have to look very carefully to see that, too. And finally, there is the 'intrinsic beauty' of the work, which is convincingly presented. This too is a conscious choice by the management. A policy memo of the museum's reads:

> **'The Groeningemuseum is also a place where the visitor's aesthetic sense is stimulated. A pleasant and thought-provoking encounter with art has an immeasurable effect. A direct confrontation with the "intrinsic beauty" of an object sets all sorts of processes in motion in the observer. It creates a sense of pleasure and taste, encourages creativity, and provides an alternative to fast image consumption and the like.'**

However, 'intrinsic beauty' is a concept that many cultural sociologists — certainly those influenced by Pierre Bourdieu — meet with a certain scepticism, as it refers to the Kantian tradition that believes in the existence of a universal beauty, and does not see that taste is very much culturally determined. Both cultural background and social class have a strong influence on what people enjoy looking at. This is confirmed by the statistics from most cultural participation research. The majority of those who appreciate the fine arts or contemporary art have pursued some form of higher education. So ideas about what is beautiful are never 'intrinsic', but are externally socialized. Those who can appreciate the Flemish primitives or international contemporary art were given the right keys to them. Bourdieu and much subsequent research tell us that primary and secondary socialization, i.e. upbringing and education, are the main influences on later taste formation. And none of the mediating instruments a museum offers can change this.

Cultural Historical
Context and the Canon

Inspired by the Actor-Network theory, I emphasized earlier that viewing art and heritage means being actively passive and passively active. The visitor must first actively acquire a certain level of insight

before he can passively enjoy the art. Whatever the visitor's social background, the audio guide is one of the keys — a cognitive redoing — that can inspire him to look actively. An analysis of this explicatory tool in the Groeningemuseum shows that it offers solid art-historical information but much less cultural-historical background information — a kind of information which is also entirely absent from the exhibition itself set-up. There is little food for the appetite for more explanation of the political, economic or religious context in which the exhibited artworks were created.

We might even carry this one stage further and ask why the museum pays no attention to the process of canonization of the Flemish primitives. Which religious and socio-political sanctification mechanisms were at work side by side? In short, why do the Flemish primitives have cultural-historical value as well as art-historical importance? What is the social context, and which players have ensured that these works are world-famous now? Was this canon always the canon? To borrow the jargon of the policy memo, was the 'intrinsic' and universal value always experienced in this way? Or is this after all a question of power, with a political dimension?

Fake or Not Fake?

A temporary exhibition entitled *Fake or Not Fake* did tackle this issue, and in a very different way. At first sight, this project seemed to be a more technical one, carried out in collaboration with the laboratory for the analysis of artworks at the Catholic University of Louvain-la-Neuve. The laboratory investigated the restoration of a number of Flemish primitives by the Flemish artist, antiquarian and restorer, Jef van de Veken. *Fake or Not Fake* was dedicated to him, and showed that nineteenth-century restoration practices followed very different criteria than those of today. For example, Van der Veken used the method known as 'complementary restoration', in which the restorer is free to fill any gaps caused by damage to a painting in his own creative way. This practice is entirely unacceptable in professional restoration today. This exhibition seemed, then, to be chiefly of interest to a technical audience such as antiquarians, auctioneers or insurance brokers. But it actually went well beyond technical explanations. The museum director Borchert said,

'The confrontation with the original seems to play on the twenty-first century human's longing

for immediacy and authenticity. It cuts through the world of levelling reproducibility in which he lives and fills him with respect and wonder for the past. At such moments, a subjective experience of immediacy bridges gap between the centuries-old artwork and the visitor. That gap is no less real for this. ... Examples ... make clear that the artwork's material history – and the condition in which it reaches us, thanks to that history – play a decisive role in its appearance. Ironically enough, a question that visitors to museums and churches are not confronted with is precisely that of to what extent the supposedly authentic originals of the old masters really are authentic and original.'

So the exhibition sought to change the way we look at the canon, in this case the Flemish primitives, by showing that time affects a work's appearance and also that the clock cannot be turned back. Today's museum visitor may be looking at an entirely or partially different work than the one seen by the fifteenth-century Bruges elite. It is this sort of revelatory practice that is labelled 're-flexive' in the foregoing essay: it not only exhibits historical artefacts themselves, but also draws attention to the way they are exhibited. *Fake or Not Fake* not only informed viewers about nineteenth-century restoration methods, but also constituted a commentary on the museum's own practice, whose roots lie in the same century. In the words of Goffman, the Flemish primitives were fundamentally reframed, and *Fake or Not Fake* changed the way we looked at a piece of art history, at least for a while — making it much more of a true event than the trendy architecture. It might be worth considering carrying out this kind of well thought-out cognitive redoing in the permanent exhibition on a regular basis too. But this would necessitate giving up the principle of monochrony, at least temporarily.

The Event Revised

I have tried to describe and explore the implications of the role of the event for art exhibitions, and have used Goffman's insights to differentiate between kinds of event. The five keys that he suggests — make-believe, competitions, ceremonies, cognitive redoings and

regroundings — remain useful for taking the measure of happenings in the art world. This theoretical approach allows for more subtlety in our understanding of the event than we find in the derogatory tone of much criticism. And it enables us to discuss both the functionality and the disfunctionality of this kind of exhibition.

An event does not necessarily involve a combination of a happening, a large audience, a lot of media attention and political legitimation. That was clear from observing the MuHKA, where the eventization of the vast collection worked above all for a small peer group of largely young artists. A combination of Goffman's keys, the ceremony, cognitive redoings and make-believe or playfulness, can alter our art-historical perception of a collection. And this at once raises the paradox embodied by a museum of modern art, and makes explicit the performativity of a museum that immediately labels contemporary art as cultural heritage.

In the case of the Groeningemuseum, it vacillates between monochrony and event. It presents itself as an event chiefly in temporary exhibitions, certainly in the case of *Fake or Not Fake*, in which a technical-looking cognitive redoing undermines (at least momentarily) our reverent attitude to the Flemish primitives. It might be asked whether it would not be interesting to do something similar with the presentation of the permanent collection, which at present is somewhat classically monochronic. The heterogeneous nature of the museum's collection would seem to invite such an approach. A regularly changing thematic display of the collection would not just change the way we look at the world-famous canvases, but broaden it as well. At the same time, a broader cultural-historical framing could provide a key.

Above all, these two cases show that museums can make successful use of the event if they use several keys at the same time, and preferably link them meaningfully with each other. This is illustrated by the story of the MuHKA. If only one key is used, or is allowed to dominate, the event is less effective. To some extent this is what can be seen at the Groeningemuseum, where the cognitive redoing restricts itself to a very classical art-historical monochronic approach to the permanent collection. A combination of several forms of cognitive redoing would have sharpened or changed our point of view. Finally, experimenting with less common keys, such as the competition and the ceremony, would seem to pose a challenge worth considering for the art world. It is precisely the experiment with new keys or the combination of them that introduces Virnosian jokes, or at least

133

makes an 'essayistic' relationship with the past possible. With these keys, the museum can work more ideologically, politically, inventively, speculatively and moralistically than can art-historical studies. The approach taken to the MuHKA's collection and the Groeningemuseum's *Fake or Not Fake* exhibition provide a stimulus for this kind of alternative way of relating to art and its past. In these cases, the effect is to invalidate certain all-too-well-trodden paths and rigid frames of reference.

In the dispute between historians and the heritage sector as conducted by scholars like David Lowenthal, the latter is accused of being 'non-committal'. The museum can turn this negativity to its own advantage, however. Being non-committal can mean the freedom or power to set up a kind of laboratory in which — relatively unshackled by the burden of proof — a more spacious interpretive frame can open up. This frame allows for the expression of more speculative, suggestive and also more ideological and political points of view, as long as the museum makes these coloured points of view explicit. So as to avoid escalating the conflict between history and the heritage sector, it would seem useful for a museum to regularly seek new inputs from the academic world, as the Groeningemuseum did. However, the public nature of an event offers an art museum a chance to provoke political debate or to state a modest regrounding, in Goffman's term. In fact, the museum must do this in a time when the intellectual — and necessarily subjective — viewpoint is being cleansed (or at least squeezed out) from the academic world in favour of a so-called neutrality, actually a post-political sterility of current dogma. This tendency can be clearly seen in social demography and social historiography. The free, semi-public and communal space of the museum has the potential to repoliticize history, and thereby to reposition it. It might, in other words, be one of the few places where the global post-political climate can be challenged and changed. When technocracy runs the show in sociology, management or historical studies, the museum may be the last refuge of an ideological 'objectivity'.

Bibliography

Badiou, A. (1992). Conditions. **Paris: Seuil**
Badiou, A., and P. Hallward (1998). 'Politics and Philosophy'. Angelaki 3 (3): 113-33
Badiou, A. (2004). Theoretical Writings. **London and New York: Continuum**
Badiou, A. (2005). Handbook of Inaesthetics. **California: Stanford University Press**
Böhrer, K.H. (1994). Das absolute Präsens: Die Semantik ästhetischer Zeit.

Memory and Event

Frankfurt am Main: Suhrkamp

Borchert, T.H. (2005). 'Hoe authentiek zijn de Vlaamse Primitieven?: Aantekeningen over "oorspronkelijkheid" in de Oud-Nederlandse schilderkunst'. In Fake or Not Fake: Het verhaal van de restauratie van de Vlaamse Primitieven, ed. H. Verougstrate, R. Van Schoute and T.H. Borchert, 12-22. Ghent: Ludion

Burke, P. (2001). Eyewitnessing: The Uses of Images as Historical Evidence. New York: Ithaca

Carr, E.H. ([1961] 1990), What is history? London: Macmillan; New York, St. Martin's Press

Dicks, B. (2000). Heritage, Place and Community. Cardiff: University of Wales Press

Foucault, M. (1998). Aesthetics: Essential Sorks of Foucault, 1954–1984. London: Penguin

Gielen, P. (2003). Kunst in netwerken: Artistieke selecties in de hedendaagse dans en de beeldende kunst. Heverlee: LannooCampus

Gielen, P., and R. Laermans (2004). Een omgeving voor actuele kunst: Een toekomstperspectief voor het beeldende-kunstenlandschap in Vlaanderen. Tielt: Lannoo

Gielen, P., and R. Laermans (2005). Cultureel Goed. Over het (nieuwe) erfgoedregiem. Heverlee: LannooCampus

Gielen, P. (2005). 'In de schaduw van het heden'. In In de schaduw van het heden, ed. P. De Rynck, 9-13. Antwerp: Culturele Biografie Vlaanderen

Goffman, E. (1974). Frame Analysis: An Essay on the Organization of Experience. Boston: Northeastern University Press

Hallward, P. (2003). Badiou, a Subject to Truth. Minneapolis and London: University of Minnesota Press

Heinich, N. (1991). La Gloire de Van Gogh: Essai d'anthropologie de l'admiration. Paris: Editions de Minuit

Jordanova, L. (1989). 'Objects of Knowledge: A Historical Perspective on Museums'. In The New Museology, ed. P. Verdo, 22-40. London: Reakton Books

Laermans, R. (ed.) (2006). Cultuurparticipatie in meervoud. Antwerp: De Boeck

Latour, B. (1993). We Have Never Been Modern, transl. by C. Porter. Cambridge, MA: Harvard University Press

Lazzarato, M. (2003). Struggle, Event, Media. At www.republicart.net

Lowenthal, D. (1996). The Heritage Crusade and the Spoils of History. Cambridge, UK: Cambridge University Press

Maffesoli, M. (1988). Les Temps des tribus. Paris: Méridiens Klincksieck

Peterson, R., and K. Roger (1996). 'Changing Highbrow Taste: From Snob to Omnivore'. American Sociological Review 61: 900-907

Smets, I. (2000). Het Groeningemuseum Brugge: Een keuze uit de mooiste werken. Ghent: Ludion

Tollebeeck, J., and T. Verschaffel (1992). De vreugde van Houssaye: Apologie van de historische interesse. Amsterdam: Wereldbibliotheek

Van der Stichele, A. (2003). 'Taxonomie van de cultuurparticipant: De culturele omnivoor'. In Cultuurkijker: Aanzetten voor cultuuronderzoek: Jaarboek 2002 van het Steunpunt Re-Creatief Vlaanderen, ed. R. Laermans, J. Lievens, and H. Waege, 127-65. Antwerp: De Boeck

Verougstrate, H., R. Van Schoute, and T.H. Borchert (2005). 'Fake or Not Fake': Het verhaal van de restauratie van de Vlaamse Primitieven. Ghent: Ludion

Virno, P. (2008). Multitude: Between Innovation and Negation. Los Angeles: Semiotext(e)

Chapter III
Global Art

Artistic Freedom and Globalization

For a work of art to be considered 'a good work of art', it should preferably be created within an autonomous free zone. This means that in the creative process, only an artistic value system should be taken into account. Considerations of a commercial or political — and sometimes even legal — nature are unthinkable. 'Commercial' is also probably the most commonly used term of opprobrium in art criticism. Pierre Bourdieu in fact largely based his sociology of art on the distinction between the commercial and the non-commercial, or as he put it between the 'short-term and long-term market' (Bourdieu, 1977 and 1992). A genuine artist renounces transient financial profit seeking, we are told. Those who hope to lay any claim to greatness in the art world should only concern themselves with artistic questions. These questions, according to Arthur Danto, were defined, far into the nineteenth century, by a linear development, namely a quest for as truthful a representation of reality as possible (Danto, 1986). Only when the dominance of the aristocracy and the church weakened, and the academy was forced to put away its collective system of rules, did anything like artistic freedom or autonomy emerge. Art got the chance to focus entirely on itself, so goes the familiar story of art history. In the jargon of sociology, and more specifically that of systems theory, this is referred to as the art world 'functionally differentiating itself' and taking its place as an autopoetic system alongside those of the law, religion, economics, politics, et cetera (Luhmann, 1995).

This is the universally accepted modernist story. However, it is also (thanks to Kant, among others) the origin of the idea of 'pure' art: an artefact that solely serves aesthetic pleasure and thus otherwise floats, free, in a social vacuum. Yet according to the critique of some sociologists, this pure art has never existed. The loss of the aristocracy and the church have in fact turned the artistic artefact, within both the modern and late-modern condition, into a heterogeneous jumble. The democratization of society has allowed anyone and everyone to claim the artwork, making it political and economic and legal and pedagogical — and of course artistic as well (Gielen, 2003). What is more, in fact, the autonomy of the work of art, like artistic freedom, is guaranteed within this heterogeneous arena as a product of capitalism. It is precisely because an artefact is produced with politically stipulated subsidies, is purchased by a well-to-do collector, is legally protected and secures intellectual property rights, is featured in schoolbooks and constitutes an artistic answer to an artistic problem, that the artwork becomes firmly anchored as an artwork from a sociological standpoint and that it can claim a right to artistic autonomy. Moreover, the more

heterogeneous the network to which the object belongs, the more performative the latter becomes. The object is elevated to the status of a quasi-subject or of a semi-social actor capable of setting the most diverse range of actors in motion. If, for instance, someone were to deface Rembrandt's *Nightwatch* with a knife tomorrow, this act would activate a gigantic network of curators, politicians, insurers, attorneys, critics, and others.

The consideration of the artwork not as a pure object, but as an 'and-and-object' — an idea admittedly derived from Bruno Latour's ANT (1993) — is crucial to any discussion in the art world about marketization, 'commodification' et cetera. It shows, for example, that a so-called commercial artwork is still an artwork because it continues to 'network' — albeit minimally — with the artistic value system. Should it cease to do so, and refuse this non-capitalizable surplus, it is simply no longer an artwork, but is reduced to mere consumer goods or property. This is why, among other things, it is vital that an artwork from a private collection should regularly be on public display, in a museum or art centre, for example, or should at least be featured in a few catalogues. It will then preserve its connection to the art world and its status as a work of art. Of course an artistic product can be more 'commercial' as well, and can also be more political than artistic (although this is particularly difficult to assess). It is important that the artwork be continually appropriated, or in ANT terms, 'enrolled' by other network configurations and thus by other value systems as well. The more an artwork networks heterogeneously, the more it becomes part of a 'common' — a notion borrowed from Virno, Negri and Hardt to delineate the loaded distinction between public and private worlds or interests. The 'common' is not the same as the 'universal', though. The former concept is differentiated and changeable, as it stands *between* people and objects. The concept of the 'universal' points to what everyone has in common, such as a biological characteristic like a heartbeat. This distinction explains why an artwork can never be universal (just as universal beauty doesn't exist), but can be communal. The communal space is nowadays fed equally by private and public, political and artistic investments. If an artwork aims to be for everyone, it must network heterogeneously. It can be deduced from an alchemy of insights from critical theory and the ANT that the relationship between the artwork and the communal space depends on which actors connect with the work and how it continues to 'network' (or not). Armed with this view of the artwork, the debate on globalization and a growing 'commodification' of the artistic space can be scrutinized.

Globalization and Its Effects

The clearest definition of globalization was formulated by Marshall McLuhan back in 1964, with the well-known metaphor of the 'global village'. With the rapid spread of electric mass media throughout the world, the theorist saw the world become increasingly like a village. By this he meant primarily the communication networks that could circulate a single news item around the world as rapidly as a rumour makes the rounds of a local community. On closer scrutiny, this powerful metaphor suggests a compression of space and time (see, among others, Urry, 2000). Today, for instance, we can travel from Brussels to London in a little over an hour, and this means we have an entirely different sense of space than our ancestors in, say, the late Middle Ages. It is true that two centuries ago there were already world travellers and traders, but the difference is the great speed with which such travel now takes place. This change gives rise to an 'instantaneous time' (Urry, 2000). What someone here knows can, in theory, be grasped within a matter of seconds on the other side of the globe. To put it more starkly: an event in a far-off place can allow us and oblige us to change quickly and fundamentally within our familiar surroundings. To give but the most familiar example: the movement of large populations from the Chinese countryside to the cities had and has an immediate effect on the American and European economies. The global network resembles a hyperkinetic nervous system — witness the latest financial crisis. And that is precisely what differentiates international networks from those of a few centuries ago. Globalization is largely a matter of speed.

Globalization also refers, of course, to increasing international contacts, or a global 'networking'. But there is no single monolithic or homogeneous network that links everything with everything else. There is, instead, a meshwork of many networks or sub-networks with at times temporary, at others more durable overlaps. So, for instance, the financial markets of Amsterdam, London, New York, or Tokyo are interlinked, but that is not true to the same extent of the artistic network. Yet we cannot deny that there is an important interaction between financial and artistic intersections. It is probably no accident that New York is not only a financial but also an artistic centre. But even within specific networks such as that of the art world distinctions can be made. So it is, for instance, that sub-networks within the art world are primarily of financial importance, while others play more of an intellectual or educational role. Later, in another

essay, the art world as such will be examined in more detail. What is important is that the global 'meshwork' contains several networks within it, and thus also a variety of hierarchies.

Mediatization, Accumulation and Commodification

Rapidly moving global movements give rise to a range of transformations. In the case of the art world, one notices in particular the strongly global mediatization. Thus we see emerging a focus of attention that increasingly seeks novelty (Franck, 1993). Artistic movements that until thirty years ago still lasted some ten to fifteen years are now reduced to trends and exhibition concepts that follow each other in rapid succession. Art production and presentation have, in other words, become instantaneous. It goes without saying, moreover, that the artistic landscape is becoming ever more colourful. In the drive to come up with something new, curators active on an international scale scour all the corners of the globe in search of new talent. Whether this movement presages a truly symmetrical and polyphonic artistic landscape or constitutes a new western cultural imperialism will not be addressed here (on this issue see, among others, Quémin, 2002). What matters is that through this sort of expansion, we are witnessing a gigantic accumulation of artistic products. Through the constant extension of the global artistic network, there are ever more artists and works of art which are linked up with one of the many sub-networks within this global meshwork. Not only the media, but also this accumulation is responsible for the increase in internal competition within the various artistic fields, which in turn raises the profile of the arts. Ultimately, what is significant is the word 'product'. Despite the discourse on process orientation in the nineteen nineties, it is above all the artistic outcome that has taken centre stage. For there has to be something to go and see: something to buy. And so, in fact, even the process itself has become an exhibition product (Hannula, 1998). Under pressure from the attention system, the art world has indeed been highly commodified.

The Artist as Star

The attention system has, since the end of the nineteen eighties, generated a new type of artist that has appeared alongside other models (Velthuis, 2005). Artists who produce their work with an eye to the demands of the media are focused primarily on mediagenic forms of

143

art that draw attention to themselves and so are easily noticed. This often results in sensational work in which blood, sex and religion (or sacrilege) play a central role: recent examples have included sliced-up cows, pornographic photos or mutilated religious images. In this case, being an artist coincides with stardom. The creative person is a public, mediagenic figure who gains recognition not only for his work, but also for an eccentric appearance. Although this model of the artist already flourished in the nineteen eighties before the artistic market crash, there are powerful heirs to this system who continue to make their appearance today. One need look only to the British art scene that emerged in the mid nineteen nineties for evidence of this phenomenon. But for the record, it should also be pointed out that in addition to the star artist, many other models continue to exist or are emerging. For this mediatization and the star system have always given rise to various counter-reactions within the art world. More-over, it must be said that a star artist who makes it in the media does not necessarily enjoy the same recognition within the art world.

Denationalizing Artistic Trends

Globalization and worldwide mediatization not only sharpen the art-ist's eccentric ego — or assertion of what Nathalie Heinich (1991 and 2005) called the 'singular'– but also leads to a progressive denational-ization of the artistic phenomenon. Even if thirty years ago the world-wide artistic rhizome structure was not so widespread, the world of fine arts was always international in nature. Well into the nineteen seventies, there were certain artists and artistic strands that enjoyed a relatively international — or at least European and American — recognition. The difference with today is, however, that at that time there was still a noticeably national emphasis. Think, for example, of the historical avant-garde movements such as futurism, with its strong basis in Italy, surrealism in France or abstract expressionism in the United States. And even younger artistic movements such as Pop Art, Arte Povera and *Neue Wilde* carry a distinctly international label. Although these artistic trends did spread out to other countries, at the same time, their national origin was confirmed.

With globalization, all artistic currents are dissolving, as dis-cussed above, and this is increasingly true of their national label too. Thus, around the turn of the twenty first century, there was, for in-stance, a blossoming of the 'New International Style', a sort of con-ceptual installation art. This had, however, hardly any identifiable

144

national identity. The artists who belonged to it represented a colourful palette of nationalities, and they exhibited in places as diverse as Antwerp, Amsterdam, Basel, Berlin, Biella, New York, Tokyo and Venice. With the disappearance of national artistic currents, the internationally active national artist is perhaps another vanishing breed.

Inflation

The denationalization just described goes hand in hand with another globalizing phenomenon: increased mobility among artists. In the first essay of this book it was mentioned that more and more young or aspiring artists can, build an international network, even while still at art school. International artists' residences, training programmes, and workshops, such as P.S.1 in New York, *Cittadellarte* in Biella or the *Rijksakademie* in Amsterdam, also stimulate an international traffic in artistic talent, both large and small. Thus the 'international' loses something of its distinctive aura or — in the words of Pierre Bourdieu — its symbolic credit. A sort of inflation sets in. Research into contemporary dance in the nineteen eighties has shown that, at least for Belgium, the foreign repute enjoyed by artists still played a role in quality assessments and funding decisions by the government (Gielen, 2004). Today's decision-makers proceed much more carefully in this regard. It would, however, be an exaggeration to say that the international dimension is no longer surrounded by an aura of quality; yet it has lost some of its persuasive power. At the very least, the 'international' represents a complex reality for arts decision-makers or talent scouts, who work, as we have seen, with a meshwork of various networks and hierarchies. The task, then, comes down to carefully tracing this development, and in particular to assessing artistic quality and taking a decision.

Dedifferentiation

Finally, there is one more important effect of globalization, namely, the 'dedifferentiation of functional subsystems'. This observation rests on the sociological insight, more precisely that of systems theory, which starts from the assumption that a society is divided into various systems with a specific social function, such as the economy, politics, law, education, or art (Luhmann, 1995 and 1997). Instead of considering 'functional subsystems', this approach, following in the footsteps of Boltanski and Thévenot (1991), examines various 'economies of worth'. Why precisely this transformation has taken place is a technical theoretical question and the subject of a debate among

sociologists that would take us too far from the current subject. The core of Boltanski and Thévenot's approach is, within the Weberian tradition, a cultural interpretation that is imbued with a meaning that actors give to their activities. For Luhmann, on the other hand, it is a macro-sociological perspective that dominates, whereby he identifies various functions within society. For this essay, however, what matters is that within the economy different values apply than those at work in politics, law, art, et cetera. Depending on the regimes of worth, anyone who wants to 'make it' also has to take into account other criteria — just as everyone knows that the economy is mostly about accumulating money. This is something different from accumulating power in the political arena or pronouncing fair judgements within the judicial system. Something that is highly esteemed within the economic or political regime — Boltanski and Thévenot speak of 'grandeur' — may not enjoy the same renown within the artistic sphere. That is why there are artists who live in poverty, something to which the Dutch economist and artist Hans Abbing (2002) has also referred. Quite a number of artists turn away from direct profit-making, and it is precisely for that reason that they enjoy a certain regard in the art world. That is an idea that Bourdieu in fact gave us in the nineteen seventies. What is important is that there are various regimes of worth and therefore also diverse hierarchies of values.

Under pressure from globalization, the boundaries between these regimes are now — at least on a meso-level — beginning to 'de-differentiate'. That is not to say that they are disappearing, but rather that it is within and between organizations that the borders are being drawn, renegotiated and redefined. The best-known example is the fact that the rise of transnational companies or multinationals within the economic sphere has a direct effect on labour policies. Labour relations and the equalization of profit margins are thus detached from national politics (Hardt and Negri, 2000). That calls for a new set of translations between the market and the civil regimes of worth. Hierarchies of values are thus rearranged, or they can also blend into a new, hybrid regime. Thus, for instance, we are faced nowadays with the creative industry as a crucible of artistic and economic values. But it is possible for more than two value regimes to cut across each other. Think, for instance, of the Guggenheim Museum in Bilbao. Paradoxically, one of the parties involved in bringing this American museum to Bilbao was a nationalistic political party seeking to showcase the Basque identity as distinct from that of Spain. What is more, today it serves as a draw for many domestic and foreign tourists, but also for

high tech firms in an up and coming Silicon Valley. The art museum
was thus built not only in order to exhibit artworks under optimal
circumstances, but also with political and economic considerations
in mind. The striking architecture was intended, moreover, to put
Bilbao on the global map. Once again, what is paradoxical is that
this should have been done by means of an American flagship built
by an American-Canadian architect. Identity can thus be imported,
and other cultures can also serve to give prominence to one's 'own'
culture, provided the appropriate translations are made. That, too, is
a paradoxical consequence of the 'blur' of regimes of worth fostered
by a powerful globalization.

Guaranteeing the Free Space: Four Positions

Within the globalization debate, four different positions can be iden-
tified. These can be distilled into four attitudes that may be adopted
by arts policy-makers as well as artists and arts organizations. Each
defines the artistic free space in a different way, leading to the devel-
opment of diverse strategies. For the record: nowhere in the existing
literature has a connection been made among the four positions with-
in the globalization debate, the art world and its 'commodification'.
What follows is thus a speculative conceptual exercise, which might
give rise to concrete proposals.

The 'hyper-globalists' adopt the first position. They view the
economy, and more specifically the neoliberal market, as the engine
of the globalization process. Financial flows, in other words, form
the foundation for other global shifts. Saskia Sassen's analyses, for
instance, are largely based on these premises. What the sociologist
absolutely does not share with the hyper-globalists, however, is their
embracing of this process. To hyper-globalists, financial flows must
always be completely unfettered. This means that cultural, political
or legal obstacles should be removed as much as possible. Within this
reasoning, art too is merely an instrument of the free market. The
economic free space has thus been given priority over the artistic.

A globally operating arts network is of interest to the hyper-
globalists only if it installs a standardized culture. If, for instance, a
Dutchman and a Japanese both know Vincent van Gogh, and appre-
ciate him to the same degree to boot, that might well promote healthy
trade between the two. The Guggenheim strategy is thus completely
legitimate for the hyper-globalists. Imposing the same collection all
over the world, after all, evokes a shared cultural frame of reference,

147

'Deciding' Art in Global Networks

How are artistic choices made in a globalizing artworld and what are the arguments that play a part in this process? In this book, a predictable answer to this question would be that market value and speculation are playing an increasingly important role in artistic decision-making processes. And while that is undoubtedly the case, this essay approaches the question at a rather more abstract level. For one thing, I am constantly looking for the 'socio-logic' involved in artistic choices. And I therefore focus, in line with the ANT, on changing social networks and the effects they have on artistic decisions and decision-makers, concentrating on a particular sort of decision-maker, namely the curator. The argument is supported with material from interviews with two Belgian curators with a certain international reputation, one of whom established his career before the fall of the Berlin Wall, while the second is younger and has done most of her work since 1989. This historic year is taken here too, then, as the turning point for globalization. The first of my curators, Jan Hoet (1936), was for many years director of Ghent's Museum for Contemporary Art (S.M.A.K.). He gained international fame with his exhibitions *Art in Europe after '68* (1980) and *Chambres d'Amis* (1986). In 1992 he was honoured with the leadership of Documenta 9. When this book went to press, Hoet was director of a museum for contemporary art and design, the MARTA in the German town of Herford. The second curator is a good thirty years younger and her name is Barbara Vanderlinden. For many years she led the Roomade art centre in Brussels, but made her name chiefly as curator of 'Manifesta 2' (1998) and 'Laboratorium', which she set up in 1999 together with Hans-Ulrich Obrist in Antwerp. For both exhibitions she also edited books with an impressively international scope. Vanderlinden was also the director of the first Brussels Biennale in 2008. Before looking at these curators' decision-making practices, I will present a theoretical model for analysing artistic selections from a sociological perspective.

In order to develop this conceptual model for the analysis of artistic selections, the sociological positions of the art sociologists Pierre Bourdieu and Nathalie Heinich will be discussed. From this debate, two main concepts will be extracted that are connected with two important sociological grids of observation: the collective and the singular regime. As will be argued, however, the theoretical exploration is insufficient for getting a clear overview of artistic selections in the field. The model will therefore be refined with another distinction that has come out of empirical research: the difference between content and context. The combination of the four concepts that were

found in the theoretical and empirical explorations will result in a model of value regimes that regulate artistic selection processes.

The Uncomfortable Relationship between Art and Sociology

In *Ce que l'art fait à la sociologie* (1998), Nathalie Heinich argues that sociology's relationship with the artistic field is rather clumsy. She explains the 'uncomfortable' relationship between the two disciplines by pointing out the difference in orientation within value regimes. Whereas, from the nineteenth century onwards, connotations of the individual, the personal, the inner self, the innate talent and the 'natural' gift have surrounded the conceptualization of art, sociology was based on the collective, the social, on what is culturally determined and (socially) conventional. Sociology tends to look for regularities, whereas art flirts with the exceptional. In various sociological theories, this stubbornness of the artistic field resulted in an epistemological incorporation. Because they shunned the singular 'event', social sciences started to overemphasize the importance of the collective and the conventional. This turned the artistic praxis into nothing more than a collective practice, and this created a blind spot for its other characteristics (Heinich, 1998).

Heinich finds a second reason for the uncomfortable relation between art and sociology in the historical development of the latter. From the nineteen sixties, the ideology of social equality established itself within the sociological field. This is one of the explanations for the strong focus on theories of social class on the one hand, and for research topics such as poverty, immigrants, and gender on the other hand. In these theories of class, artistic appreciation was correctly associated with the upper classes. Under the influence of the 'democratic paradigm' in the social sciences, however, this perception of art was rather one-sidedly explained as the expression of outward show, (luxurious) consumerism and the social urge for distinction (e.g. Bourdieu, Boltanski and Castel, 1965; Bourdieu, 1979). In other words, art as aristocratic heritage came face to face with a sociological ideal of democratization. This explains why quite a lot of sociological studies have a hard time observing the art world in a so-called 'value free' manner. It also explains why the art object often only figures in sociological theories as a status symbol. And since several consumer goods also perform that social function, it would make little sense to study the art world as a separate reality.

Bourdieu and the
Collective Regime

Though Heinich's critique addresses the sociology of art in general, she has the works of a few well-known sociologists in mind. She argues that the classical study of Howard Becker, *Art Worlds* (1982), and especially the cultural sociology of her former mentor Pierre Bourdieu do not give enough weight to the particularities of the art world and works of art. Their analyses do not focus on watching or listening to art, but on being viewed while perceiving art. In that sense, they work on the assumption that people only interact with people, and therefore only attribute a marginal role to the object, in this case the work of art. The fact that social creatures read books, study artefacts, and so on, is assumed to have almost no effect on their social action. In other words, the assumption of the Actor-Network theory (Latour and Woolgar, 1979; Latour, 1988b; Callon, Law and Rip, 1986; Law and Hassart, 1999) that objects play an active role in social networks is barely taken into consideration. Moreover, according to other critics, in Bourdieu's symbolic economy, works of art are often reduced to suppliers of status in a politics of social representation: a game of identity and distinction (Gomart and Hennion, 1999).

This critique, which was mainly expressed by young French sociologists, applies to a certain extent to Pierre Bourdieu's early work on the sociology of art, such as *Un art moyen: Essai sur les usages sociaux de la photographie* (Bourdieu, Boltanski and Castel, 1965), *Sociologie de la perception esthétique* (1969), *La production de la croyance: Contribution à une économie des biens symboliques* (1977) and especially to the classic *La Distinction: Critique sociale du jugement* from 1979. When one analyses the status of the work of art in these studies and texts, one can indeed conclude that it constitutes a status provider in a social game of distinction and internal strife. Moreover, the artistic artefact derives its value from the social alchemy of interaction or transactions between artists, publishers, art critics and so on. According to this sociological point of view, artistic artefacts are evaluated within a collective regime of positional games, struggles for power and a search for distinction or symbolic profit, and the social arena is bound together by a shared belief in art.

However, this criticism applies far less to Pierre Bourdieu's voluminous 1992 Flaubert study *Les règles de l'art* (translated into English in 1996 as *The Rules of Art*), a calibration point in art sociology. Starting his analysis with a 'strictly internal' reading of Gustave Flaubert's novel *L'éducation sentimentale*, Bourdieu seems to have taken the afore-

mentioned criticism into account. One of the motivations behind this interpretive effort is to prove that the particular work itself contains the keys for a thorough sociological analysis of the social space in which its author operates. Nevertheless, a few hundred pages further on in the same volume, the master in sociology almost literally repeats the propositions from his 1977 *La production de la croyance*. This is what makes *The Rules of Art* a highly ambivalent study, to say the least. Though Bourdieu is not blind to the singularity of a work of art, he lets it dissolve into a collective regime at the same time, thereby placing its content and social effects in the background. Nevertheless, *The Rules of Art* can be read as a pivotal text in the evolution of the sociology of art, for it has created a space for a singular reading of the artistic. This is where sociological analyses of art that depart from a collective regime are confronted with their limitations.

Heinich and the Singular Regime

With her claim that the singular has been the central value regime of the art world since modernity, Nathalie Heinich radically continues that line of thinking. Her first published study *La Gloire de Van Gogh* in 1991 (translated into English in 1996 as *The Glory of Van Gogh*), in which sociology 'discovers' the singular, constitutes the seminal text for this sociology of art. How should this regime be understood? First and foremost, Heinich argues that it is not a transcendental or universal principle. By means of a meticulous analysis, Heinich demonstrates how it originated at a particular moment in art history. At the historical fault line between academism and modern art, Vincent van Gogh acts as the stepping-stone to the singular value regime. As was mentioned in the first essay, this implies a 'coming to terms' with the collective regime of the classical art academy. The original system of artistic validation used conformity to the norm as a measure for artistic quality. An artist's position on the hierarchical scale was determined by his compliance with the assumed artistic and collective rules. The essence of the collective regime lies in a relative conformity to a group and a series of social conventions. In the early nineteenthcentury art world, this meant loyalty to the generally accepted rules of the Academy.

According to Heinich, the art world abandoned the test in the form of a stable system of rules with the rise of modernism. The first Romantic artists at the end of the eighteenth century were recognized as artists because of their very abnormality, excess and

exceptionality. Breaking the rules of the collective became the rule, which also marked the birth of the singular regime. Between the end of the nineteenth century and the end of the Second World War, the collective regime of the academy and the singular would coexist as two value regimes. Only at the end of the nineteen forties, did the latter regime start to gain importance and dominate the world of art as a whole (Heinich, 1996).

Singularity is explained by Heinich as the consequence of the overflowing admiration or adoration which actors invest in an artistic artefact or in a singular artist. To Heinich, this adoration is not a naive or blind principle, as it constitutes a negative construction which is violent and which provokes a constant struggle. Someone who adores in public also engages in a polemic with those who do not. Moreover, adoration does not merely concern the recognition of or the love for an artistic artefact. It also implies the stigmatization of 'bad' objects. In other words, it generates a cognitive dimension of categorizing. Adoration presupposes a distinction between what is good and what is bad. By means of this subjective mechanism, one can introduce a more subtle classification of artefacts (Heinich, 1996). As a consequence, adoration also involves creating a cultural hierarchy.

The intensity of the discursive dispute between Bourdieu and Heinich often led to black-and-white oppositions that resulted in coarse reductions, especially of Bourdieu's views on the sociology of art. But Heinich, too, was criticized for going overboard in her dispute with Bourdieu, as she was said to pay attention only to the singular in the art world (see for example Laermans (2000) and Heinich's response to this in 2002). However, for this essay, the importance of the discussion between these French sociologists is that it clearly defines two concepts — the collective and the singular regimes — that underly two possible perspectives. It was this opposition that constituted the most important theoretical basis for the investigation of artistic selections and the arguments involved in it.

The Singular and the Collective Value Regime

The different sociological views on art put forward by Bourdieu and Heinich lead to the claim that artistic processes of argumentation are directed both by a collective and by a singular value regime. In this case, collective values are all possible observations and forms of reasoning that presuppose conformity to the group and social conventions. Within this regime, the evaluation of both the artefact and the

artist depends on a relational context. Within the singular regime, on the other hand, artefacts and artists are considered in isolation. The observer looks for the distinction, the deviant, et cetera. The critic approaches the artefact or the artist according to the dichotomy between adoration/no adoration, and tries to construct a line of argumentation on this basis. Note that, as Heinich stated, adoration is not really an emotional and certainly not a sentimental principle, but it is a capacity to distinguish. Whereas the collective regime relates the value of a work of art to conventions, the artistic standard and the history of art, the singular regime pays attention to abnormality, excess and deviation. It is important to realise that both of these regimes unambiguously form part of the art world. Moreover, the deviation from the standard or from a historical frame of reference can only be determined if one has some notion of the collective standard or of a shared historical frame. Yet, the two regimes constantly function in a state of tension within the same network. A work of art or an artist is related to the knowledge of artistic conventions or the history of art which it or he expresses. The materials used, the underlying concept, the composition: all these aspects of an artistic object can communicate knowledge that is important for the history of art (Luhmann, 1995). Files on the artist, as well as interviews or conversations with him do the same in a discursive or verbal way. These observations within the singular regime do not preclude an assessment of the artefact or the artist within a collective regime. After all, actors can travel through different worlds (Boltanski and Thévenot, 1991), and value regimes depend on the temporal and spatial context. However, we can anticipate that changing between value contexts will demand some kind of translation effort.

The Logics of Content and Context

Further empirical research revealed that the distinction between the collective and the singular had to be refined. Analyses of art reviews and in-depth interviews showed that with regard to the argument that motivates artistic selections, a second important distinction is to be made, namely the distinction between content and context. By the term 'content', respondents refer to the work of art itself. An argument that refers to content is offered by means of artistic representation. By 'context', one refers instead to the functioning of the artist and to the way in which he introduces and represents his work. The institutional context of museums and galleries can also be considered

as context. Both during participant observation sessions and in the in-depth interviews, this contrast frequently popped up. In the following quotations, some respondents address this. Note: these words are cited here not for the historical, artistic or social setting in which they were pronounced, but for what they say about the conceptual distinction between content and context.

'Curator x, he is a pure case of networking. He once stole the list of addresses from Documenta. Whether this is gossip or not ... it is characteristic of him. He knows nothing about art. He cannot see.'
(Jan Hoet, Artistic Director of Documenta 9 and former Director of the Museum of Actual Art of the City of Ghent, personal interview, 2000)

'We had a conversation about what we could do with Documenta. But there was also a curator who had invited the members of the jury in advance to come to the wine region where he had a museum to taste wine. But that had a contrary effect. It was literally the wrong strategy. Apparently, we used the right strategy: "back to basics", back to the content of art. It always functions like that in such a group. ... Jan [Hoet – P.G.] has always been consumed by art. And for such a group of people, real commitment to art is of decisive importance. ...

We also started from the perspective of a highly commercialized art world, because a lot of things had happened since 1986. There was the gigantic boom in galleries and commercial gallery art. It was also the first time that marketing had assumed such a central position within the world of visual arts. We were against that and said for example: "No Jeff Koons", even though he was a good artist. At that moment,

it was interesting as a statement to say: "not Koons!'"
(Bart De Baere, artistic staff Documenta 9 and present Director of the Museum of Contemporary Art of Antwerp, personal interview, 2000)

'When you know something about the art context, you can start easily. You only have to keep an eye on the best galleries, museums and the selection of some curators to make a somewhat acceptable selection. In fact, to do so, you do not have to know anything about art.'
(Richard Foncke, former commercial gallery owner, personal interview, 2001)

From these quotes, it will be clear that the content/context distinction plays an important role in the artistic world. In contrast to many actors in the art world, various sociological studies seem to forget about the content of the work of art. From the quotes above, however, it becomes clear that it is hard to understand the selections and forms of argumentation in the artistic world if we do not take the distinction between context and content into account. Empirical findings showed that many forms of argumentation are being construed on the basis of the observed content of the objects themselves and their interrelation. The internal consistency of a work of art — an important value judgement — for example, is deduced from combinations of colours and shapes, the idiom used, the narrative structure, et cetera. Additionally, artefacts are related to other artefacts when they are put in the present artistic context or seen from a historical perspective. Observations, forms of argumentation or modes of reasoning which focus exclusively on the object or its relation to other objects are governed by a content logic.

Even though respondents often evaluate social factors negatively, the quotes mentioned above demonstrate that they are also at stake in the evaluation of an artefact. In the first place, there is the artist who decides whether an artistic object meets his criteria or not and whether or when it is allowed to leave the studio. Moreover, the value of a work of art is judged on the basis of the social position of the artist, the institutions which organize the exhibitions, the art

magazines that write about it, and so on. The artistic quality is determined by the position of the artefact in its institutional context. As a consequence, the 'good' quality of the work depends on the hierarchical position of the institution — which could be an important private collector or a commercial gallery — in which the object is located. This kind of thinking reflects a context logic.

Four Value Regimes

When the logics of content and context are combined with the singular and collective regime, an interpretative frame can be drawn up containing the four value regimes with which artistic selections can be analysed: (i) a singular content and (ii) a singular context logic on the one hand, and (iii) a collective content and (iv) a collective context logic on the other hand. These four value regimes by which artistic selections are motivated, differ at least in three ways from each other, namely by (i) their different focus or referent, (ii) the different argumentation forms which are used to legitimize the artistic selection, and (iii) the different time dimensions which underpin the argumentation. Let us relate these variants to the four value regimes.

An actor who reasons in keeping with the singular content logic refers to the work of art itself (focus). By doing so, attention is paid to the internal consistency of a work (argumentation form) from a non-historical point of view (time dimension): arguments for the evaluation of an artefact are offered in isolation from the historical context. The decision maker is overwhelmed (or not) by the work itself, by its internal strength, by its convincing message, et cetera, because, for example, the dance idiom of a certain choreographic performance is totally harmonious, or a painting is in complete harmony with itself.

When, on the other hand, the same actor talks about the artist (focus), he constructs an argument according to the singular context logic. This means that it is not the object but the subject that is the referent. In that case, the consistency of the argumentation is buttressed by the artistic belief or the morals that the artist brings to the fore. In other words, the 'auto-normativity' of the artist is the central point or argumentation form. This implies that artists can only impose their own norms or artistic rules and have to follow them in a consistent manner. For example, contemporary dance choreographer Anne Teresa De Keersmaeker could not suddenly switch to classical ballet or jazz ballet. Nor could the documentary painter Luc

Tuymans suddenly start to produce surrealist paintings. In such a discourse, the artistic biography of the artist (time dimension) can also be very persuasive. Unlike the singular content logic, the singular context logic does have a historical dimension, albeit a modest one since it is personal. It is important that the biography in the singular context logic is exclusively understood as an artistic path. It deals with how an artistic style develops in the course of time, something which is distinct from the (institutional) career of an artist.

Within the third value regime, the collective content logic, the decision maker refers to other works of art (focus). The artistic artefact can be related to artistic conventions, such as certain artistic movements in the past, or in these times perhaps rather to fashions or trends (argumentation form). Within this category of argumentation, insights into the history of art also play an important role (time dimension). As a consequence, the collective content logic features an important historical approach which is completely lacking in the singular content logic. A certain work of art can, for example, be considered as a good expression of conceptual art, or may be said to place itself in the tradition of minimal dance, et cetera.

Finally, arguments within a collective context logic can also be put forward. Within the collective context logic, artistic referents, artistic conventions or historical arguments are of no importance, and only social referents (focus) such as important people or institutions count. How important are the institutions that organize the artist's exhibitions, or where is a certain dance performance staged? Here, we end up in an institutional logic in which social (argumentation form), rather than artistic conventions prevail. What matters is not what artists create, but where they present it. The positions artists occupy are important, too. Are they members of certain committees, juries, important networks, et cetera? It is not the artistic biography but the positional trajectory in galleries, museums and exhibitions that structures the time dimension.

A specific argumentation form for certain artistic selections can be situated in four different value regimes. The following grid presents the argumentation forms that have been found. Finally, it is important to note that one regime or logic does not exclude the other. Translations are always possible, depending on the connotative network within which the argumentation is constructed.

In the ANT, too, the binding factor can be content-based premises, ideology, values and so on. However, there are only a handful of possible reinforcers. A network configuration could just as easily consist of, or be kept going by, money, artistic inspiration, beautiful eyes, language, a soft voice, pragmatics, functionality, opportunism, geographical proximity, telephone or internet connections, knowledge, information, prospects of profit — to name but a few of the possibilities. In the ANT, a network is always heterogeneous. The art world could be seen as a global network in which artistic artefacts are the binding factor. These quasi-subjects create the connections between museum directors, independent curators, gallery owners, artists, collectors, insurance brokers, transport companies, bioengineers, restorers, laboratories, politicians, critics, laws, essays, catalogues, paint, wood, metal and so on. Within this global network, there are many levels and sub-networks, however, and Jan Hoet and Barbara Vanderlinden work in one of them. It is simply their geographical proximity to the author of this book (in a political entity) which leads to these curators being lumped together here in one essay.

Between Provincialism and Internationalism

In 1983, a book was published called *Art in Belgium since 1945*, edited by Karel Geirland. On page 28 there is a black and white photo of Jean-Pierre van Tieghem, Karel Geirland and the young Jan Hoet, all holding a paper banner proclaiming 'the pretentious charm of the provincialist'. This photo typifies the pronouncements of many of the players in the arts in Belgium in the nineteen seventies, a period which is often dismissed as a dark episode in Belgian art history. What is meant by this is not that there was a lack of artistic potential, as Belgian art in the seventies was dominated by internationally renowned artists such as Marcel Broodthaers, Panamarenko, Raoul De Keyser and Jef Geys. But many hardly got beyond the 'province' of Belgium.

Few Belgian artists were known beyond its borders, although plenty of foreign art was bought by Belgian collectors, most of them private. The main hubs in these circles were galleries such as Fernand Spillemaeckers' MTL in Brussels, and Annie De Decker and Bernd Lohaus's Wide White Space in Antwerp. MTL offered mainly conceptual art by the likes of Carl Andre, Jan Dibbets, Gilbert & George, and Art & Language, while Wide White Space focused mainly on a network built up through the artist Joseph Beuys, Bernd Lohaus's former teacher. Artists exhibited at Wide White Space included Beuys,

Edward Kienholz, Christo, and Georg Baselitz. The Belgians exhibited were Marcel Broodthaers, Panamarenko, Hugo Heyrman, Guy Mees, Dan Van Severen, Philippe Van Snick, and … Bernd Lohaus (Coessens, 1994). They formed an international platform where many artists, collectors, professionals and other interested parties could meet. Moreover, Wide White Space and MTL were seen in the seventies as two networks or 'camps'. Collectors Annick and Anton Herbert said:

'At first we only collected Belgian art: that was a family tradition. Annick looked at things much more internationally, and this began to distance us from the Flemish art scene. Passively, we were internationally oriented, and we knew what was going on abroad. The step [to buy foreign art − P.G.] came to be taken through a crucial contact with Fernand Spillemaeckers from 1971 to 1972. We belonged more to the MTL 'clan', whereas others such as Daled [Herman Daled, collector − P.G.] belonged more to the Wide White Space group. ... At that time it was a very small world, anyway. ... MTL was the platform for Robert Barry, Sol LeWitt, Carl Andre. ... Wide White Space was more geared to Beuys and was also more German, with Polke, Palermo and the like. Fernand was more internationally oriented and was also more focused on conceptual art.' (Annick and Anton Herbert, personal interview, 2001)

So the small Belgian art scene consisted at that time of several sub-networks. What is significant is that from the mid-seventies, Jan Hoet linked into the Wide White Space network through artists Joseph Beuys, Marcel Broodthaers and Panamarenko. However, after the closure of Wide White Space in 1976 and Fernand Spillemaeckers' fatal accident in 1978, these two international hubs disappeared from the scene.

So the establishment of the Museum of Contemporary Art (the current S.M.A.K.) in Ghent in 1975 happened at an interesting moment. It certainly created some space in Belgium for the public

exhibition of (international) contemporary art. The Association for the Museum of Contemporary Art that had been fighting for the museum since 1957 got its way at the right moment. Before the establishment of the museum, the association had already build up a fair collection of international contemporary art. The association was largely made up of private collectors who bought art for the association as well as for their own collections. So in 1975 there was a collection but no building. That is why Jan Hoet was to be put up in the Museum of the Fine Arts. Until the S.M.A.K. opened in a former casino in 1999, Hoet worked in what he called a 'ghost museum'.

The first exhibitions between 1975 and 1980 were characterized by an alternating regional and international focus, with solo exhibitions of Belgian artists such as Dan Van Severen (1976), Jan Burssens (1976) and Jos Verdegem (1977), on the one hand, and of big international names such as Panamarenko (1976), Marcel Broodthaers (1977) and Joseph Beuys (1977) on the other (Hoet et al., 1999). In 1979 Hoet made a sort of inventory and analysis of the Belgian, and chiefly the Flemish, 'avant-garde' of the time in an exhibition called *Insight/Overview — Overview/Insight*. This review of the state of the art also involved constructing a new artistic frame of reference, as Hoet was providing a platform for the Belgian avant-garde, including artists such as Leo Copers, Lili Dujourie, Guy Rombouts and Jan Vercruysse. In so doing, Hoet thrust artists into the limelight whom he considered to operate by international standards. The period before *Insight/Overview* was still characterized by programming that was 'provincial' and just beginning to be more international. This situation can be considered typical of the transition from the nineteen seventies to the nineteen eighties, a transition phase in a globalizing world in which an artwork was selected according to geographical location. As far as foreign art was concerned, the focus — chiefly for buying — was on international artistic standards. Between 1975 and 1979, for example, the S.M.A.K. bought a remarkable amount of American conceptual art through the MTL gallery. In terms of Belgian artists, although on the one hand artworks were selected that met the same standards, on the other hand works were bought with a view to the regional context, and these works would not easily stand up in an international professional network. For the national art scene, *Insight/Overview* marked the end of this dual approach. With the group exhibition *Art in Europe after '68* (in 1980), Hoet largely left this dual exhibition policy behind him at the international level too.

This first big international project placed the museum director

in a European professional art network. For the sociological observer, it is interesting to note how the first international step was taken. Hoet internationalized decision-making by enlisting on the selection team such players as Germano Celant from Italy (the discoverer — or inventor? — of Arte Povera), Johannes Cladders from Germany, Sandy Nairne from the UK, and Piet van Daalen from the Netherlands. This also helped to ensure an international support base for what was happening, as word spread to various parts of Europe. The team then selected 15 artists, each of whom could choose one more artist. This created a snowball effect for artistic selections within the international art scene. And it created a broader social support base within the selection process itself. Hoet:

> 'I put together an international team that included Cladders from Germany and Piet van Daalen, who had just had a big exhibition in Middelburg with Beuys. ... Those people certainly played a very important role in anchoring it internationally. I made my choices on the basis of those meetings. I have never worked in that way since. At the start, I didn't have those contacts, you see ... it was a necessity for me to work with those people. They would tell me about things I didn't know about, they already had their network.'
> (Jan Hoet, personal interview, 2000)

Besides acquiring networks through exhibitions and involving major international decision-makers, a second wave of internationalization came about through the art itself. After all, the acquisition of certain artistic artefacts tends to draw others in its wake. The donation of a number of Joseph Beuys's drawings in 1977, and even more the purchase in 1980 of his *Wirtschaftswerte,* had this kind of magnet effect. On top of this, Hoet inherited a considerable legacy from the Association, which had put together a nice international collection over twenty years. In such a context, artworks gain the mandate of actors that can attract new actors. So the acquisition of a famous artwork is an important enterprise for a novice museum director, and that is why I shall go into some detail here about the investments Hoet had to make to acquire *Wirtschaftswerte.*

An acquisition of this kind in the art world often starts with an exhibition. When an artistic project is undertaken with an artist, this often creates an opening for acquiring a work, possibly quite cheaply. It also makes it possible to bypass the commercial galleries. This is a strategy used by many museum directors. I examined how works were purchase by the S.M.A.K. between 1975 and 1999, looking at data on the museum's internal collection list. It was possible to trace the origin and the purchasing price of 617 works at the S.M.A.K., about half of which were obtained directly from the artists, twenty nine percent as donations and twenty percent as purchases. The remaining donations came from the association (five percent), galleries (three percent), collectors (three percent) and anonymous donors or other organizations (sixteen percent). As far as purchases are concerned, besides the significant role of direct purchases from artists, nineteen percent came from galleries, two percent from private collectors and three percent from other sources. Some simple maths reveals that most of the art (forty nine percent) came directly from artists, and this was therefore the main route into the museum collection. In view of the overlap between such acquisition processes and the central question of this essay, I shall quote extensively from Hoet's own statements about the mechanisms involved in the Beuys case:

'I already knew him, but it wasn't easy. At first I could only buy, I had no space to exhibit. But I absolutely wanted to do Beuys. In 1975, I said, "Panamarenko, Broodthaers and Beuys. Beuys completes it". I needed Beuys to place it internationally, and the Arte Povera too. ... Then in 1977 there was Europalia in Germany. I went then to Count x, the boss of Europalia, and said, "I don't want any German art, I just want an exhibition of Beuys". This was my big chance to get work by Beuys for this museum. I could more easily have got a group exhibition of various German artists from Europalia; I even had money for that. But then it was not sure that I could get Beuys. So what did I do? Germany had vetoed Beuys, and so the city of Ghent didn't want to fork out. So we came up

with a compromise, thanks to Count x, who
was interested in art and who I asked to lobby.
De Smet, the director of the Museum of Fine
Arts in Brussels, was behind me too. In the end,
it was agreed that Beuys would be included in
the brochures of Europalia, but the organization
would not give any money. The city of Ghent
paid. ...
Then I had to fight for Beuys, because the
gallery world closed ranks around him. "Surely
you're not going to exhibit in that ignorant city,
what's the good of that?" It had to be London,
Paris, New York. Then suddenly Beuys agreed.
I went to talk to people in the Netherlands,
the director of the museum in Nijmegen, who
was the son of farmers with whom Beuys
had stayed a couple of years when he was in
a depression. And then he agreed ..., and he
made Wirtschaftswerte for Art since '68. It cost
450,000 German marks. And I was able to buy
it for 900,000 francs [22,310.42 Euros - P.G.]. ...

And I was therefore also able to purchase
other works cheaply, such as works by Mario
Merz, Kounellis and Kabakov. I literally used
the argument: "Look, we have a major Beuys
collection", to show that we'd arrived. I still
often use it. I say, "Do you know what we
paid for Beuys at the time, and that you are
asking twice as much". ... Panamarenko even
once came down in price. And because I had
Panamarenko, I was able to buy Broodthaers
cheaply from collector x and his son.'
(Jan Hoet, personal interview, 2000)

In the first place, it is interesting to identify why the purchase
of a work by Joseph Beuys was so important. It was important be-
cause Hoet wanted to use it to raise a coalition of Belgian artists such

171

network can be created. From the linking of people and artefacts in exhibitions and collections arises a stronger actor who can get through to the core of a network. The first coalition between Hoet and a few important artefacts and art professionals through for example *Art in Europe after '68* (1980), thus formed the basis for later projects such as *Chambres d'Amis* (1986), which in turn paved the way for Documenta 9 (1992) in Kassel.

But alongside his successful internationalizing, Hoet also remains strikingly 'local'. In a manner of speaking, the museum director never cuts loose from Belgium, in spite of his international career. In the words of another museum director and former close colleague of Hoet's: 'he refuses to lead a nomadic existence in a virtual international art scene' (De Baere, personal interview, 2000). Indeed, after an international breakthrough, many curators do lead a nomadic existence, in which assignments, art scenes and countries follow each other in quick succession. Hoet, by contrast, always returns to Belgium, and preferably to Ghent. This constant alternation between the local and the international is reflected in all sorts of projects, and it is striking how often there is a switch in scale. For example, the S.M.A.K. will simultaneously work on exhibitions in Watou, Ghent's art school and the O.L.V. ten Doorn institute in Eeklo, and on the Venice Biennale, Sonsbeek or Documenta. The same applies to the many lectures Hoet gives or the debates he participates in. From the annual reports of the S.M.A.K. it is clear that between 1980 and 1999 he took part in 657 such occasions — and this too builds a real network. Before *Chambres d'Amis*, his lectures were mainly given in Flanders, but after that they extended to the surrounding countries. After being appointed artistic director of Documenta 9 in January 1989, Hoet travelled all around the world, but still had attention for the local. He travelled between the art school in the small Belgian town of Mol and The American Academy in Rome, between Amarant in Ghent and the University of Stuttgart, between the *Willemsfonds* in Bruges or the cultural centre in Temse and the Centre Pompidou in Paris. He constantly goes between local and international platforms, between Belgium and the rest of the world. And the same phenomenon can be seen at work in the choice of an artwork for the museum. Here again, Hoet draws a distinction between Ghent, Belgium and overseas:

I'm quite strict in my choice. Artist x, for example, is not so good, I wouldn't take him. They have to meet the museum's standards.

I do make different frames: for example, I use different norms for Ghent than for the national or international context. I believe it is a municipal museum. All over the world, such museums work from their own local base, actually. So I work with three sets of weights and measures. I do try, for example, to be strict within that locality. I still consider painter x to be the best in Ghent, but I don't say that he is as good as Tuymans, who is nationally and now internationally known. A municipal museum has a duty to look at what is going on in the city. I'm working with money from the Ghent community. Imagine if we didn't include any local artist here. A collector can do that, but we can't. Jan van Imschoot, for example, is a good Ghent citizen, and is now becoming nationally known. I go on supporting that wholeheartedly.' (Jan Hoet, personal interview, 2000)

This statement tells us something about how the museum director observes and selects. He distinguishes between Ghent, national and international art in an apparently ontological manner. But it is a relative ontology, because it is based directly on comparison: 'painter x is important in Ghent, but is not as good as Tuymans'. Artistic assessments and attributes are therefore built up in a network of mutual relations. In terms of the two value regimes described above, Hoet makes use of arguments from both the singular and the collective content-related logics. At the same time, Hoet himself labels (or stigmatizes) as Ghent, national or international. This is a matter of ontological politics (Mol, 1999), in which the museum director can make or break by what he says or does. By offering artists a place in the museum and by ranking them geographically, the director helps to construct the artist and his ranking. In sociological terms, this can constitute a self-fulfilling prophecy (Merton, 1948 and Weick, 2001). But a brief survey of articles in the press shows that not since the nineteen nineties has the S.M.A.K. been seen as a Ghent museum. A regional artist in the museum is instantly seen in relation to a national context at least. The example that Hoet gives of the painter Jan van

Imschoot is therefore at least in part generated by the museum director himself. In the words of Bruno Latour, we are witness here to a relative constructivism, with Hoet functioning as an instrument that helps to determine an artistic 'fact'. However, the museum director is never entirely responsible for the success of an artwork, as it also has to submit to comparison with other artworks, besides needing other investors as well. Failing which, the artistic artefact will never more than briefly get beyond the local level.

This story allows us a glimpse of Jan Hoet's artistic selection process, and to some extent those of his generation. Of course, how an artwork is chosen depends on the context. In expanding the collection, for example, a number of symbolic referents were sought that provided an artistic frame for the collection. In the scheme described above, this is known as a 'collective content-related logic'. These key works also play an important role in attracting other top works. This informal economy is usually set in motion by an exhibition, after which there are negotiations about the purchase of a major artwork. And although Hoet is thoroughly integrated into the international art scene via his coalition with foreign professionals and artworks, he continues to operate locally as well. In the process of incorporating an artwork, a friendly geographical anchoring often takes place. The locality mainly plays a role in artistic selections for his own municipal museum, but now and then it shows through in more prestigious international projects. For this reason, some respondents see Jan Hoet as a provincialist with a pretentious — because international — charm, while others see an internationally operating star curator who will always stay a provincialist.

Allies in Artistic Selections

The story just told illustrates the fact that for the Hoet generation an artwork is no passive agent in artistic selection processes. Well-chosen artefacts are like allies for such a museum director and they strengthen his own network. They can generate an accumulative spiral that attracts other artworks appreciated by the peer group of the artistic network. The artefacts form a kind of extension of the selector and extend (or reduce) his own radius of action. After all, there are also artefacts in the museum depot that can either play the role of a rich heritage or that of a burdensome one. Besides the many demands they make in terms of conservation, management and restoration, as actors they can also increase or decrease the owner's symbolic credit. This

analysis suggests, moreover, that the acquisition process for an artwork often goes hand in hand with a double enrolment. It is not only the artwork that must be acquired; if the artist is living, it's important to get him on board too.

But what is important here is that material objects, namely artworks, still play a crucial role in both the careers and the decisions of decision makers in the art world. This is why a museum director or curator will network closely with other players such as private collectors and gallery owners. Demonstrating coalitions with major collectors offers a museum director, for example, the chance to acquire an artwork cheaply. If the director can negotiate an important purchase for a collector, he might expect to buy a work from the same artist quite cheaply — and vice versa. The double bind between collectors and museum directors does not only generate useful price reductions. Many private collectors have considerable knowledge about artistic evolutions, movements, and possibly also about the 'bargains' to be had on the art market. It is this mass of information that is often indispensable to the museum director. And not just for Jan Hoet. The former director of the Van Abbemuseum in Eindhoven and ex-collection director of Tate Britain, Jan Debbaut, has this to say:

'I have a very good relationship with Anton Herbert, who is also on my advisory board. But I also have good contacts with Daled and Goeminne [collectors – P.G.]. It's my job to keep myself informed about developments in the art world, after all. And private collections play an important role in them, so there is a business motive here too. If I am surrounded by good private collectors, I have access to works with which to make good exhibitions. If you are not on good terms, they can say, "No, you can't have them." But these people are also highly intelligent, experienced and tremendously well-informed. You have to realize, many of them travel all around the world. They get more quickly to more places than I can get to as museum director. So they are also a useful source of feedback. It's not just collectors but

177

also artists who play this role. They look very sharply and have antennae on their heads.'
(Jan Debbaut, personal interview, 2001)

Networking between collectors and museum directors is therefore something of a professional necessity in a network in which the material artwork is central. Here again, informal, symbolic and monetary economies are intertwined. Friendships can ensure that directors can get hold of valuable works for their exhibitions, or can purchase artworks more cheaply. They can then set up more interesting and better artistic projects and expand the museum collections with higher quality works. On the other hand, the presence of collectors' artefacts in those exhibitions increases their symbolic and possibly their monetary value. The enrolment of the artwork is therefore partially dependent on this complex interplay between economies and the connections between museum directors and collectors. Research at the Museum of Modern Art (MoMA) in New York showed how important this internal networking is in the United States. Within a system which is hardly subsidized, museums are largely dependent on the collectors with whom they can form relationships. The museum collection is almost entirely built up from donations from collectors, on which the latter get significant tax rebates. This is much less the case for European museums. A quick bit of arithmetic reveals that the S.M.A.K. gets only half of its artworks through private donations. Thanks to government financing, the museum director can therefore afford to take up a more independent position. Or rather, as suggested earlier: It is precisely dependence on a range of actors (government, private collectors, companies et cetera) that offers the curator or museum director more chance to operate independently.

The incorporation of an artwork therefore depends mainly on the amount of support it has found in private circles. Collectors already help to anchor an artefact in a professional and international artistic network. They help to ensure that it penetrates to the inner circle. These almost unavoidable connections in the art sector general a crucial trading zone between the public and the private spheres, between public and private institutions, between artistic and economic logics, and so on. To some extent, decision-making logics and selection processes come to stand within this field of influence. However, this is less the case for the so-called independent curator. It was mentioned earlier, for example, that Harald Szeeman has not only detached himself from the museum but also from the material

artefacts in its depots. Entirely in line with Post-Fordian logic, the immaterial interplay of ideas comes into the foreground. The point is here that a totally different selection logic takes hold. Someone who is not dependent on material artefacts, but who also cannot form lasting alliances with them, takes other routes to decisions and makes use of other network figurations. With the rise of the 'independent' curator in the nineteen eighties, and especially during the tremendous boom following the fall of the Berlin Wall, an alternative selection rationale grew up in the global art world. But to understand this, we first need an introduction to the second protagonist in this story.

The Independent Curator

Besides her work at the now closed-down Roomade art centre in Brussels, Barbara Vanderlinden has been operating as an independent curator since the mid nineteen nineties. She led *Manifesta 2*, the European Biennale for Contemporary Art (Luxembourg, 1998), together with Maria Lind and Robert Fleck; she created the exhibition *Fascinating Facets of Flanders — two hours wide or two hours long* (Lisbon, 1998 and Antwerp, 1999); and she organized *Generation Z* in P.S.1 (New York, 1999), together with Klaus Biesenbach and Alanna Heiss. Other fairly large-scale projects of hers were *Laboratorium* (Antwerp, 1999) and *Indiscipline* (Brussels, 2000), and she also led the first Brussels Biennale in 2008, as already mentioned.

It was striking how quickly this relatively young curator was working with big names from the art world. In 1996, for example, after an exhibition of the still young Belgian artist Gert Verhoeven, she went straight on to a project with the famous American artist Matt Mullican. This is intriguing. What strategies did this still young curator use to win the loyalty of top artists and other highly reputed individuals (such as Chantal Mouffe, Boris Groys and Bruno Latour)? A good place to look for an answer is in the strange world of the selection rationales used in the fine arts.

'Mullican is best-known for his logos and pictograms. At that time he was a successful artist in the gallery circuit, he sold well and everyone knew his "little prints". Mullican also used other media, such as hypnosis performances. I noticed that he didn't come out

with that any more. People in museums and galleries don't ask for it. The stronger the market, the less interest in that in the art world. What I intended was to show the public what kind of thought process precedes the pictorial artwork. You can't just do the same as other people. ...
To work with someone you first have to build a relationship of trust. For that I read the simplest management books, such as Larry King. He tells you how to get someone enthusiastic. For example, never begin by talking about yourself. You always have to position yourself as the inquisitive one. I often use the interview for this, the interview as an excuse for getting invited by someone. And I never say straightaway that I want to do a project with them. First I go round several times, sometimes for an interview, sometimes to chat about something completely different, another project or so ... Quietly, you create a context. Through the many discussions you also find out what someone is doing. You find the points of contact. How do you create a situation in which Bruno Latour comes to feel like revealing something of himself? This is a world of egos, too. You have to work with that. X is a bit hysterical, Y is a bit abnormal. So you have to visit them a thousand times with cakes and cookies and I don't know what all. You may have to visit the artist's mother before anything gets started. ...
In the art world a lot depends, too, on who you are and what you've already done. Of course, they phone their colleagues to ask who you are. ... There are always side doors and lower thresholds. Larry King's first lesson is "never talk to them straight, first call their secretary or their assistant". It's much too pretentious to go straight to them. And you have to pick your

subject. If it hasn't been done before, people are keener. I often do a lot of preliminary research, too. So when I call them, I can already mention what they've done. Like that you don't come away empty-handed, of course ... You can play names off against each other of course. One big name attracts another. So you can do that to get important people on board.'
(Barbara Vanderlinden, personal interview, 2001)

So it all starts with demonstrations of respect and recognition for an artwork or an oeuvre. The next step is to build a relationship of trust with the artist, a process in which the symbolic economy of 'playing names off against each other' is useful. Who you are and especially what you have already done are also important factors in this economy. Vanderlinden gives a clear picture of how the selection process can be optimalized. Through showing interest, showcasing prior knowledge, and entering into the domestic sphere, an informal economy grows up — entirely in line with the Post-Fordian workfloor — in which the reciprocity principle can operate. The interview often provides an interesting instrument for an initial approach. Or, as suggested in the second essay in this book: the interview helps to turn a new idea into a relevant idea by bringing to light and formulating contemporary tendencies. The international artistic context — in the collective context logic — and the current debates within it are painstakingly observed before the curator makes selections. This theoretical angle is quite different from the selection practices of Jan Hoet described above. For one thing, the starting point for artistic choices — ideas — is fundamentally different, and is one that makes it possible to incorporate scientists and theorists into the process in a way which also makes the relationship between theory, art criticism and the artwork more complex. Texts about work will no longer fulfil the sort of straightforwardly legitimating function described by Bourdieu (1977 and 1992). Of course, discursive products continue to play an affirmative role. But alongside them, theoretical commentaries also gain the authority of an artistic artefact within this enrolment practice. They can easily mingle with other artefacts, so that an artwork comes into existence in a much more heterogeneous intertextual context, to say the least. The oeuvre of artists such as Carsten Höller are an indirect result of this. But the important point is that a more complex relationship between text and artwork comes about than Bourdieu suggests. That complexity is partly driven by the

181

nature of the incorporation process. A new internationally compulsory circuit of curators, of which Vanderlinden is symptomatic, is bringing about a change in the global art world, where the distinctions made nowadays have a considerable immaterial element.

However, a distinction proclaimed by a curator has to be observable and recognizable to others. And that is why Vanderlinden emphasized the importance to her of working with relatively well-known artists or theorists. After all, the public is expected to have a knowledge of the oeuvre concerned that enables them to recognize the different approach of the artist or theorist. This presupposed artistic or theoretical knowledge reveals that the young curator mainly addresses the peer group of the artistic network. From the point of view of a young generation, this orientation is quite understandable. The new professionals — as the nineteen nineties generation of 'independent' curators are sometimes called — seek above all affirmation among their artistic peers, a social mechanism that has much in common with what goes on in the knowledge business, where young academics also have to prove themselves to an international peer group. Vanderlinden is out to establish a place and a profile in a globalized artistic network and not at a regional level, like Hoet.

This international orientation also affects the selection of artworks, which depends much more on standards and trends in an international peer group. This explains why Vanderlinden goes about it so differently to Jan Hoet. While the erstwhile museum director — partly for the sake of his museum's local network — selected by three sets of criteria, the 'independent' curator is largely led by the international context. Among these international peers many temporary issues crop up, such as gender issues (especially in the early nineteen nineties), the process approach, the science metaphor or the globalization question. According to the Latin American art historian Mari Carmen Ramínez, the latter theme arises mainly as an impact of a developing cultural identity market. After the thaw in east-west relations, curators have been asked to set the scene for various new identities. With their selection, framing and interpretation of peripheral groups, exhibition makers can lay claim to having created a more democratic space. At the same time, they create a distinguished international profile for themselves. After all, 'discovering' new marginal groups also means extending artistic boundaries and expanding the art market (Raminez, 1996). These newly discovered groups are indeed often claimed by curators.

182

'You have to see scouting for international exhibitions quite simply as promotion and as research. You become powerful if you know the whole of Eastern Europe, for example. There are not many people in the art world who do.'
(Barbara Vanderlinden, personal interview, 2001)

This — often politically correct — politics of cultural representation was partly shaped by the fall of the Berlin Wall, as we saw in the early nineteen nineties. Suddenly, the 'forgotten' artistic potential of the former Eastern bloc was opened up, and with it the scope for enrolling artworks from these countries. And, as already mentioned, after the former Eastern bloc, it was Africa's turn. Now a lot of curators are going in search of Chinese and Indian talent — as can be seen from Documenta 11 (2002), led by the new York 'African' Okwui Enwezor. Where Documenta 10 in 1997 absolutely had to be led by a woman, it was now the turn of another 'minority'. The European Biennale for Contemporary Art, Manifesta, also developed in the mid nineties within this globalized politics of cultural representation — certainly the second edition, headed by Vanderlinden among others.

'Manifesta was a new institution that would operate between the territories of the centre and the periphery. In 1989, those boundaries were still strongly influenced by the east-west divide. Besides this aim, the organization also wanted to experiment with young curators by letting them test new models and publicize their own discourse. So when I was selected by the organization, I felt that there were certain things you had to live up to, otherwise you would jeopardize the organization. This meant we were confronted with a lot of obstacles. "How many women [women artists - P.G.] are represented?" At some point we only had twenty five percent women, and that was borderline. We didn't want to get caught up in those politics, but we realized that if we went under that it would be seen as deliberate rebellion. We didn't want that

183

misunderstanding. ... The boundary between centre and periphery doesn't necessarily have to lie between east and west, at least not in 1996. Another big debate was about the Muslim community and its presence in Europe. We didn't address that, however, which brought a lot of criticism down on us. You have to deal with the reality of a public and the day-to-day debate that influences your decisions. That is not the core of the content of your exhibition, but it does affect it. At the Manifesta level you do have a representative role.'
(Barbara Vanderlinden, personal interview, 2001)

Selection criteria at the international level are therefore sub-ject considerable influence from representation considerations. It is fairly obvious that these rarely have much to do with artistic interests and preferences. Or, once again in the terms of the value regimes outlined here: the choice of content is less governed by a collective content-related logic and hardly at all by a singular content-related logic. Vanderlinden does note that cultural representation consider-ations are not key determinants in the selection process, but the role they play is not negligible either.

Other current themes in a globalized context are related to metropolitanization and the increasing mobility — real or virtual — which is emerging around identity, the non-place, transit zones and so on. Vanderlinden specifically plays on this through certain site-specific projects such as the Office Tower Manhattan Projects (Brussels, 1997) and the Century Center Projects (Antwerp, 1999). Another key issue at the end of the nineteen nineties and early 2000 was the exploitation of the possibilities of the internet. Artistic exhibitions such as *Laborato-rium* (Antwerp, 1998) and *Indiscipline* (Brussels, 2000) were largely vir-tual. This international agenda setting by nomadic curators inevitably has consequences for the selection of artworks. The material object or image recedes into the background. To a great extent, concepts or themes developed beforehand by an international peer group deter-mined the parameters of the selection, so that the rationale is clearly different to that used by Jan Hoet in his artistic choices. Whereas the museum director states that his starting point is interest or 'love' of a material object, or the (autonormative) ideas of an artist (e.g. Beuys),

independent curators often start from an internationally constructed 'relevant idea', which the artwork exemplifies or illustrates. This immaterial work process in which a preconstructed concept is 'filled in' was particularly prominent in the late nineteen eighties and early nineteen nineties. New professionals such as Vanderlinden were quite aware of the limitations of such practices, however, and they therefore often distinguished themselves from their predecessors by developing other selection processes. After all, nowadays a good idea must be a 'relevant' idea. The interview plays a predictable and important role, but even Deleuze's ideas get a look-in again. ...

'Someone like De Duve, for example, has developed a very clear discourse and then he goes looking for figures that can play a role in it. Artists then support a thesis or an academic discourse. I, on the other hand, use the ideas of Deleuze more. He states that the interview is an important way of thoroughly exploring an idea. That's what I always say: "Don't close doors". You can also let your content speak by letting that in first. Through the interview process I try to detect which debate is involved and I try to express it clearly. I call that simply an editing process; you "edit" your subject yourself when you talk it over with other people. So this selection process is very different to when someone is reinforcing a thesis.' (Barbara Vanderlinden, personal interview, 2001)

And yet we still see the same mechanism at work, to some extent: an idea or a theme is established after research and then a preferably public authorization is sought within the art scene. After all, the concept is required to bring distinction with it within an international peer group. Just as with claims by 'peripheral groups', a thematic selection determines the identity of an exhibition maker. A specific concept is then repeated as appropriate at successive art exhibitions, and thereby becomes the brand of an art professional. Social network configurations once again play an important role in this game of identity construction: an association with certain curators and big exhibitions

can also work against an authentic identity construction. An exhibition maker who claims a position of his own may prefer not to form a coalition with his more outspoken colleagues.

'X, who was also linked with Documenta [11 – P.G.], insisted on not identifying with it. So he will do something at Documenta, but he refuses to be named in the press. He didn't want his name mentioned as part of the team. I know that I have to keep my hands off, then. Otherwise they stay away from you for ever because you are too strongly identified with someone. You have to be able to do your own thing and make sure your own identity is not threatened.' (Barbara Vanderlinden, personal interview, 2001)

If Max Weber were still alive, he would perhaps explain all this as an increase in the goal-rational behaviour which increasingly takes its place alongside its value-rational counterpart (Weber, 1975) in a thoroughly professionalized and globalized art world. The new professionals already partly operate in a politics of distinction, in which directions are determined through the detection of a theoretical starting point, the authorization of cultural minorities or of a specific concept, and the subtle social game of forming and declining connections in the facade. We see here the return of the field rationale described by Bourdieu, but then in a broader context. The Bourdieusian competitive politics of distinction certainly plays a role in the international social arena of young curators (Bourdieu, 1977 and 1992), who are concentrated at certain focal points where they can measure up against each other. These meeting points for the international network of curators are provided by Manifesta, Sonsbeek (Arnhem), P.S.1 (New York), I.C.I. (New York) and smaller organizations such as Apex in New York. The biggest platform is of course Documenta. Just as in the field, a certain amount of hierarchical rank order is detectable, but then at global level.

The Dematerialization of Artistic Selections
The story of Hoet and Vanderlinden points to an important shift in selection rationales. In the nineteen seventies, there were still strong

local influences on the choice of an artwork, so that an artwork some-times had difficulty getting beyond the regional context. Globaliza-tion and the nineteen eighties and nineties opened up new possibili-ties, in which Jan Hoet can be seen as an important transitional figure, a 'provincial international' who moved to and fro between the two levels. His commitment to artefacts in his museum depot was a key factor in this. Nowadays, however, there is such a thing as 'art with-out locality'. Some organizations and curators still operate within a region, but with a minimal degree of anchoring. The geographical proximity of an artwork or an artist plays only a limited role. Selec-tion criteria show few signs of a local or geographical influence, unless it is one that relates to a globally determined representation agenda.

The main difference between the selections of Jan Hoet and of Barbara Vanderlinden, a museum director and an 'independent' curator practising before and after the definitive globalization of capi-talism, seems paradoxically to lie in the disappearance of the capitaliz-able object. The artwork itself plays a much smaller role in the global selection rationale of 'independent' curators. And this also means that — in line with the value regimes described — singular and collec-tive content logics play less of a role in artistic selections. Hoet could always allow himself to be led — or perhaps misled — by the artwork itself. This sometimes resulted in years of generous support to the same artist, without any real external reinforcement being accrued. But if such support really failed to materialize, Hoet was obliged to drop the artist. When a material artefact itself has a key role in an artistic network, it also helps determine the make-up of the network. That is why Hoet maintained good relations with gallery owners and collectors. Within his collective context logic they are important al-lies, along with other museum directors. The 'disappearance' of the material object ensures, however, that the 'independent' curator has to fall back on a singular and, even more, on a collective context logic. Within that collective context logic, however, it is not so much collectors and gallery owners as other curators and sometimes art his-torians who are the crucial social referents. Even the artist still counts. But to put it provocatively: what the artist says becomes more impor-tant than what he makes. True to Post-Fordism, linguistic virtuosity plays a crucial role right from the selection process. The shift from material artworks to a trade in immaterial ideas also speeds things up in the art world. After all, material artworks which were once ac-claimed possess a certain inertia. They are deeply and heterogeneous-ly anchored in the artistic network: not only have many critics spent

many words on them, but restorers and insurance brokers, too have close links with them. It's not so easy to get away from an artefact that has been so sanctified — albeit in the past. It's rather different in an art world that thrives on concepts. Ideas come and go like the wind.

The dematerializing of the artistic selection process does not, it should be noted, mean the 'decapitalization' of this process. The immaterial idea itself is commodified within a new global competition rationale — and that in spite of all the idealistic, culturally representative, engaged, sometimes politically correct, but always noble ideas of the 'independent' curator. In Post-Fordism, the word has become flesh.

Bibliography

Becker, H.S. (1982). Art Worlds. Berkeley, Los Angeles and London: University of California Press
Boltanski, L., and L. Thévenot (1991). De la justification: Les économies de la grandeur. Paris: Editions Gallimard
Bourdieu, P., L. Boltanski, J.C. Castel et al. (1965). Un art moyen: Essai sur les usages sociaux de la photographie. **Paris: Editions de Minuit**
Bourdieu, P. (1969). 'Sociologie de la perception esthétique'. Les Sciences humaines et l'oeuvre d'Art **241** (4): 161-76
Bourdieu, P. (1977). 'La Production de la croyance: Contribution à une économie des biens symboliques'. Actes de la recherche en sciences sociales **13**
Bourdieu, P. (1979). La Distinction: Critique sociale du jugement. **Paris: Les Editions de Minuit**
Bourdieu, P. (1992). Les règles de l'art: Genèse et structure du champ littéraire. Paris: Seuil
Callon, M., J. Law and A. Rip (eds.) (1986). Mapping the dynamics of science and technology: Sociology of Science in the Real World. **Hampshire and London: The MacMillan Press**
Coessens, P. (1994). Wide White Space. Brussels: Palais des Beaux-Arts
Gomart, E., and A. Hennion (1999). 'A Sociology of Attachment: Music Amateurs, Drug users'. In Actor Network Theory and After, ed. J. Law and J. Hassard, 220-47. Oxford and Malden: Blackwell
Gielen, P. (2003). Kunst in netwerken: Artistieke selecties in de hedendaagse dans en de beeldende kunst. Heverlee: LannooCampus
Gielen, P., and R. Laermans (2004). Een omgeving voor actuele kunst: Een toekomstperspectief voor de beeldende kunsten in Vlaanderen. Tielt: Lannoo
Heinich, N. (1991). La Gloire de Van Gogh.
Heinich, N. (1993). Du Peintre à l'artiste: Artisans et académiciens à l'Age classique. Paris: Editions de Minuit
Heinich, N. (1996). The Glory of Van Gogh: An Anthropology of Admiration. Princeton: Princeton University Press
Heinich, N. (1996). Être artiste: Les transformations du statut des peintres et des sculpteurs. Paris: Klincksieck
Heinich, N., and M. Pollak (1996). 'From Museum Curator to Exhibition Auteur: Inventing a Singular Position'. In Thinking about Exhibitions, ed. R. Greenberg, B.W. Ferguson, and S. Nairne, 231-50. London and New York: Routledge
Heinich, N. (1998). Ce que l'art fait à la sociologie. Paris: Editions de Minuit
Heinich, N. (1998). Le Triple jeu de l'art contemporaine. Paris: Editions de Minuit
Heinich, N. (2000). 'What is an Artistic Event?: A New Approach to Sociological Discourse', Boekmancahier **12** (44): 159-68
Heinich, N. (2000). Etre écrivain. Paris: La Découverte
Heinich, N. (2002). 'Let Us Try to Understand Each Other: Reply to Crane, Laermans, Marontate and Schinkel', Boekmancahier **14** (52): 200-207

Hennion, A. (1993). La Passion musicale: Une sociologie de la médiation. **Paris: Edition Métailié**

Hoet, J. et al. (1999). S.M.A.K. Museum of Contemporary Art. **Ghent and Amsterdam: Ludion**

Laermans, R. (2000). 'Nathalie Heinich, Sociologist of the Arts: A Critical Appraisal', Boekmancahier 12 (46): 389-402

Laermans, R., and P. Gielen (2000). 'Flanders: Constructing identities: "the case of the Flemish dance wave"'. In Europe Dancing: Perspectives on Theatre, Dance and Cultural Identity, ed. A. Grau and S. Jordan, 12-27. London: Routledge

Latour, B., and S. Woolgar (1979). Laboratory Life: The Social Construction of Scientific Facts. London: Sage

Latour, B. (1988a). Wetenschap in actie: Wetenschappers en technici in de maatschappij. Amsterdam: Uitgeverij Bert Bakker

Latour, B. (1988b). The Pasteurization of France. Cambridge, Mass. and London: Harvard University Press

Law, J., and J. Hassard (eds.) (1999). Actor Network Theory and After. Oxford and Malden: Blackwell

Luhmann, N. (1995). Die Kunst der Gesellschaft. Frankfurt: Suhrkamp

Mauss, M. (1925). The Gift: Forms and Functions of Exchange in Archaic Societies. London: Cohen and West

Merton, R.K. (1948). 'The Self-fulfilling Prophecy', Antioch Review 8: 193-210

Mouffe, C. (2005). On the Political. London and New York: Taylor and Francis Group

Moulin, R. (1992). L'Artiste, l'institution et le marché. Paris: Flammarion

Raminez, M.C. (1996). 'Brokering Identities. Art Curators and the Politics of Cultural Representation'. In Thinking about Exhibitions, ed. R. Greenberg, B.W. Ferguson, and S. Nairne, 21-38. London and New York: Routledge

Weber, M. (1975). Een keuze uit het werk van Max Weber. Deventer: Van Loghum Slaterus

Weick, K.E. (2001). Making Sense of the Organization. Oxford and Massachusetts: Blackwell

Zolberg, V. (1990). Constructing a Sociology of the Arts. New York and Melbourne: Cambridge University Press

Art Politics in
a Globalizing
World

The world of the contemporary arts is more and more globalized, steadily incorporating new regions. As I have mentioned, with the fall of the Berlin Wall, curators and other decisions-makers hurried to the former Eastern Bloc to scout for talent. More than eight years later, it was Africa's turn, and now China and India are becoming a significant market. Artistic centres seem to shift rapidly, or at any rate several centres are forming side by side. This does not necessarily mean that the art world no longer has a centre, but rather that there are many smaller and larger hierarchies appearing in parallel, and which, moreover, are relatively mobile. Processes of rapid hierarchization, de-hierarchization, and re-hierarchization quickly turn every region on earth into a potential player on the contemporary art scene. Who could have predicted, for instance, that the hitherto 'insignificant' Spanish city of Bilbao would find itself on the world map with an icon of modern and contemporary art: the Guggenheim Museum?

Politicians, policy-makers and actors within the contemporary art world itself are becoming ever more aware, thanks to such examples, of the fact that even peripheral zones can in a relatively short time gain a place in the worldwide art scene. After reading Richard Florida, no time is lost before deciding to set up something along the lines of a Guggenheim Bilbao. Policymakers are eager to join a global competition between places-to-be. In this essay I ponder the consequences for the art world of this neoliberal urge for a high profile. Does this 'cultural industrialization' open up new opportunities or are there things that are lost to it? Are there other ways for peripheral zones in the global art world to profile themselves without risking isolation? In other words, is a global networking possible without a capitalist phallic rationale?

The Art World: A Meshwork

Some of the previous essays discussed globalization and its effects on contemporary fine arts. Briefly, these are: an increase in the number of artists; a speeding up in their careers with the coming and going of new artistic trends in an immaterial rationale of ideas; mediatization; de-nationalizing of artistic movements; inflation of the international as symbolic credit and de-differentiation of value regimes. It was also noted in passing that the worldwide art system is in fact a meshwork of countless international sub-networks. A few cities such as New York or London function in that system as universal intersections. Many places are, however, simply mandatory 'passages' for

specific events, such as a biennale (Venice, Lyons, Istanbul) or an art fair (Basel, Madrid). But there is also a level just below the 'top'. This consists of regions and cities that play in the second, third or fourth league and are situated somewhat on the periphery of the global art system. That is not to say that they have no international connections whatsoever. They may simply not be the obligatory passages of this artistic meshwork. I have therefore chosen to use the ANT expression 'weak passages' to designate them. These are regions or cities that do have some connection with worldwide artistic happenings, but none that make them truly significant points of intersection. A previous study concluded that Belgium is one such region, but there are others (Gielen and Laermans, 2004). A follow-up study indicated that even the Netherlands is of limited international importance in the art world, and so are Italy, Luxembourg, Austria and Switzerland (Gielen, 2006). This may be too sweeping, however. The Basel art fair in Switzerland certainly belongs to the top international level. Along with New York, this show is a key centre for the art trade, but, as mentioned, only a temporary one. The same is true for the Venice Biennale, not so much in economic terms (although the Biennale certainly is solidly aimed at mass tourism) as at the artistic and intellectual level. Amsterdam and Biella (Italy) at first sight appear rather insignificant within the worldwide art system, but they do have internationally sought-after artists' residences.

What can we learn from this brief summary? First: there are regions or cities in the world that play only a very temporary role as a mandatory passage in the contemporary world of fine arts. Outside of this short period, they are merely peripheral zones. They are thus, as it were, purely transitory passages. What does Venice represent for today's global art world during the time between biennials? This suggestive question indicates that centre and periphery can change rapidly. It also reveals that some cities, such as Berlin, London, New York and Tokyo, are taking up more long-term positions as significant centres.

Second: the globalized art world is highly differentiated. Thus there are intersections of which the importance is primarily financial in nature (Basel and New York), while others play a role mainly as artistic and intellectual centres (the biennales of Venice, Istanbul, et cetera), or have a crucial 'educational' role (the Van Eyck Academy in Maastricht, *Cittadellarte* in Biella or P.S.1 in New York).

Three: in most cases only cities are involved. We are not talking, therefore, of Italy, but of Venice and Biella; not of the Netherlands, but of Amsterdam; not of the United States, but of New

York, et cetera. What is more, it is not even about cities as such, but about specific museums, galleries, artists' residences, collectors, et cetera. What is important here is that at this level as well, the national label is disappearing.

Mapping the Art World

How can we provide a general and relatively clear picture of this meshwork of differentiated networks and sub-networks? What are the coordinates of this contemporary globalized art world? What are the key notions that form the core of current debates and give meaning to artistic activity? The first one that emerged from our studie is a cultural distinction between two value regimes — based therefore on interpretation and valuation — namely, the opposition between 'development' and 'product', or between a more development-oriented and a more product-oriented set of practices. Development-oriented activity, according to respondents in interviews, follows an investigative approach and is reflexive. Production, by contrast, pursues the goal of showing, and perhaps also trading, the completed artistic works. Production privileges performativity over reflexivity. And yet we must not regard these binary opposites as mutually exclusive. For reflexivity or investigation and a visible product can go hand in hand: witness the modernist and above all the conceptual or avant-garde traditions within twentieth-century art. Moreover, orientation towards production and towards development can both be present in turns within an artistic career. Yet a substantial number of practices were observed that are nearly exclusively development-oriented. These do not lead to a tangible, visual, exchangeable product. But they do deliver, despite their apparent lack of productivity, what is doubtless an important contribution to the artistic climate of a region. When we observe the aforementioned global art centres through the presented binary opposition, the cultural observation grid comes into its own. For artists' residences such as *Cittadellarte* and the Van Eyck Academy are, along with P.S.1, more development-oriented, while the majority of art fairs such as the one in Basel and galleries such as those in New York aim primarily at exhibiting and selling completed products. Although biennales such as those of Istanbul and Venice, and museums such as the Bilbao Guggenheim are, as far as is known, not concerned with the sale of art, yet they also put the main emphasis on exhibiting an artistic product.

When we turn our attention to the cultural difference be-

tween development-orientation and product-orientation, we get a more refined sense of possible activities in the art world. Even a biennial that is in principle 'product-oriented' can nonetheless set up development-oriented activities in order at least to stimulate these. And a gallery owner can also surround his product-oriented activities with platforms for development such as debates, publications, et cetera. The core activity of both the biennial and the gallery remains, of course, primarily product-oriented.

Besides the difference between development and product, a second distinction emerged from the observation of the world of fine arts — one that is not cultural but social. This was suggested, moreover, by the literature on globalization and the theoretical perspective of our study, namely that of ANT. Given the importance this approach attaches to networks and networking, a second differentiation, namely that of the degree of networking, comes to the fore. This has to do with the degree of artistic and social embeddedness, which ensures that a member of the sector can function in more or less optimal circumstances. A good professional network can provide an actor with growth, expansion, 'more and better'. That is the classic career perspective of the (ongoing) growth scenario. More associates, more alliances with recognized artists, with foreign galleries, with internationally active curators, with museums or important art collectors: that is indeed the familiar story, which incidentally fits in with Pierre Bourdieu's (1977 and 1992) vision of the art scene. The actor aims for a greater symbolic capital, which over time can be transposed into economic credit. But in the contemporary fine arts, by no means all artists opt for a fast-paced, international career.

An appropriate networking can also mean finding a stimulating artistic or intellectual context, with room for artistic mentoring, the opportunity for meaningful, substantive discussions, and so on. An actor who seeks this is not career-oriented, but focuses instead on self-transformation and reflexivity. And that is precisely because the person may have the sense that his career as an artist, curator or critic is drying up. Both perspectives, the career-oriented one and what we might call the experimental, demand both a high level and a substantial degree of professional networking. This last point is important. For the mere number of alliances, possibly including international ones, does not tell us anything about the relevance or quality of those contacts.

When the cultural and social axes are crossed, we come to a two-dimensional space for art that can usefully be mapped out in a quadrant.

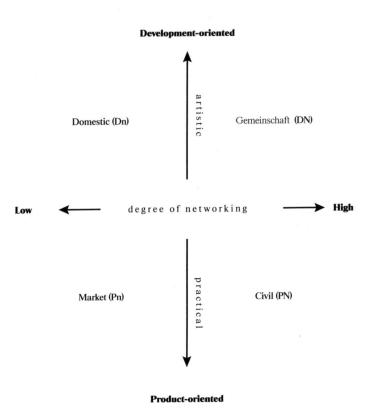

The combination of the two axes results in four zones in which artistic practices and actors can be easily located: domestic, community, market and civil zones. The letter D stands for development-oriented and P for product-oriented. The degree of networking is indicated with a lower-case n for a low degree of networking, and a capital N for a high degree of networking.

The domestic space stands for a development-oriented practice with little networking (thus Dn). The prototypical actor in this zone is the ('Romantic') painter, who meditates at great length in his garret on his potential œuvre. The domestic space provides a safe, intimate atmosphere in which (possibly future) artists or curators can concentrate on the artworks or reproductions around them in peace.

This is the space in which the catalogue can be perused, and where theoretical exposés about art and society can be read. Paradoxically, it is nowadays the space of the internet with which the world can be scanned from the living room. The domestic space safeguards the 'slowability' mentioned in an earlier essay: those in this zone set their own pace. It should perhaps be made clear that the domestic space is not necessarily the same as a 'home'. Domesticity can equally well be experienced in semi-public spaces such as libraries, museums or trains. For example, when an artist or other actor sits peacefully reading or typing on a laptop in the train, the conditions are domestic, however full the train. What is more, the presence of the internet in the living room means that it can be transformed into a different space at a click. Online shopping takes internet users to the mall, and signing a petition takes them into civil society. And when they sit chatting about a new exhibition concept or artistic idea with a peer group of artists, critics or curators, they participate in the artistic community from their armchairs. The rise and democratization of the internet makes it very clear, then, that the activities in the living room are not totally synonymous with those of the domestic sphere. Whenever artists or curators can develop their work or themselves (whether by reading an essay or analysing an image) in peaceful intimacy, they find a typically domestic form of concentration. This space is very different from an open workshop, training programme or residence with an international population such as UNIDEE at *Cittadellarte*, the Van Eyck Academy in Maastricht or P.S.1 in New York. In these centres, there are opportunities for interaction with other artists, and often with professional visitors from various countries and regions. The exchange of ideas stimulates reflexivity, creates a research-oriented climate and, generally speaking, makes for a greater sense of artistic opportunity. At the same time one can speak of a primary networking, and therefore the acting and actors are placed in the space of the *Gemeinschaft* (DN). The reason for dusting down this Ferdinand Tönnies term (with its admittedly romantic and nostalgic undertones) has to do with several issues that crop up in this zone, which recall the attributes of what the nineteenth-century sociologist called the *Gemeinschaft*. Within the *Gemeinschaft*, social interaction revolves around the 'total personality' and face-to-face relations. It is not just the specific skills that actors may have that matter, but also their character, communication skills, capacity for empathy, and sometimes even their appearance, smell or manner of speech or movement. In short, Tönnies' concept has new relevance in the Post-Fordian work context. Of course we are no

197

longer talking of the tribal *Gemeinschaft* that is sustained by strong, long-term, often kinship relations. The open studio and international professional community resemble more the neotribal tribe described with reference to Maffesoli. Relationships here are temporary but are intimate enough (recall the earlier mentioned 'urban intimacy') for a confidential exchange of ideas and other informal social transactions. The open studio, occupied by an international peer group, thus forms one of the institutionalized junctions on the art scene. The crucial thing is that within this space an artistic oeuvre can ripen via social transactions, and can be tested in an international context at an early stage. The reflexivity this generates is therefore social in nature, and quite different to the isolated meditation of the domestic space. Like the domestic space, the space of the *Gemeinschaft* is a 'free' one, in the sense that it has not yet been capitalized on. Developments in this zone can progress relatively peacefully as long as they pay off on the market or are 'recuperated' by it. For the market, these kinds of free zones for 'autonomous' artistic development always carry a risk of a slippery, non-capitalizable surplus. The domestic space, for example, gives the artist the option not to develop any ideas, or just to be lazy. Or even to develop excellent artistic insights and refuse to share them anywhere else. In turn, the space of the *Gemeinschaft* creates scope for endless babble and murmuring which fail to produce any capitalizable end product. And people in this zone can collectively decide to set up alternative economic transactions — an informal exchange market for example — to escape from the market principles that dominate the globe today. (It is well known that artists regularly exchange works or barter them for food and shelter. And in the informal culture of the global nomads, there is an exchange circuit of loaning work, offering accommodation and so on. So the globetrotting art world is not all artistic jetsets and three star hotels.)

In the third space, the market space, the degree of professional networking is low, and the emphasis lies on the visible product (hence Pn). The reason that the degree of professional networking is low here relates to the way the market stimulates a total alienation of an artistic product. One of the central principles of the free market and its competition is that, *de facto*, all goods are exchangeable. Social relations are restricted, then, to purely economic transactions. The prototypical actor in the art world in this zone is the auction, where an artistic product can be turned out without any social relations and in all anonymity. This is also true to a lesser extent of the professional gallery which deals in the art of living artists. Besides the purely

monetary transaction, the symbolic and informal economies discussed in the former essay are at work here too. Art dealing via galleries retains something of the pre-modern trade that depends on less than 'purely' economic transactions and makes buying an artwork a bit different to buying a car. Just as tribalism and neotribalism meet in the art scene, so do pre-modern and Post-Fordian work forms meet in the gallery. But the market itself has little of this hybridity.

Examples of the market space include the bulk of today's art tourism projects, which include the Bilbao Guggenheim. It is difficult for the latter to remain connected with the contemporary professional fine arts world. The institution certainly attracts many foreign visitors, but these are mostly lay people when it comes to art, or rather tourists who show more interest in the building than in the artwork exhibited therein. Only the collection ensures that the museum remains artistically networked, but the international networks that cut across the building today are in fact largely economic and political in nature. A high degree of international networking does not, in other words, necessarily mean a professional, artistic or relevant global position. Institutions such as this tend to play it safe and to bring in temporary exhibits of existing artefacts, arousing little interest therefore among art connoisseurs or professionals. Usually there is little or no space for interaction or discussion with artists or critics. The civil zone, finally, is also product-oriented, but with a high degree of networking (thus PN). Typical examples of such institutions are art fairs, but of a different kind to those of the market space. Art fairs such as that of Basel, New York and Madrid of course exhibit completed works as marketable products. But a professional art fair is also an important meeting place for curators, gallery owners, and collectors — and that's where it takes on a civil character. The museum or biennial, certainly the publicly funded one, go one step further towards the civil space. A museum or a biennial concentrates on exhibiting completed artworks but can also function as a meeting place where informal contacts, especially verbal ones, play a key role. Public debate and legitimation are crucial in the civil domain: the director of a publicly funded museum must justify his purchases in a way the private collector doesn't have to do. Such institutions are therefore the prime locus of art criticism and also of political legitimation. The publicly conducted argument generates a social support base and public debate that is seen as totally superfluous and even disruptive in the market space. Anyone buying or displaying an artwork in the civil space must be prepared to defend it publicly, whereas anyone doing so in the market space prefers to do so as quietly as possible.

Artistic Zones and Legitimation

Perhaps — it is best to be cautious in this regard — the above quadrant constitutes the four-leaf clover, the species that the art world keeps alive. Ultimately, it is a question of maintaining a fine balance between the four zones. For the domestic zone (Dn) offers space for private reflection, but also the right to 'retreat' from the sometimes hectic social whirl of the art world. This is true, moreover, not only for the artist but also for the curator, the gallery owner, the collector, and even the public. The latter get the chance, in the intimacy of a private space, to delve into a catalogue or an artwork. The domestic zone is for private satisfaction, but also for the necessary reflection that is equally justifiable from an artistic point of view. It would suggest a certain degree of 'sociologism' to consider reflexivity to be possible only within a strong socially networked space. So the rationale of ANT must be applied, seeing artefacts such as paintings, books, and videos as social actors too. In this sense the domestic domain is indeed sociable, but people are not the only actors, as in classical sociology. The *Gemeinschaft* (DN), by contrast, starts out from a reflexivity and sense of (preferably international) possibilities that arise from interaction with other subjects and awareness of global artistic evolutions and debates. And yet this space is important first and foremost for the artistic peer group. The aim is artistic development at a high level, which may not yet be comprehensible, accessible or even desirable for the general public. Most people are not interested in how chocolate is made, but simply enjoy the taste, to borrow a metaphor from the food industry. What counts, however, is that this zone is highly valued mainly within professional artistic circles or the art system, where it enjoys the legitimacy it needs and can — as Boltanski and Thévenot put it — lead to 'grandeur'. In this respect, the *Gemeinschaft* contrasts primarily with the market space (Pn). For here the artistic product enjoys top economic, and also political and media interest. In other words, very different regimes of worth are addressed here. Tourism, political representation and mediagenic images or newsworthiness are higher on the agenda than artistic considerations. But — and it is necessary to remain very cautious here — perhaps the art world needs this broad, heterogeneous recognition to a certain degree in order to legitimate or at least gain acceptance for its autonomous artistic, experimental and sometimes quite idiosyncratic place within a wider social context. The tourist or lay person who visits an event with great pleasure, the politician who is happy to use the opportunity for electioneering, and the media which

talk about the readership and viewing figures are perhaps more likely to tolerate the domestic zone and above all the domain of the artistic *Gemeinschaft* than those that show no artistic interest at all. But this is only speculation and based on observations during interviews with artistic stakeholders rather than systematic surveys of public opinion at major art events or tourist sites. What matters is that in the market space there are different types of non-artistic legitimation, and thus it is chiefly other regimes of worth that are addressed. The market space is dominated by the quantitative accumulation regime, whether we are talking about money, the number of artworks in an exhibition, votes, or numbers of visitors/readers/viewers. What is accumulated is irrelevant. It is precisely in this regard that the civil domain (PN) differs from the market space, but also in a way from the other two domains. For this zone enjoys a high artistic value which is *publicly* defended with words or arguments. This can be simply through public exhibition forms which are the main expression of the appreciation of artistic work in the common domain. An artistic product that is not viewed cannot truly go through public, political life — at least social life — as an artwork. That's why this space does not have a solely artistic legitimacy. It is, instead, a truly heterogeneous zone that also applies economic, political and media regimes of worth. Its economic interest lies not so much in mass tourism, but rather in the possible sale of artworks. Yet a high-quality museum or arts event that enjoys a high level of artistic appreciation can also awaken appropriate political or media interest. As we have seen, the distinctive feature of the civil space is the spoken word: the public argument that accompanies artistic, political, economic or media transactions here. The civil space is ruled by a regime of adoration and argumentation. It is worth underlining that it is a combination of these two, to make it clear that we are not working with a Habermasian version of purely rationally-based argumentation. This kind of public argumentation relies just as much on emotional, sometimes sentimental and rarely scientifically verifiable arguments. The way people can adore a work of art without having rational grounds for it is comparable to the way they can embrace a loved-one, believe in a religion or support a political ideology. The civil space, in other words, is all about the publicly defendable choice, and it is important that it is always implicitly communicated that it is just one of the possible choices.

The important thing is that in the quadrant each zone has certain dominant regimes of worth as well as significant legitimations that differ from those of the other zones. Extending the reasoning of ANT further, it can be stated that the present-day art world

needs this heterogeneous recognition, given that according to the 'theory', it is precisely heterogeneous networks that have the greatest chance of survival — providing of course, for the necessary transformations or even transmutations. One thing is certain: where a single zone dominates, there is the danger that artistic dynamism will run aground. Imagine, for instance, that only the domestic domain (Dn) were to survive: in that case, the artistic scene will be reduced to a private event, and perhaps even a purely therapeutic activity. Too much of the space of the artistic *Gemeinschaft* (DN) will make for a lot more debate and laboratory work, but without the results (if any) being implemented. And a dominance of the market space (Pn) or the civil space (PN) could mean that space for experimentation dries up and artistic renewal is absent. Such a situation tends, in other words, towards maintaining a status quo within the art world.

This analysis leads, therefore, to the conclusion that every 'healthy' art world must maintain a sometimes agonistic balance between the domestic, the *Gemeinschaft*, the market and the civil domains. The question is whether national governments can maintain such a balance. And indeed, whether this is still necessary today in such a highly globalized art system.

The Politics of the Arts in a Global Context

The questions just posed are, of course, deliberately provocative. Using the quadrant to 'map' and analyse the global art world raises the possibility of proposing an internationally differentiated arts policy. This means that certain countries, regions or cities will deliberately choose specific policy emphases, based on their knowledge of the present-day global art scene and their specific political, economic, demographic and geographic position.

But now that we known that the globalization of the neoliberal market space leads, among other things, to a much faster accumulation and commodification of the current art scene, the question is how we should respond to this. In the terms of the quadrant, it means primarily that the market space (Pn) is overpopulated at the global level. This reduces and even threatens to eliminate the space available for public argument. The result is a lack of artistic innovation and an increasing likelihood of our consuming variations of the same thing wherever we go. An arts policy that takes this as its aim will tend to develop neoliberal market instruments and logic, for example by investing in spectacular museum architecture and tourist art

events. Such policy decisions can best be described as 'post-political', since they really only follow market principles and fall under one ideology: neoliberalism. A truly political or neopolitical policy looks for alternatives, whether by investing in development-oriented activities or by strengthening the intermediary role of public argument. It should at least be made clear that a genuinely political choice does not have to be anti-market: it can also be neoliberal. For a policy to be called neopolitical, its decisions should be communicated as choices from among multiple possibilities — including neoliberal ones. But the problem with post-politics is that it pretends that there is only one possible — or realistic — option. The quadrant shown above demonstrates that a government or a policy has the choice of investing in several domains. What is more, it can do so without fear of global isolation. In a global context in which the market space is gaining ground, it might be useful to look for alternative spaces. This will also enable people to make their mark in a global context and gain international appeal. And we should not forget that capitalism can only survive because of free spaces such as the zones for development sketched above. Capitalism only exists thanks to zones that lie beyond it and thus escape its logic and laws (for example, the political space in which it is decided that there is such a thing as the right to property, and a judiciary that enforces this right). Spaces for development in which ideas can grow (and can also fail) are part of this territory. The market can of course cash in on ideas at any time, but in the free spaces there is always the 'risk' of a non-capitalizable surplus. This surplus can stay unnoticed in the domestic space or it can be dispersed in the endless murmuring of the artistic *Gemeinschaft* ... or it can flow into the 'common' where anyone can use it and no one can appropriate it. The chances of having this free-floating surplus, or idiosyncratic murmuring, is certainly great within the Post-Fordian economy that depends on communication, linguistic virtuosity, and thus on the word. Post-Fordism develops its own biopolitical strategies for exploiting this communication flow. A truly arts-minded policy will always look for escape routes within this, maximizing the spaces for surplus. By doing so, politics in fact defends its own domain and rationale as that of the non-capitalizable word, of sometimes endless debates and undirected murmuring, but always aimed at creating social opportunities. To paraphrase Robert Musil, everything that is could be otherwise. This is exactly what politics and art have in common. And if politics or art cease to believe in Musil's slogan, we'll be left with nothing but post-politics and an equally cynical post-art.

203

Bibliography

Abbing, H. (2002). Why Are Artists Poor?: The Exceptional Economy of the Arts. Amsterdam: Amsterdam University Press
Bennett, T. (1996). The Birth of the Museum. London and New York: Routledge
Boltanski, L., and L. Thévenot (1991). De la Justification: Les économies de la Grandeur. Paris: Gallimard
Bourdieu, P. (1992). 'La Production de la Croyance: Contribution à une économie des biens symboliques'. Actes de la recherche en sciences sociales 13
Bourdieu, P. (1992). Les Règles de l'art: Genèse et structure du champ littéraire. Paris: Seuil
Danto, A. (1986). The Philosophical Disenfranchisement of Art. New York: Columbia University Press
Franck, G. (1993). 'Ökonomie der Aufmerksamkeit'. Deutsche Zeitschrift für europäisches Denken 47 (9-10): 748-61
Gielen, P. (1998). 'Dans om de macht: Positionering van de hedendaagse dans in Vlaanderen'. Boekmancahier 10 (36): 127-41
Gielen, P. (2003). Kunst in netwerken: Artistieke selecties in de hedendaagse dans en de beeldende kunst. Leuven: LannooCampus
Gielen, P. (2004). 'Welcome to Heterotopia'. International Fine Art Journal for Social Change 3 (2): 1-21
Gielen, P., and R. Laermans (2004). Een omgeving voor actuele kunst: Een Toekomstperspectief voor het beeldende-kunstenlandschap in Vlaanderen. Tielt: Lannoo
Gielen, P. (2005). 'Art and Social Value Regimes'. Current Sociology 53 (5): 789-806
Gielen, P. (2006). 'Educating Art in a Globalizing World: The University of Ideas: A Sociological Case-study'. International Journal of Art and Design Education 25 (11): 5-18
Gielen, P. (2007). 'Artistic Freedom and Globalisation'. Open: Cahier for Art and the Public Domain 12: 62-70
Glaser, B., and A. Strauss (1967). Discovery of Grounded Theory. Chicago: Aldine
Hannula, M. (ed.) (1998). Stopping the Process?: Contemporary Views on Art and Exhibitions. Helsinki: NIFCA
Heinich, N. (1991). La Gloire de Van Gogh: Essai d'anthropologie de l'admiration. Paris: Editions de Minuit
Heinich, N. (2005). L'élite artiste: excellence et singularité en régime démocratique. Paris: Editions Gallimard
Held, D. et al. (1999). Global Transformations: Politics, Economics and Culture. Cambridge, UK: Polity Press
Latour, B. (1993). We Have Never Been Modern, transl. by C. Porter. Cambridge, MA: Harvard University Press
Luhmann, N. (1995). Die Kunst der Gesellschaft. Frankfurt: Suhrkamp
Luhmann, N. (1997). 'Ausdifferenzierung der Kunst'. Art & Language & Luhmann, ed. Institut für soziale Gegenwartsfragen Freiburg I. Br. und Kunstraum Wien, 133-48. Vienna: Passagen Verlag
Luhmann, N. (1997). 'Die Autonomie der Kunst'. Art & Language & Luhmann, ed. Institut für soziale Gegenwartsfragen Freiburg I. Br. und Kunstraum Wien, 177-90. Vienna: Passagen Verlag
McLuhan, M. (1964). Understanding Media: The Extensions of Man. London: Routledge & Kegan Paul
Moulin, R. (2000). Le Marché de l'art: Mondialisation et nouvelles technologies. Paris: Flammarion
Quémin, A. (2002). L'Art contemporain international: Entre les institutions et le marché. Nimes: Jacqueline Chambon/Artprice
Robertson, R. (1992). Globalization: Social Theory and Global Culture. London: Sage
Sassen, S. (2001). The Global City. Princeton: Princeton University Press
Urry, J. (2000). Sociology Beyond Societies. London: Routledge

Art Politics in a Globalizing World

Velthuis, O. (2005). Talking Prices: Symbolic Meanings of Prices on the Market for Contemporary Art. **Princeton: Princeton University Press**

Welcome to Heterotopia

'Heterotopia are not easily located within a system of representation but neither do they exist sui generis. Heterotopia do not exist in the order of things, but in the ordering of things. They can be both marginal and central, associated with both transgressive outsiderness as well as "carceral" sites of social control and the desire for a perfect order. But in both cases heterotopia are sites of all things displaced, marginal, novel or rejected, or ambivalent. They are obligatory points of passage that become the basis of an alternative mode of the ordering of those conditions. Through their juxtaposition with the spaces that surround them, they come to be seen as heterotopia.'
Kevin Hetherington

The Art Project

In February 1994, the Italian artist Michelangelo Pistoletto laid the foundations of his *Progetto Arte*, The Art Project in Munich. To say the least, this is a remarkable title for a work by someone who has occupied quite a prominent place in the art world for about half a century. When he abandoned the self-portrait in favour of the mirror in 1961, he assured himself a place in the annals of art history. What then could this title mean? Would it deal with the ultimate work of art, or maybe with his very last one? Or rather, does Progetto Arte suggest with a touch of irony that we are dealing with Pistoletto's first real work of art? Upon closer consideration, it appeared that The Art Project is not a material object. It is not an artistic artefact or an image. At the most, it comprises a concept or an idea which originated in 1994, yet which still has not been completed. It looks as if that project will not be brought to completion within the artist's lifetime. For this reason, Pistoletto is doing everything to further the continuation of the artistic work without him.

The Art Project could be described as an ongoing conversation. Since 1994, the artist has been organizing workshops, mainly at art academies all over the world. Munich, Turin, Milan, Vienna, London, Tokyo and his present residence in Biella have provided temporary plateaus where discussions and video conferences are held. The subject of discussion: 'the role of art and of the artist in the world

of today'. Pistoletto found the initial impetus for all these talks in some rudimentary assessments of the present condition of our society. In his view, the twentieth century witnessed an exponential acceleration of scientific and technological developments. On the one hand, fast communication technology brought the inhabitants of this earth closer to each other; on the other hand, they are the root of conflicts between ethnic groups which are desperately seeking their own stable identity. Within the global system, only one logic is playing a dominant role, namely that of the neoliberal economy which leaves less and less space for resistance to the rule of profit. This basic analysis of the world is, to a remarkable degree, in keeping with a lot of macro-sociological assessments by sociologists and researchers like Arjun Appadurai, Manuel Castells, John Urry, Paolo Virno, Michael Hardt and Antonio Negri. In different ways all these thinkers point at the same phenomena within our contemporary globalized society. This increasing globalization is mainly prompted by the logic of the free-market economy and it causes time and space to shrink. The economic basis of the new world makes every form of ideology look suspicious. Utopia gives way to crypto-utopia: a way of thinking which sees perception, value and belief as substantial realities. As of today, we are dealing with a new idealizing vision of the world which pretends not to be an ideology and proclaims pragmatism as the sole value. The manager with his love of order and efficiency is the quintessential citizen of this new cosmopolitan world, as well as an arduous propagandist of its new ideology. Within this paradigm, utopias are considered to be a senseless waste of time. At present, a new category of new professionals constitutes a new global hegemony, broadcasting 'we have to be realistic' as their main message. The only legitimate dream tells us that we can no longer be dreamers. Quite paradoxically, this is the essence of The American Dream. In the vehement character of the no-nonsense rhetoric or of market-manager realism, it is easily to forget that it is only one possible principle of organization among so many other ones.

In addition to this dominant anti-utopia, technological developments such as communication technology and transport facilities generate both a real and a virtual hypermobility which enable individuals and groups to trot about the globe at greater speed. An exponentially increasing number of 'movers' such as tourists, migrants, travelling business persons, refugees, and diplomats, cross over regional cultural practices with the same ease as they cross over the borders of the antiquated nation state. The place from which power

was wielded and which was easy to locate, as it was confined to a certain area, has changed into a permanently moving or fluctuating space. Politicians can no longer govern their region or nation in the same manner as a farmer takes care of his carefully fenced-in plots of land. Geographical borders have become easier to cross than to patrol. And if they are closed, many movers will find other escape routes or flows. The traffic controller is a better metaphor for the role of the politicians than the farmer. One of their main tasks is to direct massive streams of these who pass through the electoral domain via train stations, airports, cargos, and computer modems. At the beginning of the twenty-first century, the political region and the nation state turned into transit zones for capital, goods, people, viruses and information waves.

In one way or another, Michelangelo Pistoletto appears to be especially sensitive to such global shifts in society. In 1988, he announced that the next year would be the *Anno Bianco* (The White Year), an artistic project in which the dimension of time occupied a central place. Pistoletto attempted to organize twelve exhibitions in galleries all over the world, registering the most important events of that year. Just as the mirror reflects the surroundings in which it is placed at random, *Anno Bianco* was to reflect the year in which the project took place. In other words, Pistoletto allowed his work to depend on relatively contingent factors. This is of course one of the central motifs underpinning his oeuvre, in which a lot of space is given over to the fortuitous or the 'accidental'. Every fact corresponds with an accident and an artistic oeuvre is both separated and linked by fate. By embracing this concept, Pistoletto reveals himself to be the artist of contingency. Everything that is could just as easily have been otherwise: nothing is necessary and nothing is impossible in the capriciousness of history. With this vision, the artist penetrates to the heart of the question of the place of art within contemporary society. It is a place that can no longer be actualized by means of unequivocal, abstract positions. For instance, not for decades has the role of artistic artefacts and concepts in our society consisted of an alleged imitation of reality. This mirror function has long been taken over by other media. Nor is art's essential preoccupation its critical function. The artist does not stand outside society, as so many creative individuals would be quite happy to believe. Like all other subjects and objects, they are always part of society. The putative outsider position is simply based on an exotic misunderstanding. Yet artistic artefacts do confront common-sense concepts with other conceptions of reality and with other

perspectives from all over the world. In other words, they widen the horizon of possibilities and thus make visible the contingent character of the continuous reductions of complexity through which we observe the world. 'Good art' disrupts the aforementioned crypto-utopia, as it were. The artistic domain shows that contingency is a necessary pre-requisite for a viable, because perpetually 'possibly different' world: the ultimate protection against social claustrophobia or collective compul-sive neurosis. By making contingency the central subject of his oeuvre, Pistoletto consciously thematizes this effect of art.

'Order is not determined by an a priori will but is a combination formed by accident or by a series of accidents. The fragment is ordered material interrupted by accident; the generating or regenerating element is therefore accident. The knowledge and the experience of ordered forms is projected into the future through the accident of today. To place difference of every kind (of style, conception, space, meaning) between my various works is to mark as deeply as possible the condition of accident, hence the vital present.'
(Pistoletto, 1988)

Whether by coincidence or not, 1989, the year which was chosen to be the *Anno Bianco*, would go down in history as the year of the student revolts in Tiananmen Square in China and, probably to a much larger extent, at least for Europe, of the fall of the Berlin Wall. This crumbling of the physical borderline between East and West confirmed a new phase in the process of globalization and ushered in the above-mentioned crypto-utopia. The competition of the free market became the ultimate organizing principle within global social interaction. By choosing this very year as his *Anno Bianco*, Pistoletto became the registrar of this series of events with their great impact. The introduction of the historical fault-line in his work could be considered to be an important substratum for the Progetto Arte: the reflection upon the position of art and of the artist in this new world, whom Pistoletto considered to be slowly drifting away from histori-cal surroundings. The Kantian paradigm of immanent artistic beauty which is marked by its a-historical universality and disinterestedness

still inspires a great many thinkers. Quite to the contrary, Pistoletto conceives of art and of the artist within reality. This implies that both relate to a historically determined artistic context, but also to scientific, economic and political contexts. And in his view, the artist ought to play a role in all of these social spheres. He can no longer withdraw into the cocoon of his own artistic universe, since society can no longer be understood in terms of neatly defined territories. The existential conditions of this universe are determined elsewhere and the artist has to intervene in this, if he is to play a role in the future. By maintaining the position that the artist has to weave a web between all the major threads making up the contemporary 'fabric of society', Pistoletto is defending a relatively a-modern idea. The artistic domain cannot be conceived of as an independent, sovereign space, because art in a Post-Fordian society has been decentralized. This means that, like all other social practices, from its very inception, art is embedded within a complex network of power relations and epistemological relations; this is the case even before artefacts are launched on the art market. Within this concept, both art and the artist are hybrid beings which are artistic and political and economic all at the same time. Whereas the modern 'constitution' liked to keep things separate — one was either political or economic or scientific or artistic — Pistoletto tends towards an 'impure' form which, at the same time, is of much greater complexity. At present, it is this very body of ideas which nourishes the debate in the Progetto Arte: is there a need today to rethink the model of the artist which is still based on ideas of purity dating back to the Enlightenment?

The Artist in the Mirror

As we saw in the first essay in this volume, throughout her work, the French art sociologist Nathalie Heinich outlines a version of the evolution of ideas about the role and nature of the artist. In her view, the conception of the artist as a timeless prophet is an archetype which emerged towards the end of the nineteenth century, based on the Dutch painter Vincent van Gogh. For Heinich, Van Gogh symbolizes the transition from the collective regime of academia to the singular constitution of modernity. Furthermore, the discourse that grew up around Van Gogh reflects a shift in several important artistic values. For instance, the focus shifted from the oeuvre to the individual who creates it; the normal was traded in for the abnormal, for instance in the way conformity to the academic norm was traded in for the cult

of the strange. An image of 'particularity' is associated with the artist; it is based upon concepts like 'excess', 'personality', and 'marginality'. According to Heinich, this emphasis on particularities happens by means of — amongst other procedures — linking the uniqueness of the work of art to biographical and psychological information about the artist. This entails the personification of the work of art: subject and object, art and artist conclude an obscure pact which is 'signed and sealed' — by a signature. Shot through all this is the notion of authenticity: for the Romantic artist, there was a connection between the artwork and his innermost being. The artistic artefact is the mirror of his unfathomable psyche: art as expression, exemplified by the painting in which Van Gogh portrays himself with his ear cut off. For the avant-garde artist, the successor of this Romantic artist, this labour of individualization implies a transgression of the frameworks defining art. However, this deviance must bear the stamp of the artist: transgression always needs to be ascribed to an individual. Indeed, it is a brand name: for almost fifty years, Pistoletto has been defined by his one distinctive 'discovery' of the mirror.

What does it mean when an artist trades in the painted self-portrait for a mirror? To begin with, it points to a lot more than to a simple politics of distinction within a modern logic of art. An evident angle of incidence lies with the positioning of the mirror with regard to the painting. For one thing appears to be rather evident: the painting fixates. It fixates an image through which it freezes time at first, after which it will inevitably be caught by time. The first makes it possible for paintings to have a special documentary value regarding events which took place both within and beyond the art world during the period in which they were made. The second move entails the possibility of speaking about 'dated' images. The painting can be situated in time and, for this reason, can be labelled 'classic' or 'déclassé'. The image reflected by a mirror is of a totally different nature. It abandons fixation in favour of instability. The image which is presented to us by the mirror only refers to the moment of its genesis in a minimal manner. First and foremost, it attempts to continuously catch up with time. The reflected image comprises the instantaneousness in which past and present merge. It was for good reasons that the first mirror which Pistoletto exhibited in Turin in 1962 was entitled *Il Presente*, or The Present.

The self-portrait as *pars pro toto* of a form of painting not only freezes time, but also incarnates the way in which this fixation is realised by means of the personality of the artist. By fixating himself,

the artist emphasized his own uniqueness and singularity. It is no co-incidence that the self-portrait gained importance during the Renaissance, the cradle of bourgeois individualism. The link between the artist and the artwork is visually sealed in this type of artistic artefact. The singular authorship is triumphant, as it were, in the self-portrait. The artist places himself in an auratic perspective at the centre of the world. He construes his ego as a historical figure at the junction of different events. The mirror not only changes the dimension of time, it also radically breaks with this ego-staging. The artist who observes himself in the mirror, no longer just sees himself, but also his surroundings. Furthermore, any spectator can take his place. By means of the mirror, Michelangelo Pistoletto allows heterogeneity to erupt and he can no longer leave it unaccounted for afterwards: 'There arises a relationship of triplication of the subject: I the viewer, I on the surface, I in the reflection; and there arises a weaving together of relations among all the other elements' (Pistoletto, 1988).

In this process, the artist conceives of himself as a heterogeneous being with regard to all other things and therefore also to his own relativity. When he steps out of the reflecting surface of the mirror, his own image disappears. Its space is cleared for the reflection of other objects and subjects. The artist in the mirror is but a passer-by like numerous others. The politics of the ego which were symbolized by the self-portrait give way to a politics of an alter-ego relationship, as it were; in the process, the artist puts time and space in perspective. Pistoletto often emphasizes this idea by introducing people in the mirror. While the people who have been fixated on the mirror freeze in time, many other egos pass them by. In other words, it is in the mirror that Pistoletto discovers in 1961 a particular possibility, namely heterotopia. It was only twenty years later that the French philosopher Michel Foucault would make a comparable association:

'The mirror is a utopia after all, since it is a placeless place. In the mirror I see myself where I am not, in an unreal space that opens up virtually behind the surface; I am over there where I am not, a kind of shadow that gives me my own visibility, that enables me to look at myself there where I am absent – a mirror utopia. But it is also a heterotopia in that the mirror really exists, in that it has a sort of return

214

effect on the place that I occupy. Due to the mirror, I discover myself absent at the place where I am, since I see myself over there. From that gaze which settles on me, as it were, I come back to myself and I begin once more to direct my eyes toward myself and to reconstitute myself there where I am. The mirror functions as a heterotopia in the sense that it makes this place which I occupy at the moment when I look at myself in the glass both utterly real, connected with the entire space surrounding it, and utterly unreal – since, to be perceived, it is obliged to go by way of that virtual point which is over there.'
(Foucault, [1984] 1994)

Pistoletto calls himself a Minus Artist: the artist who devises a modest move within an immense configuration network of many moves, of which he himself is a constituent part. Each work becomes a new point in this interplay which is no longer completely subordinated to the artist. The 'author' moves to the sideline as soon as the artistic intervention is completed in order to have it 'filled in' by other things: contemporary surroundings in case of the mirror, for instance, or a contingent succession of historical events in *Anno Bianco*. Pistoletto thus construes 'perpetuum mobiles' or motionless movers. After having been constructed by the artist, the artefact starts to operate autonomously as a cause in-and-of-itself, 'sui generis'. The mirror continues to endlessly reflect in front of it, independent of the artist. One could state that Pistoletto constructs 'open' works of art which are based on an awareness of otherness. At times they let the latter slip in, or at least invite it to do so. The Minus Artist does however retain his singular character, but always relates it to a much larger world and history. The artist in the mirror no longer is a person who falls back upon himself; instead he opts for a directed self-relativization of his individual position. At the same time, it implies a calling into question of the role which he plays within the present constellation of the common. Pistoletto puts a question mark over the humanist inheritance of the belief in the autonomy of the artist. The artistic act of complete self-determination is approached with due scepticism. However, self-relativization does not imply a minimization of the role of the artist. It

215

simply quite literally means: 'to relate itself to'. Acts, whether or not of an artistic nature, always take shape in an interplay in an interdependent chain of actions and reactions between people and things. The world does not revolve around the artist, who is but a tiny particle within a gigantic quantum conglomerate, a multitude.

Minus Objects/ Quasi Objects

In the mid sixties, Pistoletto took these ideas further with his *Oggetti in Meno* or *The Minus Objects*. The reflection in the mirror is abandoned in favour of the practice of placing the most divergent objects in a given space. The only thing which keeps these objects together is the differences between them. Compared to the mirror, these objects bestow a more active role upon the spectator as the latter needs to move in between these artefacts. This performative statute bestows the role of quasi-objects upon the *Oggetti in Meno*, as they were described by Bruno Latour: hybrid beings in the border zone between an ideal and a material world. Latour problematizes the dichotomies between the idea and the material, mind and body, subject and object, culture and nature, which originated in classic antiquity and were subsequently reinforced all over the West by Christianity and which have ultimately been validated as basic differentiations by several scientific disciplines. In his oeuvre, Pistoletto regularly plays with this dichotomy. For instance, in 1995 he had concepts like 'Scienza', 'Musica' or 'Economia' inscribed in three-dimensional letters on top of the doors on the outside of the spaces in *Le Porte di Palazzo Fabroni*, which implies that the 'meaning' of a given space was present in the adjacent room. In *Anno Uno*, a piece of theatre performed in 1981, he used people as columns to hold up a wooden construction. In this work, subjects became objects, or rather quasi-objects: if they were to break down, the fragile architectural construction would collapse. Within Latour's frame of reference, one could locate the *Oggetti in Meno* and the quasi-objects of *Anno Uno* in between the poles of people and things. They are located at the very spot where splitting them up becomes unthinkable because, as Latour proved, dualism and dialectics are endlessly revolving around it without focusing on it. For instance, as artistic artefacts, the *Oggetti in Meno* are much more 'social', much more construed and much more collective than natural objects; yet one can by no means reduce them to simple machines for the projection of meaning. They are much more real, a-human and objective than mere symbolical representations: '... with regard to the

"Minus Objects" and to Pistoletto's oeuvre as a whole, one should not speak of symbols. These things don't "represent", they simply "are". They do not carry concepts, they are the arrival point, the terminus' (Serafini, 2001).

The *Oggetti in Meno* constitute a terminus, indeed. For this reason, Pistoletto does not refer to them as constructions, but rather as 'liberations'. They were constituent parts of a whole from which they have been subtracted, hence the minus. The artefacts do not signify a surplus, but rather a 'less-than-the-whole'. This 'negative' definition might, at first sight, appear to be quite opaque, maybe even mystical. Yet, Pistoletto's discourse relies on a well-known paradigm, namely that of semiotics. This scientific discipline works on the assumption that signs only get meaning in relation to other signs. The context is decisive for the frame of interpretation of the concept in question. Consequently, meanings are interwoven in a network of signs. Something comparable is at stake with the *Oggetti in Meno*. In Pistoletto's view, they get new meaning as the combinations between them change. Yet artefacts do have some defining power, if only on account of their materiality. At the simplest level, they oblige the spectator to walk around them, for instance. In this sense, they represent a relative ontology and not an absolute relativism, as some semioticians and other postmodern characters would have us believe. However, artefacts have barely any immanent value. I say 'barely' because as a result of their historical uses, the *Oggetti in Meno* do fixate certain meanings, just as some signifiers solidify as a result of being used repetitively within the same semantics. An identity is fixated in the refrain, in repetition.

In the *Oggetti in Meno*, the refrain is contained in a programmatic manner in the plural of their name. The *Oggetti in Meno* can be exhibited as singular objects, but their common label makes it impossible to avoid interpreting them in terms of a connection with other artefacts. Once again, their very name points out to us that we are dealing with heterogeneous entities whose identities and roles are in part determined by the relations between them. The relational is the very instrument by means of which we are to acknowledge them. Each artefact exists in a juxtaposition with other objects that is enhanced by the passage of time. This relatedness is underlined by the plural form. Consequently, every presentation modality implies a simplification of the work, for it is but one choice out of many possibilities. In theory, an indefinite number of combinations are possible; in practice, however, the patterns of interdependency are limited to

a certain number of configurations. Within a given presentation, the possible contributions of the *Oggetti in Meno* to the whole are temporarily located within a relatively marked definition. Consequently, both the architecture — the material and the discursive space — and the exhibition curator carry a special responsibility, for both contribute to the way in which the *Oggetti in Meno* will 'enrol' the spectator. This refers to the way in which the spectator will be defined by the presentation and to the role which will be allotted to him by means of this presentation. Subsequently, the contextualization of the *Oggetti in Meno* determines the possible scenarios according to which the spectator can 'enrol' himself, for he still has the personal choice between several trajectories within the (pre-)organized space.

Whereas the above is implicitly valid for all presentations of art, Pistoletto thematizes this complexity in his *Oggetti in Meno*. The title in the plural form shifts the focus from the singular object to the relations between them and consequently also to the problem of displaying them. Furthermore, the artefacts represent a whole minus one, which means that they need to be redefined time and again to arrive at this common. The *Oggetti in Meno* are conceived in such manner that they refer to the contribution of several actors as well as to their shared responsibilities. In their capacity as quasi-subjects, they call upon an extended social configuration. Once again, the impact of the artist is called into question or is at least related to — and hence made dependent upon — the contribution of other people, institutions and objects. They become co-authors or co-producers in a heterogeneous game within one unique presentation. By doing this, Pistoletto's shift of accent from the singular object to interrelations and mediation emphasizes the event character of every exhibition. The focus shifts from the intentional artistic act to the perceived event. The total group of actors can only try to create the conditions in which an experience can take place in optimal manner. Every exhibition brings together objects, subjects and social configurations in a different relational context, thus also in a new frame of meaning. For each and every time, they are turned into a conjectural event in co-production with objects, subjects and configurations which may or may not be of relevance. In other words, the *Oggetti in Meno* are not dealing with the order of things, but with the process of ordering. In this manner, Pistoletto impacts not only on our perception of art, but also on the way in which the art system functions. The *Oggetti in Meno* can be read as a modest institutional comment: only up to a certain degree does the meaning of artistic artefacts depend on the intention of the artist,

218

since a polyphony of connotations is woven by a heterogeneous common of subjects and objects. It is this collective configuration which generates artistic meaning by its interwovenness. What is uncovered in the process is one of the few things which can be stated with regard to the work of art with relative certainty. During its entire history, the artwork has attempted to connect itself. For instance, music 'begs' to be listened to; paintings, sculptures, dance performances beg to be seen and/or heard. Without these interested eyes and ears of the common space, the artefact does not have any artistic meaning. With the rise of modernity, this urge to connect has only been intensified. In pre-modern times, only nobility and the clergy decided what was 'artistic'. This all-controlling royal or religious gaze on the artefact has been sidelined by modernity. As a result, however, the reference point of the artwork became less unequivocal. With whom or what ought it to associate now? For, in the modern world, the work of art is the object of economic, political and artistic configurations. Despite the efforts of many, it refuses to be reduced to one of these categories. Whenever the artistic artefact shows itself in the common — for example in a museum — it is subject to the gaze of politicians, businessmen, sponsors, art critics, programme makers, and curators alike. Consequently, it is at this very locus that the artefact engages in the most heterogeneous of connections. Like a tiny Machiavellian, it is searching for 'fans', coalition partners or allies. In the process, it is oblivious to those who might be in the exhibition hall or in the museum, for, as everybody knows, artefacts cannot see. Artworks — not to be confounded with artists — can unconditionally and without any preference associate with everything and with everybody. After all, it is up to the spectator — for the work of art still is in the eyes of the beholder — to decide whether its desire to construct a network is reciprocated or not. Quite paradoxically, in this urge to connect, the artwork does not contradict the modernist claim to autonomy. In fact, it is dependent upon an amalgamation of spectators and mediators. The *Oggetti in Meno* make this abundantly clear. Michelangelo Pistoletto further extends and expands the heterotopic artistic reality of the mirror by emphasizing the relational instead of the immanent, differentiality instead of univocality, heterogeneity instead of homogeneity, ambivalence instead of unequivocality, the common instead of the universal. Pre-existent frames of reference and categories of observation are increasingly shaken and shuffled.

Heterotopia

In his book *The Badlands of Modernity*, the English sociologist Kevin Hetherington (1997) probes the nature of the social order within modernity. For this purpose, he searches for spaces which, during the eighteenth century, gave meaning to marginality, transgression and resistance. Michel Foucault's (1984) concept of heterotopia occupies a special place in this research. In Foucault's work, this originally medical concept is translated into sociological terms as the organization of a social space which is somewhat different from everyday surroundings. Heterotopia displays itself in between eu-topia: the place of good, and ou-topia: the non-place. As early as the sixteenth century, Thomas Moore intertwined both Greek notions in the neologism utopia: a good place which only exists in our imagination. Utopia shows us the way to a better place, yet only exists as a socially constructed desire. It is the horizon, a point of possibilities beyond reach which creates a glimpse from the other side of both the world and of heaven. However, as we progress, this horizon continues to recede as an unreachable border. To be sure, such a collective fiction does generate reality effects. It organizes real spaces by means of ideas and of practices which, in some way or other, represent 'the good life' or at least the desire for it. Heterotopia expresses a concrete translation of this sort. Whereas utopia is an imaginary construction of a well-defined social order, heterotopia constitutes the uncertain local play of social ordering in reality. And precisely because of the way heterotopia allows space for hybridity and paradoxes, utopia is in the air. Contradictions are only experienced as such because of the way the surrounding space is organized. Consequently, heterotopia only exists in relation to other social forms of organization.

According to Hetherington, at a certain moment in history, the Palais Royal — which was built for Cardinal Richelieu in the vicinity of the Louvre in Paris — was a good example of such a place of paradoxes. Towards the end of the eighteenth century, its then owner, the aristocrat Louis-Philippe, the Duke of Orléans (a cousin of the King of France) transformed the complex from a monolithic function as a place of residence into a multifunctional space with several shops. Rather quickly, the Palais Royal developed into a polyphonic complex with theatres, an opera, cafes, restaurants, commercial enterprises, coffee houses, et cetera. Festivals and circus entertainment generated a carnivalesque atmosphere. They were the vehicles which brought about social inversion between the highest and the lowest strata of the population. Quite paradoxically, all the symptoms of

modern consumer culture found a place within the property of one of the leading members of the aristocracy at that time. Incidentally, it was in a coffee house at this complex that, on July 12th 1789, Camille Desmoulins jumped on a table and gave his famous speech, after which the Bastille was stormed, sparking the French Revolution. In other words, the Palais Royal was a stage for a curious mix of the orthodox and the heterodox. Whilst part of the heritage of the *Ancien Régime*, it was at the same time a place for a new era. These are more or less the features of a heterotopic place. The boundary between centre and periphery cannot be drawn by evidence. Every social order always implies deviant forms which converge at those places populated by irreconcilable things, people and ideas. Cultural practices which are experienced as paradoxes merge in an unexpected bricolage. In other words: disorder is always already present within order.

It is this very principle which Michelangelo Pistoletto introduces into his Art Project: 'Progetto Arte is the visible sign of a possible principle — that of the joining of opposites — which can be applied to all social contexts, in terms both ideal and practical' (Pistoletto, 1994).

Cittadellarte

The debate which was started with the *Art Project* in 1994 was continued as an active project in 1996 in the form of *Cittadellarte*. This contraction of the Italian words for citadel and for city refers to the presence of two categories which are difficult to reconcile. The former stands for a secluded, protected area, whereas the latter is a symbol of dynamism, expansion and a complex of mutually interdependent elements which fan out into the world. By means of these internal paradoxes, the word refers to one of the basic paradoxes of heterotopia, as described by Michel Foucault. It presupposes a mechanism of opening and closing which, at the same time, both closes off the place and makes it accessible. The most adequate metaphor to understand a comparable heterotopic place may be the one of the sailing ship, according to Foucault.

'... the ship is a piece of floating space, a placeless place, that lives by its own devices, that is self-enclosed and, at the same time, delivered over to the boundless expanse of the ocean, and that goes from port to port, from watch to watch, from brothel to brothel, all the way

to the colonies in search of the most precious treasures that lie waiting in their gardens, you see why for our civilization, from the sixteenth century up to our time, the ship has been at the same time not only the greatest instrument of economic development, of course, but the greatest reservoir of imagination. The sailing vessel is the heterotopia par excellence. In civilizations without ships the dreams dry up, espionage takes the place of adventure, and the police that of the corsairs.'
(Foucault, [1984]1994)

Writing about *Cittadellarte* is — in the manner described above with regard to a painting — fixing time and fixed in time. In other words: the written format can never compete with the image in the mirror: black words on a white sheet are always dated, while history continues. The 'final' analysis depends very much on the moment of observation. Certainly *Cittadellarte* evolves very fast and Michelangelo Pistoletto is someone with plenty of wind in his sails. So, in a sense, the reader is warned: this text can only be read as an attempt to describe the state of affairs in an organization at a particular moment in time — all the more so since it is generally known that heterotopic places don't usually last long.

From Artistic to Social Artefacts

Cittadellarte was realized in a former textile factory next to a former mill along the river Cervo in the city of Biella. During both the Middle Ages and under the rule of the house of Piemonte-Savoie, Biella was one of the centres which contributed to making the North of Italy into a prosperous textile region. Here, in a short period of time, the Fondazione Pistoletto founded a genuine organization. The time-honoured practice of weaving provides a metaphor for the organization of this centre. For, within the walls of this factory, a network is woven in which the artistic element functions as a link connecting the most divergent practices. The organization is conceived in such a way that all possible art forms such as music, theatre, literature, dance, photography, architecture and the visual arts can be connected with other types of societal systems. *Cittadellarte* reveals itself to be a mediator between art and economy, politics, science, education, et cetera.

222

Through it, Pistoletto, opens up a social space for his a-modern 'and/ and' discourse. His artistic trajectory has been translated into the social sphere in a very ambitious manner. The 'classic modern' singular position of the artist is transformed into that of someone who places himself in a collective collaboration, not only with other artists, but also with scientists, businessmen, politicians and a very diverse group of social actors. In a way, one could say that Pistoletto started to combine his original relationship to his artefacts with a social setting marked by very intensive interactions and negotiations with a lot of people in order to work out a huge 'work of art'. By doing so, he transformed his own artistic position and career into an inventive collective model. With *Cittadellarte*, Pistoletto initiated an open space in which other actors can come to work on an artistic process. This implies that this project can be translated and transmuted by others. Some of them just pass through and leave after some months, whereas others stay to work for many years. Some people leave to come back after a few months or a year. By operating in this way, *Cittadellarte* became a central focal point in an ever-expanding network, and the identity of this passage is the outcome of many interactions and collaborations. Consequently, one could no longer identify one 'auteur' for this artistic project. In other words, Pistoletto made his concept of the Minus Artist which was described above into something very concrete. The man literally became an actor who devises a modest move within an immense configuration network of many moves, of which Pistoletto himself, of course, is a constituent part. All the artists and other social actors in *Cittadellarte* retain their singular character, but always relate it to a much larger common.

Uffizi

By means of slogans like 'Eliminate distances while maintaining differences', 'Art at the centre of a socially responsible transformation', 'The artist as sponsor of thought' and the like, Pistoletto refers to a heterogeneous cluster of the most divergent forms of social praxis. These direct one-liners appeal to many people in different social spheres. The discursive regime is building up a horizon to which other actors can relate: this means they can get involved or distance themselves from it. The heterogeneity is also illustrated by the activities within and around the '*Uffizi*', as they are called within *Cittadellarte*. The term '*Uffizi*' refers to the Renaissance concept in which economy, education, politics, philosophy, religion, art and science, but also both private and public life interacted in a premodern hybrid

manner. In one of these offices the work currently carried out consists of building the architecture of an alternative economic system, an 'economical organicity', which attempts to implement social, ecological, ethical and aesthetic values within contemporary economy. In the 'Economics Office', artists and scientists set up a research to find a possible answer or answers to the crypto-utopia described above. By attempting to bring art into the centre of the economic system and by describing the artist as an actor who has to take his responsibility in this system, *Cittadellarte* wants to break open the contemporary dominant neoliberal capitalist system, not by working against this system, but by creating an open space for artistic contingency inside it. This not only happens on a macro-level by trying to develop a so-called 'grand theory', but also by working on a micro-level in particular companies. The 'Economics Office', for example, functions as an intermediary between artists and companies in order to stimulate the influence of art in those companies' factories. In that way, artists can become a kind of 'free space' in companies in which to develop projects with workers and other employees. By giving this space to 'the unknown' called art, companies demonstrate at least an openness to the 'other' which can be the starting point for further transformations. *Cittadellarte* is creating as much space for art in the economic system as possible, in the hope that the latter will change step by step. By combining the research for a new 'grand theory' with very practical empirical artistic research, the organization in Biella can be described as working on a mid-range level which tries to find the right concepts for a concrete praxis on the one hand, and uses the experiences from these concrete artistic acts to develop a different vision on how economy can function, on the other hand.

In the context of another project which originated in the 'Politics Office', *Cittadellarte* works on an artistic movement for Inter-Mediterranean politics, called 'Love Difference'. This is an attempt to find an answer to the previously sketched globalization and the new world order. The project that was presented at 'Utopia Station' at the Venice Biennale in 2003 can be seen as the start of a participatory artistic movement that is open to anyone interested in the artistic encounter between different societal systems which are a reflection of worldwide tensions. The 'Politics Office' of *Cittadellarte* conceives of the Inter-Mediterranean area as a symbolic place where the major problems and conflicts of the world come together. The countries around the Mediterranean Sea, for example, are the locus of oppositions between rich and poor, between different religions and conflicting cultural habits.

The political movement of *Cittadellarte* seeks to stimulate interaction between all those extreme differences and thus once again conceives of art as an important communication modality.

All of these projects are based on the very big ambition to make a real difference using art. In order to do this, they combine a utopian desire with a high level of pragmatism and an entrepreneurial spirit. The aims, often expressed in the above-mentioned slogans, point out the direction and energize the artistic process of transformation. The activities are intended to make real progress in the desired direction. In order to make this difference on the ground, all possible roads are being followed and continuously reconfigured and all possible resources are being invested and reinvested. Full-time staff members, experts, trainees, young residents, civil servants, members of the family and ever more former residents form a very hybrid group that gets involved in the ambitious plan. Their goal is not so much a final, totalitarian result as to move as far as possible in the desired direction. A small step forward is preferred over no movement at all.

By means of slogans and manifestos, Michelangelo Pistoletto attempts to generate a space for alternative societal praxes. However, the discourse which buttresses it is quite rough and unfinished. To be clear, *Cittadellarte* articulates neither part of any well-delineated scientific framework, nor a sophisticated, let alone verified theory. This is probably a characteristic of an artistic approach, for art wants to move fast (and, as mentioned, Pistoletto seems to want to move very fast) and often impacts upon situations before they have become facts. Scientific progress, by contrast, depends on specific methodologies that are part of a consistent conceptual whole. For this reason, scientists work at a considerably lower speed than artists, since the latter are not bound by the burden of proof. This does not mean that artists would not make use of any form of methodology, but that they may develop one of their own. Speaking with artists in *Cittadellarte*, one finds that they often see this artistic 'methodology' as a question of ethics. Can I really interfere in an economic system? Can I really participate in a political movement? And, what then is my position as an artist, how can I define or redefine my praxis? These are reflexive questions you often come across in Biella. But one thing seems to be certain: in spite of any doubts they may have, artists can react to historical events and to the world surrounding them in a much more sensitive manner than the scientist can. According to the American sociologist John Manfredi, it is this very independence from standardized methodologies which enables the artist to enter quickly and sensitively where the

225

angels of science dare not tread. Compared to the scientist, the artist is therefore always in the avant-garde. *Cittadellarte* does not constitute a model for well-founded scientific research on a viable social model. But it does offer space for a quest. As in mediaeval ballads, this word does not refer to a search for something that has already been adequately defined. For the quest is a type of research which produces its own object, as the Knights of the Round Table fabricated their Holy Grail. Moreover, it is a search which never ends:

'A quest, unlike a search, never ends; it alternates between striving for resolution and immediate relaunching, between the certainty required for action and the demolition of certainty that results from reflection, between the very human dreams of sitting still and moving forward.' (Czarniawska, 1997)

Characteristic of such a quest is the fact that it entails quite a lot of trial and error. In other words, sitting still and moving at the same time does imply a considerable loss. For *Cittadellarte* is not a goal-oriented undertaking which operates in Utopia under the dispensation of the crypto-utopia. Quite to the contrary, the very many contradictions lead time and again to blockages and tensions for which solutions have to be found. Consequently, loss is a part of the productive quest: no experiment, no laboratory, and no invention without loss or surplus. This may be one of the biggest problems with the contemporary crypto-utopia. The efficiency of the 'manager realism' I have described does not accept loss or non-capitalizable surplus as an inevitable, even productive aspect of every inventive enterprise.

In *Cittadellarte,* time and again, there is a need to search for other ways of doing things in an empirical manner. By means of his slogans and his manifests, Pistoletto constantly produces borderline ideas or markedly ambivalent categories which are used as vehicles for this purpose. This ambitious performance of hybrid ideas is provocative to the curious spectator, company executives, scientists, politicians and young artists, because Pistoletto refers to a different order than the one we are currently used to. The *'Manifesto dell'Arte e dell'Impresa'* *('Manifesto of Art and Enterprise')* of 2002 can be seen as one example of this hybrid discourse:

'Italy possesses the essential elements required to move towards new and significant horizons, recombining ideals and activity in the present, a period in which the need for a new Renaissance is clearly evident. The Italian productive and artistic spirit has in its DNA the characteristics of multiformity, multiplicity and difference, previous values of the past that project towards the future. They are resources that must be preserved and protected in every possible way, like the major historic monuments, of which Italy has the greatest number. At the same time, ancient ambitions must be reconverted into the shared commitment to produce a new history. The artistic-entrepreneurial figure established with this project embodies a "moral" factor which enters into the economic calculations of the entrepreneur, whose objective is enriched to become a fully-fledged mission. The manifesto can basically be summarized by this slogan: Italian enterprise is a cultural mission.'
(Pistoletto, 2002)

A-modern

To the sedentary modernist, this curious mixture of art, politics and economics will appear to be extremely suspect. From the birth of modernism, social reality was conceptualized as a differentiated space. Art occupies an autonomous place within this space which must cut off from other social realities in order to remain unpolluted. However, the ordering of the world, according to this morality of purity, leads to a particularly ambivalent methodology of repression. As early as 1977, Bourdieu pointed out in great detail that artistic activity is banishing economical transactions to the cellar of the socially unconscious; yet the same goes for political practices or private matters. The 'good', or rather, 'the genuinely incorruptible' artist is solely devoted to his artistic endeavour. The rest is of secondary importance, according to the artistic ethics of modernism. Quite paradoxically, a comparable rhetoric of independence leads to a great measure of dependence. For instance, artists who do not deal with economics or

227

politics will not develop alternative systems of distribution; nor will they engage with the powers ruling over them.

Not only artists but also artistic institutions lay claim to this modernist purity. For example, if you enter a museum of contemporary art, on one side of the entrance you will notice the names of politicians who contributed to the realization of the building and/or the collection, while on the other side, you see the names of sponsors who keep it going with their financial support. When you enter the museum halls, you leave these representatives of power and economy behind you in order to be surrounded by nothing but pure Art. You imagine yourself in an autonomous and spotless space, as the white cube evoked by the ubiquitous white walls. This is the very staging which Michelangelo Pistoletto calls into question. According to him, this (western) way of ordering is overripe. The internal contradictions it breeds whilst continuously trying to obfuscate them are proliferating and need to be brought to the fore. This, amongst other things, is the aim of 'Art at the centre of a responsible social transformation', a sequence of exhibitions which takes place every year at *Cittadellarte* and which allows for divergent contents and for the testing of new modalities of presentation. Young curators are invited to develop models of exhibiting which target the borderline and the possible relations between art and politics, economy, science, et cetera. In this regard, it becomes a matter of fact that representatives of the economy and of politics are involved in the exhibitions. Maecenatism in the form of sponsors who just want to make a cash donation is not encouraged; a more thorough form of engagement is expected from them which, at the very least, implies a relationship with the artistic. For example, the *New Agora* exhibition in 2002 faced up to the interdependent relations with the corporate business structure and the political arena. The 2003 exhibition *Public Art in Italy* investigated the complexity of public art, again rendering visible the broader network around a work of art. According to *Cittadellarte*, this integrated approach offers the sole possibility to arrive at a sound analysis.

On the basis of this work, one could attempt to redefine the relation between the artist and his surroundings. Perhaps this line of thought is not all that odd. More than in the recent past, the world of visual art of today is hemmed in by political and, above all, economic types of logic. Trying to suppress this reality does not appear to be the most efficient strategy. Only upon acknowledging different relations of dependency can one start to work on new models for artists, organizations, presentations and distribution systems for art.

UNIDEE

An important factor in all of this, a source of opportunities but also a goal in its own right, is The University of Ideas or UNIDEE, founded in a workshop in 1999 by Pistoletto and other artists at *Cittadellarte*. A 'place within a place', the university is one cell in the organism of the organization. This metaphor reflects its autonomy as well as its interdependence with the larger whole. Under the banner of UNIDEE, people from all over the world are offered a residential place. The organizers of the programme they follow have a function which is quite unique to *Cittadellarte*. They not only support the residents, but also constantly act as interpreters seeking to link the quest of the organization with the residents' personal research. In a sense, they try to connect the individual path of the singular resident with the possibilities offered by the organization. They also play the role of translation centres between the individual 'passengers' and the 'Uffizi', which, in their turn, engage in translations in relation to the world outside *Cittadellarte*. In a subsequent stage, the offices organize and accompany the residents in their negotiations with companies, politicians, economists, scientists, or other social actors with whom they want to work. In this way, *Cittadellarte* is conceptualized as one big translation centre between the art world and other societal subsystems.

Even the selection of the residents proves that *Cittadellarte* accepts far-reaching consequences of its choices. The selection of residents does not aim at guaranteeing results. Instead, it seeks out potential. Openness and aspiration are the main criteria, rather than being established professionally, so that the residents may take part in the project of *Cittadellarte* and eventually transform or widen it by their own orientation. It is also unique to UNIDEE that there is just one very big studio, called the laboratory, where all the residents have to define their own place. Just like the 'Minus Artist', they have to redefine their own individual position, and, in the first instance, inscribe it within the common of the other residents. Consequently, the very spatial setting calls into question the classic articulation of the singular artist and egocentric individuality. The group of 2003 included a Danish economist and philosopher, an English and a Portuguese architect, an English composer and an Indian designer. Some of the selected residents have experience and have had a measure of success, while others are very young people who are just starting to develop their own ideas and concepts. All of them are confronted with the strange mix that is characteristic of the place: the quest dedicated to lofty goals combined with a pragmatic commitment to making

229

real progress on the ground. The residents can work on their own projects, but are also involved in project-based activities supported by scientists, entrepreneurs and other artists. Hereby, the residents are strongly encouraged to organize artistic projects within a non-artistic environment. Socially disadvantaged neighbourhoods, business companies, educational systems, urban developments and virtual spaces on the web are sites that have been explored to date. It is of great importance that the residents work in a position requiring direct negotiations in which they repeatedly have to fend for themselves. UNIDEE also proposes working in twilight zones such as a private company, for example. Unavoidably, in this regard, the quest generates considerable losses which are a quintessential part of a laboratory context of trial and error. As for *Cittadellarte*'s own projects, the volatile combination of openness, aspirations and outside parties (politicians, entrepreneurs, or factory workers) does not guarantee a perfect finished product. The choice of both settings and residents is adventurous and may lead to less than satisfactory results, both for *Cittadellarte* and for the residents themselves. But even the less satisfactory result is seen as a new experience that opens up more new possibilities. UNIDEE deliberately accepts this risk of loss or limited progress, in the hope and expectation that these or other residents will go on to use the place of paradoxes with better results. For heterotopia is a space in which the world is complete in all its superabundance, and it holds out the possibility that diverse elements will find one another in an interesting constellation, although they might end up with a loss as well. The difference between *Cittadellarte* and Foucault's ship as a floating fortress in the midst of an ocean of waiting or of killing time is that in *Cittadellarte* the quest can perpetuate itself, less driven by an external wind than by materialized activity.

The double-sidedness of idealism embedded in pragmatism can also be seen in the projects that are being developed at *Cittadellarte*. Because artists sometimes work in risky twilight zones such as the non-artistic context of a private company, they can fall short of their aims. Dealing with companies, especially, can result in a rapid adaptation of the artistic project to the company's main strategy. In some cases, art is used for nothing but sheer image building. For instance, the company's products are given a new design by — as they see it — some 'eccentric creative character'. In that case, the project is enrolled in a Post-Fordian logic as an aestheticizing patch-up: quite a clever marketing strategy for the enterprise. And the artist's touch is then recruited by a capitalist accumulation rationale that is precise-

ly what *Cittadellarte* opposes. This is very much the risk of working in an a-modern area. In other cases, the interventions have a much deeper impact, however. For example, residents could analyse the Post-Fordian or often still Fordian structure and production process, and subsequently plan an artistic move in the process. They attempt to get a grip on fossilized phenomena like routine or its opposite, a Post-Fordian dynamic, fixed or flowing time schedules, standardized or de-standardized production, management or neo-management. They then translate these into an experiment which stimulates a critical surplus inside these environments. Those projects create possibilities for reflection which can at some point be reinvested in the social system as a place of practical transformations. In *Cittadellarte,* those transformations mainly aim at a 'return to Fordism', as Pistoletto calls it. What he means by this is that production should once again be tested for its functionality. But this is no longer the functionality that ruled until the nineteen seventies, when a car was only expected to get you from A to B, or a raincoat had to keep the rain off you. In the neo-Fordism that Pistoletto stands for, functionality must be judged in terms of its responsibilities within other value regimes: ecological, humane and political (democratic) criteria, and also the economic implications of the car's ride from A to B. 'A responsible transformation' along these lines involves a heterogeneous functionality (that operates within all subsystems) of the kind that art is permitted, dares, and is capable of. It is precisely this holistic vision that is expressed by the utopia of *Cittadellarte*, but it is a utopia with an incredible level of realism.

Consequently, the residents at UNIDEE are encouraged to take up the position of negotiators in non-artistic places such as companies, in order to search for possible intermediary forms. This position challenges young residents to adopt both the ambition and the pragmatism of *Cittadellarte*. They have to impose their artistic will within a context that is not made for it and which quite often can hardly deal with it. At times, this requires an especially sophisticated form of ingenuity because they need the tactics to 'appropriate' a strategically conceptualized unit of production. Consequently, the project can turn into a very tiresome process of negotiating, devising detours, making compromises, undoing compromises, et cetera. This raises doubts in the minds of some of the residents, at least at the start. *Cittadellarte*'s clear willingness to work together with the most heterogeneous range of societal subsystems provokes a lot of debate within the project. Initially, many residents have the feeling that, for

example, they 'have to sell their artistic soul' to a company or other non-artistic environment. In discussions they warn their fellow-residents about the suspect compromises they may engage in, the dubious intentions of the corporate world or the perceived naivety of Cittadellarte's utopia. These debates have their own importance, since they fuel agonistic positions which generate reflective energy. Michelangelo Pistoletto sees this as one of the most constructive conditions, as he explains in his own metaphor:

'This space is free, open and responsive, like an open, free and responsive mind. Free, as the mind needs to be free in order to understand what happens in this place. It is a massive generator, a generator of energy. In nature, energy manifests itself in the meeting/ clash between two poles. In the meeting/clash between the positive and the negative pole. We all know about the experience of destructive lightning. But now we can experience productive, civilized lightning, namely electricity: a perfect contact between opposite polarities.' (Serafini, 2001)

Just like Pistoletto's mirror, *Cittadellarte* lets alterity erupt. It offers a space for contradictions and for contradictory visions, which regularly lead to heated discussions among fellow-residents, and not least with Pistoletto himself. For it should not be forgotten that the artist of the mirror is himself part of the context of modern art. Inescapably, he carries the burden of this heritage along with his desire to surpass it. As such, the mirror and the *Oggetti in Meno* represent the orthodoxy of the configuration of modern art to which the heterodoxy of the heterotopic place of *Cittadellarte* has to relate. Conversely, the objects make the heterodoxical place undeniable for the orthodoxy outside. In his capacity as a modern artist, Pistoletto generates an a-modern space, just as Louis-Philippe, in his capacity as aristocrat, let the new world of consumption erupt. This openness towards alterity contains its own tensions and leads to internecine contradictions, and hence to discussions. At any event within *Cittadellarte*, there is more than ample space for discussion. At times, this is organized within a

formal framework, yet the most interesting debate takes place around the table at night, whilst enjoying the evening meal. Wine and delicious food constitutes the ideal informal context for constructive discussion of both surplus and loss. Consequently, it is not only its laboratory which is at the heart of the former textile factory, but also its cafeteria. In the middle of copious blathering, a reflexive discourse regularly pops up in which definitions of art and of the artist are made and unmade on an ongoing basis. It expresses a real stake because it is steered by a utopian vision, yet besides an aspiration to materialize this vision, there is also a constant openness and willingness to accept otherness. As such, *Cittadellarte* is generating a field of tension in between art and economy, art and politics, compliant and rebellious voices, young artists and Pistoletto, and so on. This is the main way in which it differs from the many other artistic places of residence, open ateliers, or postgraduate programmes. In Biella, the artist has to search for relations which reach beyond the art world. While many types of programmes are limited to a citadel or a sealed-off, safe space, 'a nursery for art', *Cittadellarte* attempts to take in the world with all its complexity and contradictions. The result of the artistic endeavour is as important as the process of negotiating, for it obliges the resident to define himself with regard to other frames of thinking and value standards, and it obliges art to take into account the rest of the world.

Grandeur

I have said that *Cittadellarte's* main challenge is to develop relations between art and other domains of reality. This is done through experience, by building bridges wherever possible, and wherever a space is offered. A lot depends on the limits of this space, and these bridges have to find a link between worlds that have different languages, modes of behaviour, understandings. Residents have to be able to relate to other 'worlds of grandeur'. This concept was coined by Boltanski and Thévenot (1991) to indicate the polyphony of systems of *valorisation* which coexist in a given society. The appreciation of 'great' accomplishments or of persons or objects with grandeur depends on the regime of values in which one operates. For example, the French sociologists differentiate between the world of inspiration, the domestic world, the world of fame, the civil world, the market world, and the industrial world in which qualities are evaluated in a different manner. Incidentally, in The New Spirit of Capitalism, Boltanski and Chiapello (2005) add the project city or world to the list. The regime of artistic value in the world of inspiration is characterized by an

appreciation of constant movement and change, which is being dictated by a singular regime.

> 'This world, in which persons have to be ready to welcome changes of state according to inspiration, is not very stable and is poorly equipped. Everything which, in the other worlds, supports and equips equivalence, such as measures, rules, money, hierarchies, and laws, is being cast aside. Taking into account its poor level of equipment, this world tolerates the existence of internal tests which are more or less objectifiable, which protects "inspired grandeur" from the opinion of others – it is indifferent to signs of contempt by others – yet, this also constitutes its fragility. In fact, the inspired world has to deal with the paradox of a 'grandeur' which eludes measure and of a form of equivalence which privileges singularity.' (Boltanski and Thévenot, 1991)

We are dealing here with an apparatus of evaluation which is totally uncalled for in the civil world or in the industrial world. The civil world, for example the domain of politics, is much more geared towards collective and public acknowledgement within a regime of affirmation. 'Grandeur' is measured here according to the degree to which one addresses collective objectives as opposed to private preoccupations. It is a world of slogans, resolutions, univocally formulated objectives, and programmes aimed at convincing as many people as possible. This insight of Boltanski and Thévenot's therefore puts Pistoletto's use of slogans and manifestos in a different perspective. For, in his capacity of artist, he generates a curious hybrid form which steers a middle course between artistic and political value regimes. By doing so, *Cittadellarte* attempts to force breakthroughs to another world of 'grandeur'. On the other hand, in the industrial world or the Fordian economy, qualities are evaluated for their functionality, operational values and professionalism. Individual acts are collectivized by integrating them within a common plan, homogeneous rules, directives, and mission statements which standardize the production

process within a rational goal-oriented scheme. Both time and space are organized within a fixed pattern which is organized with a view to maximizing productivity. In this regard, too, *Cittadellarte* attempts to establish relations, and this does not only come to the fore in contracts with companies and the national network of the 'distritti industriali'. The project also runs '*Uffizi*' for Art, Communication, Rights, Ecology, Economics, Education, Work, Nourishment, Politics, Science and Religion, all of which mediate between the organization and the different social subsystems in the outside world. Pistoletto's slogans also tackle the order of 'grandeur' of the industrial world in order to gain access to it. They obtain the status of the mission statements which are quite a familiar feature of the corporate world. Slogans and manifestos are vehicles for translations and transmutations intended to operate as intermediaries between different worlds of 'grandeur'. They constitute a method of enrolling other, non-artistic actors. By means of '*intéressement*', Pistoletto links different worlds of 'grandeur' and directs them to in-between possibilities, 'inter-esse', or the search for links. This always happens according to the same formula: a hybrid third possibility is constructed between two apparently irreconcilable polarities.

For sure, the experiment with the world of industry makes it clear what kind of risk *Cittadellarte* is taking. Steering a course along the cutting edge between art and the business world can always lead to being co-opted into a Post-Fordian logic. And that is not exactly the organization's aim. It does, however, want to proactively resist such a process on behalf of the artists and their freedom. In short, this is a political experiment of a kind that is undertaken by very few of the governments with their cultural industry and creative city policies.

The experiment of *Cittadellarte* is part of a broad aim: not to import new energy from the outside world into art but to let art become an integral part of that outside world again, not under the conditions of the industrial world, but under those of the artistic logic. And finally, to de-instrumentalize the use of art in society, and enable it to exploit its full possibilities in each of its domains. That is the target of *Cittadellarte*: to make as many passage points as possible all over whole the globe, starting from its heterotopic space, in order to reorder society and transmute its crypto-utopia.

As of now, Pistoletto looks back upon an oeuvre which spans half a century. In his work, he has transformed his singular artistic trajectory into a broad social one. The hybridness, alterity and contingency in the mirror or *Anno Bianco* and the heterotopia of the

Oggetti in Meno have been translated into an ambitious social project. By means of its residential programme, its pragmatic projects like the introduction of art in nearby companies, and its utopian initiatives such as the foundation of a political movement and the design of an alternative economic system, *Cittadellarte* creates a space for hetero-topia within the ruling order of the Modern Constitution. Art and reality, fiction and reality are merging into a curious hybrid in Biella. An artistic concept is being transformed into a political movement or alternative economics, and vice versa: politics and economics become a work of art. By means of this a-modern game, Pistoletto is looking for an answer to extremely relevant questions. How can art or the art-ist still have meaning within the hegemony of the market economy? And how can we continue to observe and evaluate artistic practices within a globalized context? Only the future will show whether this quest will come to determine new orders of grandeur. Yet one thing is certain: with his quest, Pistoletto is asking the right questions at the right time. By doing so, he assumes his modest mission as a contem-porary artist in quite a unique manner, for, with his *Cittadellarte* as a heterotopic place, the Minus Artist creates spaces for murmuring, a sense of possibility: a sense that everything that is could just as easily be otherwise.

Bibliography

Boltanski, L., and E. Chiapello (2005). The New Spirit of Capitalism. **London and New York: Verso**
Boltanski, L., and L. Thévenot, (1991). De la Justification: Les économies de la grandeur. **Paris: Gallimard**
Bourdieu, P. (1992). 'La Production de la croyance: Contribution à une économie des biens symboliques'. Actes de la recherche en sciences sociales **13**
Certeau (de), M. (1984). The Practice of Everyday Life. **Berkeley, Los Angeles and London: University of California Press**
Czarniawska, B. (1997). Narrating the Organization: Dramas of Institutional Identity. **Chicago and London: The University of Chicago Press**
Foucault, M. ([1984] 1994). Aesthetics: Essential works of Foucault. **London: Penguin Press**
Foucault, M. (1998). Aesthetics: Essential Works of Foucault: 1954–1984. **London: Penguin Books**
Gomart, E., and A. Hennion (1999). 'A Sociology of Attachment: Music Amateurs, Drug Users'. In Actor Network Theory and After, ed. J. Law and J. Hassard, 220–47. **Oxford and Malden: Blackwell**
Heinich, N. (1991). La Gloire de Van Gogh: Essai d'anthropologie de l'admiration. **Paris: Editions de Minuit**
Heinich, N. (1993). Du Peintre a l'artiste: Artisans et académiciens a l'Age classique. **Paris: Editions de Minuit**
Hetherington, K. (1997). The Badlands of Modernity: Heterotopia and Social Ordering. **London and New York: Routledge**
Hetherington, K. (1999). 'From Blindness to Blindness: Museums, Heterogeneity and the Subject'. In Actor Network Theory and After, ed. J. Law and J. Hassard, 51-73. **Oxford, Malden: Blackwell**

Laermans, R. (1998). 'Moderne kunst en moderne maatschappij: Luhmanns kunsttheoretische observaties geobserveerd'. De Witte Raaf 12 (74): 20-3

Latour, B. (1993). We Have Never Been Modern, transl. by C. Porter. Cambridge, MA: Harvard University Press

Latour, B. (1997). De Berlijnse sleutel en andere lessen van een liefhebber van wetenschap en techniek. **Amsterdam: Van Gennep**

Latour, B. (1999). 'On Recalling ANT'. In Actor Network Theory and After, ed. J. Law and J. Hassard, 15-25. Oxford and Malden: Blackwell

Law, J. (1986). 'The Heterogeneity of Texts'. In Mapping the Dynamics of Science and Technology: Sociology of Science in the Real World, **ed. M. Callon, J. Law, and A. Rip, 67-83. Hampshire and London: The MacMillan Press**

Law, J. (1999). 'After ANT: Complexity, Naming and Topology'. In Actor Network Theory and After, **ed. J. Law and J. Hassard, 1-15. Oxford, Malden: Blackwell**

Law, J., and J. Hassard (eds.) (1999). Actor Network Theory and After. **Oxford, Malden: Blackwell**

Lee, N., and P. Stenner (1999). 'Who Pays?: Can we Pay Them Back?'. In Actor Network Theory and After, **ed. J. Law and J. Hassard, 90-112. Oxford, Malden: Blackwell**

Luhmann, N. (1995). Die Kunst der Gesellschaft, **Frankfurt, Suhrkamp Verlag**

Luhmann, N. (1997a). 'Ausdifferenzierung der Kunst'. In Art & Language & Luhmann, **ed. Institut für soziale Gegenwartsfragen Freiburg I. Br. und Kunstraum Wien, 133-48. Wien: Passagen Verlag**

Luhmann, N. (1997b). 'Die Autonomie der Kunst'. In Art & Language & Luhmann, **ed. Institut für soziale Gegenwartsfragen Freiburg I. Br. und Kunstraum Wien, 177-90. Wien: Passagen Verlag**

Manfredi, J. (1982). The Social Limits of Art. **Amherst, Cambridge, Mass: University of Massachusetts Press**

Pistoletto, M. (1970). L'Homme noir, le côté supportable. **Paris: Ecole Nationale Supérieure des Beaux-Arts**

Pistoletto, M. (1988). A Minus Artist. **Florence: Hopefulmonster**

Pistoletto, M. (1994). The 'Projetto Arte' manifesto. www.pistoletto.it/eng/testi/the_progetto_arte_manifesto.pdf

Pistoletto, M. (2002). Love Difference Manifesto. www.pistoletto.it/eng/testi/love_difference_manifesto.pdf

Serafini, G. (2001). Pistoletto Codice Inverso. **Città di Castello**

Urry, J. (2000). Sociology Beyond Societies: Mobilities for the Twenty-first Century. **London and New York: Routledge**

Afterword

Rien van der Vleuten

The Fontys College for the Arts in Tilburg is one of the largest art schools in the Netherlands. Every year at least 1,500 students study there and about 250 of them take their first steps into professional life. Naturally, the main priority for a general director is the quality of the education. We want our students to play a high-level role in both the professional art world and art education. But as director of such a big school, you do worry. Where will all these students end up? Will there be good jobs for all of them? And if they do get jobs, do they know enough about the society in which they will have to build their careers?

The art world has changed considerably in the last twenty years, as is explained in this book. This is something that our students — and indeed all art students and professionals in today's art world — need to be aware of. What are the effects on their occupation of globalization, digitalization, and cultural policy? But also, how does the economy work these days, and with it the labour market they will be entering?

As director of an art school I think these education-related questions need answering. Students need to learn, not just to stand out for their talent, but also to approach their role in the world self-reflectively. Art education today has to deal with a 'booming' creative and cultural industry. Every city that considers itself to have any global significance wants to be on the cultural map as well. As director of an art school you can only embrace this evolution. After all, it increases the job prospects of our students and it only makes an art school more appealing. And yet I think it is important that students look at these developments with a critical eye. They should know what the creative industry stands for, and which social and economic mechanisms are at work. They should therefore understand what a word like Post-Fordism stands for, and what it may demand from them. Insight into this will broaden the scope of their choices. They can then either consciously go along with it, or creatively go in search of alternatives. In other words, the self-reflective student has more options.

It is the task of the 'Arts *in* society' research group to make a substantial contribution to this reflection, not just for our students but also for a broader professional field. *The Murmuring of the Artistic Multitude* — already the sixth publication by the research group — is a highly critical analysis of the position of art in contemporary society. But it is not a fatalistic book, as its author explores a number of interesting detours and alternative routes. In other words, he too makes us aware that we have more options.

Rien van der Vleuten
General Director of the Fontys College for the Arts

Afterword

241

Acknowledgments &
The Arts in Society series

'The Murmuring of the Artistic Multitude' was the inaugural lecture for the Arts in Society research group chair at the Fontys College for the Arts, delivered in March 2008.

'The Biennale: A Post-Institutution for Immaterial Labour' was published in *Open: Cahier on Art and the Public Domain* 16 (April 2009).

'The Art Scene: A Production Unit for Economic Exploitation?' was first published as a catalogue text for the exhibition *Un-Scene* in the Wiels arts centre in Brussels. An expanded version linking the art scene with Post-Fordism appeared in *Open: Cahier on Art and the Public Domain* 17 (June 2009).

'Remembering in the Golden Age' was first published in P. Gielen and R. Laermans (2006). *Cultureel goed: Over het (nieuwe) erfgoedregiem.* Leuven: LannooCampus.

'Shopping Memories in the Global City' is a revised version of an essay entitled 'Sign 'O' the Times', published in H. Defoort and W. De Vuyst (2005). *De Veldstraat/Gent.*

'Museumchronotopics: On the Representation of the Past in Museums' is a revised version of a contribution with the same title in *Museum & Society* 2 (3), November 2004.

'Memory and Event' is a thoroughly revised version of the chapter called 'The Event' in Gielen, P. (2007). *De onbereikbare binnenkant van het verleden: Over de enscenering van het culturele erfgoed.* Leuven: LannooCampus.

'Artistic Freedom and Globalization' was published in *Open: Cahier on Art and the Public Domain* 12 (2007).

'"Deciding" Art in Global Networks' is a fully revised version of 'Arts and Social Values', published in *Current Sociology* 53 (5), 2005.

'Art Politics in a Globalizing World' is a revised version of a chapter from P. Gielen and R. Laermans (2004). *Een omgeving voor actuele kunst: Een toekomstperspectief voor het beeldende-kunstenlandschap in Vlaanderen.* Tielt: Lannoo.

'Welcome to Heterotopia' first appeared in *Michelangelo Pistoletto & Cittadellarte &,* published by Snoeck and the Museum of Contemporary Art, Antwerp in connection with an exhibition at the museum in 2003.

The Arts in Society series

The Murmuring of the Artistic Multitude: Global Art, Memory and Post-Fordism is the sixth publication in the *Arts* in *Society* series published by the Arts in Society research group at the Fontys College of the Arts in Tilburg (the Netherlands). In keeping with the general research framework of the programme, this series of publications seeks to describe and explain the interaction between social changes (technological, scientific, economic, cultural-political) and artistic practices. Partly inspired by insights from critical theory, the programme researches the possibilities for an ideological (re)positioning of the arts in society. The programme is open to potential publications in the forms of essays, theoretical texts, practical artistic research and research assignments.

Earlier publications in the series were:

Gielen, P. (2007). *De Kunstinstitutie: De identiteit en de positie van de artistieke instellingen van de Vlaamse Gemeenschap.* Antwerp: OIV.

Gielen, P. (2008). *Het gemurmel van de artistieke menigte: Over kunst en Post-Fordism.* Eindhoven: Fontys

Gielen, P. (2003, 2008, second edition). *Kunst in netwerken: Artistieke selecties in de hedendaagse dans en de beeldende kunst.* Leuven: LannooCampus.

De Bruyne, P. (2009). *Een stoet van kleur en klanken: De muziek van Luc Mishalle & Co.* Ghent: Academische Pers.

Gielen, P., and J. Seijdel, (2009). 'The Art-Biennial as a Global Phenomenon: Strategies in Neo-Political Times'. *Open: Cahier on Art and the Public Domain* 16. Rotterdam and Amsterdam: NAi Publishers/SKOR.

Gielen, P., and P. De Bruyne, (eds.) (2009). *Arts in Society: Being an Artist in Post-Fordian Times.* Rotterdam: NAi Publishers.

245

Index of Names

Index of Subjects

255

Colophon

The Murmuring of the Artistic Multitude:
Global Art, Memory and Post-Fordism
Author: Pascal Gielen
Antennae Series n°3 by Valiz, Amsterdam
Part of the Fontys-series 'Arts *in* Society'

Translation Dutch-English Clare McGregor
Copy editing Clare McGregor,
Els Brinkman
Design Metahaven
Paper inside Munken Print White 100gr,
hv satinated mc 115gr
Paper cover Bioset 240 gr
Printer Bariet, Ruinen
Binding De Haan, Zwolle
Published by Valiz, Amsterdam
www.valiz.nl

Other titles in the Antennae Series:

The Fall of the Studio: Artists at Work
edited by Wouter Davidts & Kim Paice
Amsterdam: Valiz, 2009, ISBN 978-90-78088-29-5

Take Place: Photography and Place from Multiple Perspectives
edited by Helen Westgeest
Amsterdam: Valiz, 2009, ISBN 978-90-78088-35-6

This publication was made possible through the generous support of
Fontys College for the Arts, Tilburg
Prins Bernhard Cultuurfonds

Colophon

The essay texts in this book are licensed under a Creative Commons Attribution-NonCommercial-NoDerivativeWorks license.

The user is free to share - to copy, distribute and transmit the work under the following conditions:
* Attribution - You must attribute the work in the manner specified by the author or publisher (but not in any way that suggests that they endorse you or your use of the work), for details ask info@valiz.nl
* Noncommercial - You may not use this work for commercial purposes.
* No Derivative Works - You may not alter, transform, or build upon this work.

With the understanding that:
• Waiver - Any of the above conditions can be waived if you get permission from the copyright holder.
• Other Rights - In no way are any of the following rights affected by the license:
- Your fair dealing or fair use rights;
- The author's moral rights;
- Rights other persons may have either in the work itself or in how the work is used, such as publicity or privacy rights.
• Notice - For any reuse or distribution, you must make clear to others the license terms of this work. The best way to do this is with a link to this web page.

The full license text can be found at http://creativecommons.org/licenses/by-nc-nd/3.0/nl/deed.en_GB

The authors and the publisher have made every effort to secure permission to reproduce the listed material, illustrations and photographs. We apologize for any inadvert errors or omissions. Parties who nevertheless believe they can claim specific legal rights are invited to contact the publisher.

Distribution:
USA: D.A.P., www.artbook.com
GB/IE: Art Data, www.artdata.co.uk
NL/BE/LU: Coen Sligting, www.coensligtingbookimport.nl
Europe/Asia: Idea Books, www.ideabooks.nl

ISBN 978-90-78088-34-9
NUR 646
Printed and bound in the Netherlands
www.valiz.nl